About the Author

KAREN DUFFY (a.k.a. Duff) is a super
spokesmodel, actress, and a writer. A
former MTV VJ, she is also a Revlon
spokesmodel. She lives with her hus-
band in New York City.

MODEL PATIENT

RX # 0 0 6 0 9 5 7 2 7 1

Karen Duffy

MODEL PATIENT

My Life as an Incurable Wise-Ass

Refills# 4

Perennial

An Imprint of HarperCollins*Publishers*

To John Fortune Lambros,
in love and gratitude.
And in celebration of the life of
Lambros J. Lambros, 1935–1999

Acknowledgment

Francis Gasparini is the spine of this book. He's the glue holding the pages together. It's been my highest privilege to have a collaborator and friend so wildly talented, hilarious, and dedicated to this project. My gratitude is limitless. Saul Bellow said that the process of writing a memoir is like being measured for your own coffin. Francis, your insight, encouragement, humor, and carpentry skills made my dream come true. Thank you with all my heart. I adore you.

Contents

Introduction 1

1. The View from the Penthouse Overlooking
 Success Street 3
2. I Had It Coming 7
3. I Didn't Just Fall Off the Turnip Truck 11
4. Welcome to My World of Disease and Decay 53
5. Modern Immaturity 73
6. My Misery Had a Lot of Company 85
7. Recapturing the Juice 101
8. Dr. Sawbones 109
9. Love and Luther Vandross Burgers 119

10. Helen and Potato Joe 137

11. John's Side of the Story 147

12. Pimple-faced Judas 167

13. Urine for a Surprise: A Love Letter to Western
 Medicine 173

14. Un Couple Malade: The Marriage of Patient and
 Doctor 187

15. No Finnering in the Waiting Room 197

16. I Love My Sarcoidosis! 203

17. Sick Joke 209

18. My World May Be Going to Hell, but I Want to Look Good
 for the Trip 223

19. Things I Wish Somebody Had Told Me 231

20. A Big Fat Happy Stinkin' Life 235

Duff Thanks 247

Francis Thanks 249

Resources 251

Bibliography 257

MODEL PATIENT

Introduction

I recently mentioned to a British friend that I'd read a book about cancer by one of his in-laws, and he said, "Yes, there's an entire spate of these books by literary people cruelly stuck down. Soon we'll be getting books titled *My Bad Cold* or *My Day of Lethargy*." It was a better book than that, but I still take his point—I didn't want to write what I call a disease-pornography book, where the writer wallows in his or her sorrows, and the reader eagerly flips the pages to find out just how bad it can get for the poor old sod. I wanted to write a book that I'd want to read, the kind of book you rarely come across in the "sick person" genre. I wanted it to

be a good story, full of twists and turns and amusing anecdotes. I wanted a book that would appeal to people who might not usually read a book about illness. Above all, I wanted it to be full of life, not weepy, because that's who I am and that's what I prefer.

Writing a memoir is like writing an obituary with the last sentence missing. Well, I'm certainly not dead yet, although this *is* only the first edition. I apologize for the lack of a proper climax, and to make up for it I've worked extra hard to include some entertainingly gory stories, and I promise to drop plenty of names. Did I mention I was with George Clooney when I first got sick?

1

The View from the Penthouse Overlooking Success Street

In 1995, I went to the Emmy Awards in Los Angeles with George Clooney. To nobody's greater surprise than my own, except for my aunt's, who always said I'd wind up living in my parents' basement, I was a mildly warm commodity. I was acting and modeling, and the show I was a correspondent for, *TV Nation*, had already won an Emmy the night before for best documentary show. But the small-to-medium-size spotlight that shone on me didn't blind me to that fact that an Emmy date with George was a score, not just because he was a real star, but because he was such an enormously entertaining guy.

I'd also been palling around with Dwight Yoakam, and I'd even been spending time with Robert DeNiro. I wasn't exactly dating any of them at the time, and I certainly wasn't serious about any one relationship, but in getting to spend time with three rad dudes like George, Dwight, and Bob, I felt like I'd hit the man trifecta at Celebrity Raceway Park.

George was nominated for Best Actor, and although he didn't win, I threw a big party at the Chateau Marmont afterwards. As far as I knew at that moment, everything was perfect in my life and all I had to do was enjoy it to the fullest extent possible. I was going to do a documentary on kayaking in the Sea of Cortez with Arnold Palmer. I was busy modeling for Revlon, I'd just been in *Dumb and Dumber*, and I had TV development deals all over the place. I was happier than Jerry Lewis in Paris. Everything was going smoothly.

I had worked hard to achieve some things, but I hadn't had to struggle and, like a lot of people in the same circumstances, I didn't really appreciate all that I had. Not in the way I do now, that's for damn sure. When I first got a child's-size portion of fame from being a VJ on MTV, *People* magazine named me one of the "50 Most Beautiful People in the World." (I had a cold sore on the day of the photo shoot and they had to shoot me only in profile.) I told the interviewer that the night before I got the word from *People*, I'd won an Ernest Borgnine Look-alike Contest, and I was incredibly honored to receive both accolades. I also told him I'd never had a bad day in my life, and that remained true all the way up until I had a really bad day—the worst of my life.

Though I'd been trying to ignore it, for a couple of weeks I'd had a bad headache, which had gotten steadily worse. By the evening of the Emmy Awards it was like the Devil himself was inside my brain with a hot poker, which he was trying to ram through the top of my skull. Still, I would have gone to the

Emmys with George if it meant carrying my head in with me in a hand-tooled leather bag.

The next day the headache was even more intense. I was still trying to ignore the pain, so I decided it was just too much champagne. I called George to see if he had a touch of the Irish flu as well. He said no, he was fine.

As the day went on, the headache didn't get any better. The pain exploded in my head like a can of Coke that had been violently shaken and then popped open. I was trying to have a normal day resting in my room, but when the pain struck I was stopped in my tracks, as if I'd been electrocuted. I'd been miming the aura of good health for a few weeks, but when I looked around for painkillers and realized I'd downed an entire large bottle of Advil in just two days, I knew I couldn't fake it any more.

I cancelled everything in Los Angeles, hopped a plane to New York, and took a cab straight to my doctor's office. I didn't know it at the time, but when I stepped out of that taxi, my life as a healthy person ended and my life as a sick person began. And I was about to get really, really sick.

2

I Had It Coming

When I was a kid I was terrified of getting leprosy. My grandmother had given me a children's Bible (I still have it) with these really alarming illustrations of lepers that scared the pants off me. I didn't know exactly what leprosy was, but I sure didn't want my fingers to start dropping off. Now I have sarcoidosis, a medical condition that's just as scary. Basically, the soft parts of my body—lungs, eyes, spinal cord, and other important stuff—develop hard, granular spots that impair the functioning of whatever organ they strike. It's not really related to leprosy, but it's always seemed to me like there's a connection. As far as I know,

though, I'm not actually in danger of any body parts falling off, so if you see me on the street, don't be afraid to shake my hand.

What's happening to me is more like what happened to Lot's wife in the Bible. She was turned into a pillar of salt for looking back at the destruction of Sodom and Gomorrah, and I'm crystallizing from the inside out, maybe because I once took a Vietnamese refugee to see *Midnight Cowboy*. I had no idea what the movie was about, I swear.

In a way I do deserve it—it's karma, or fate, or one of those other things I don't actually believe in. I just had way too much fun at the expense of serious diseases when I was younger. In college I tried to help my boyfriend get passing grades by wrapping a bandage around my head and claiming I had massive head trauma, and that it would be cruel to punish him for the distraction caused by his worry about my condition. I kept a bottle of ipecac handy for friends who needed an excuse to postpone a test. One guy actually vomited all over his professor's office in what must have been a pretty convincing display of dire illness. One Christmas break, I got a job as a temporary office worker. I figured receptionist duty would involve answering phones and doing the crossword puzzle, but at the interview they told me I'd have to take a typing test on my first day. I bought an Ace bandage and a sling, told them I'd sprained my wrist, and got the job anyway. Faking a sprained wrist for four weeks turned out to be almost as hard as actually learning to type, but as far as I was concerned, it was worth it. (All this was while I was studying to be a recreational therapist, by the way.)

After I moved into the post-college adult word, the faking became more elaborate. I took a job at a real estate firm, and I couldn't stand it. I showed up one day with yellow eye shadow lightly brushed on my skin and complained of being sick. The next day, more yellow and more complaining. On day three I

called in and said I might have hepatitis. That was the last communication I ever had with anyone in that office. I suppose I could have just quit, but that wasn't my way.

Liver disease also helped ease another short-lived job—as a fishmonger at the South Street Seaport. I was stationed at a little cart selling seafood to strolling tourists, and of course every one of them wanted a half-dozen raw oysters. Shucking an oyster out of its shell is hard, and the little knife you use is really sharp, so I told anyone who asked for some, "Listen, confidentially, those oysters are stinky. I drove them in from New Jersey myself. We're talking hepatitis on the half shell. Why don't you try some boiled shrimp?" Of course, the customers had to peel the shrimp themselves. (My sister Kate was going to charm school at the time, and I had to pick her up after work and drive her back to New Jersey. I was lucky if I came home from work with all my digits, but for my little sister a run in her stocking was a bad day. Her attitude put it all in perspective: "Can you NOT come to my school reeking of fish?")

When I was at MTV, my manager, Peg Donegan, gave me a doctor's reference book for Christmas so I'd know how to fake my illnesses better. MTV never had such a sick employee. I "came down with" shingles, gout, and piles, and I wasn't above renting crutches and claiming I'd stepped on a nail so I could go skiing in Aspen for the weekend. My roommate Lori and I practiced our fake limps by putting stones, nails, and even little pieces of glass in our shoes to see which would produce the most convincing but least painful gimp. I'd perfected the art of malingering.

And then the bony finger of mortality tapped me on the shoulder. Don't kid around with serious diseases; they have a poor sense of humor.

3

I Didn't Just Fall Off the Turnip Truck

When I arrived at my doctor's office in early September of 1995, he did what any physician would do for a patient who'd gotten a bad headache while at the Emmy Awards, canceled her appointments, and flown home immediately: he sent me for a CAT scan that very afternoon to see if there was anything screwy in my head.

The technician who performed the scan was a real wiseacre. Right away she started in: "Ohhh, so you're the MTV girl. MTV sucks!" When you work at MTV, people constantly tease you about the network. I read once that Stephen King thought he was

going insane because he kept hearing his own name repeated over and over, as if people were talking about him. It turned out that people just recognized him when he walked down the street and would mumble his name to whoever they were with. The article said being famous is pretty similar to mental illness—you constantly hear things. From my experience, this is true even if you're a C-level celebrity. I was constantly gawked at and sometimes harassed because my mug was vaguely familiar. A lot of times people insisted we must have gone to high school together, although I used to get a lot of "MTV sucks!"

So here was this technician giving me grief about MTV and teasing me about George Clooney as she had me lie down on the table. "I saw you with him at the Emmys, is he your boyyyy-friend?"

A CAT scan isn't like an MRI, where you're in a big enclosed tube. It's still kind of like a living sarcophagus, but your head is exposed. The technician and I were still bantering as she started the procedure, and then all of a sudden she just clammed up. She had no poker face whatsoever, and I could tell from the fact that she refused to meet my eyes that she'd seen something that wasn't supposed to be there. I said, "For the love of Pete, it can't be that bad. Lemme see the scan." But she wouldn't show me. "Talk to your doctor," was all she'd say. She barely made eye contact with me as I thanked her and said goodbye.

Although I had a feeling something was wrong, I wasn't too worried about it. I figured it was something manageable, like, say, an aneurysm. How bad could that be? Probably just a little, stinking aneurysm.

So I called my doctor. He told me I had a lesion in my spinal column and brain. To give you an idea, my current neurologist, Dr. Frank Petito, described it as being about the size and shape of

a mostaccioli. If you're not Italian, or a fan of Italian food, that means about four inches long and about an inch thick. Actually, that's a little bigger than a mostaccioli, but you get the idea.

My doctor said I'd need an MRI so they could begin to determine what had caused the lesion, and how to treat it. I said fine, I'm free any time next week. "No, I mean tomorrow," he insisted. "I got you the first appointment, at seven A.M."

I had just signed on with the Ford modeling agency, and that night they were throwing a big party. I decided I would go—I wanted to keep moving forward with my life and try to enjoy the good things, not sit home and worry.

I called my parents and told them that I needed more tests. They were really upset and wanted to come in to New York from their home in New Jersey, but I told them not to bother. Then they showed up anyway, which really shook me. I hadn't had time to think very much about the fact that I might be in the soup up to (literally) my neck, or what that might mean. The only fleeting fear I had was that being sick—with what, I didn't even know—might take away some of my independence until I got better. After my parents came unannounced, I figured, I'm never gonna get rid of them and there goes my independent life. (Plus, I had a gentleman caller over, and he had to scoot out of my bedroom window and hide in the garden.) Of course, I love my parents dearly, but imagine yourself in the same situation. I sent my folks home and went to the party anyway.

The following day, a Friday, I went in for the MRI. I was pretty spooked. I sat with my parents as a technician screeched questions at me across the crowded waiting room: "Are you pregnant? What was the date of your last period?" "I'm a model. We're too skinny to have periods," I snapped. But clever repartee couldn't stave off the grim cloud that was settling over me. I was thirty-

four and single, and I thought, This is when you pay the piper for thinking you're bulletproof and don't need anything permanent in your life.

In my unnoticed, unappreciated, majestic good health I'd been happy. I was an unsolicited testimonial for lightheartedness, an enthusiastic conscript in the good-time army. I committed to nothing and no one. Whether at work or in a relationship, I always had one foot out the door, just waiting to move on to the next adventure. Being tied down in any way was anathema to me. My attitude was, as Oscar Wilde said, "I can live without life's necessities, as long as I have life's luxuries."

I'd enjoyed more than my share of life's luxuries. But the luxuries and the ability to enjoy them were about to be snatched away from me. So was the one necessity in my life—my independence.

After the humiliating question-and-answer, the technician shot me full of radioactive dye and put me in a metal tube for an hour. I had never paused to spend any time considering the possibly ephemeral nature of my work, my relationships, even my life. But in that antiseptic white MRI chamber, I had ample time to reflect.

———•-•◦•-•———

I grew up in a very cold family. An extremely cold family. In the '70s, during the oil crisis, Jimmy Carter came on TV wearing a sweater and said something like, "I want every American to lower their thermostat to sixty-five and wear a sweater to save energy." My mother took that as gospel, and essentially Jimmy Carter made me uncomfortable for a good portion of my life. Once when I returned home from my overheated college dorm, I said, teeth chattering, "Here's twenty bucks, Mom, why don't you turn up the heat."

Actually, my family is populated with cheery, happy-go-lucky, kindhearted people, especially my mom, who's a saint. One day, when we were out to lunch, she told me, "I never had a happy childhood until I married your father and had you kids." Turning down the heat might have been annoying when I was a kid, but it was in both my parents' natures to care about society and community, and to put those feelings into practice. My parents are pretty liberal sorts, but I think the real motivator was their Catholic faith—they believed that they were doing their duty as Christians by helping others. Of course, they sent us to Catholic schools and brought us to church every week, and for better or worse (mostly better), I've been an observant Catholic all my life.

When I was a kid, my brother Jim and I went to confession every Saturday night, because you had to confess your sins before going to church Sunday morning. I used to wake up really early on Sunday to watch cartoons, and Jim told me it was a sin to change the channel if a religious program was on. So before I went to bed, I'd turn the TV to the channel with my favorite cartoons.

Of course, when I woke up I'd discover that my parents had changed the channel to whatever they were watching the night before, so I'd turn on the TV and it would be Mass for shut-ins. How was I going to watch *Scooby Doo?* I was so incredibly conflicted over the "sin" of changing the channel to watch cartoons, because I'd cleared my conscience the night before at confession, that I'd wake up my little sister Kate and make her change it instead. If I had to flip the channels myself, I'd watch *Davey and Goliath* to sort of split the difference, but I still had to confess it next Saturday. I don't remember what the priest said, but I assume he probably gave me a couple of Hail Marys and an Our Father. Eventually Jim admitted that he'd made the whole thing up.

Obviously, my religious upbringing was a pretty profound

experience for me. My first grade teacher, Miss Hennessey, told our class that every time we heard a siren on an ambulance or fire truck or police car we should say a Hail Mary prayer for the person the siren is wailing for. I thought that was beautiful, and three decades years later, I still say a quick prayer whenever I hear a siren. (In New York City, that's a cartload of Hail Marys.)

I attended Catholic schools through eighth grade, and of course that meant a lot of scary nuns. They constantly warned us about the godless Communists who were going to invade the United States any day now with the express purpose of defiling American Catholic girls. On the way to school, I'd practice a face to make if the Communists ever came and stormed the school bus. I stared at my reflection in the window, and I'd make myself go cross-eyed and stick out my lower jaw in a vacant, *Deliverance* kind of way. The idea was that the Commies would take one look and be so grossed out that they wouldn't want to kidnap and rape me. So far, it's worked.

Sister Ginetta, my seventh grade teacher, was a bulldog of discipline. Her mantra, if a Catholic nun can be said to have a mantra, was "Knock the smile off your face, or I'll knock it off for you." The problem was, I wasn't really smiling. I have the risorius of Santorini, which means that in my normal state of facial repose, the muscles around my mouth pull my kisser into a smirky and obviously irksome puss. It's just the architecture of my face. If I'd known about the risorius at the age of twelve, I would have tried to explain, but I don't think Sister Ginetta would have bought it. (Oliver Wendell Holmes, a famous dead Supreme Court Justice, said he would have his risorius of Santorini cut out if he had it. He found it particularly annoying in an acquaintance. I've often wondered if this is the problem with the Bush family— maybe George H. W., the dad, and George W., the son, have those irritating little smirks because of the risorius.)

Years later, when I was a correspondent on Michael Moore's *TV Nation*, we did a theme show called "Bully Night." All the correspondents had to get together and make nice with the person who'd bullied them as a kid. I couldn't decide who to ask on the show because I honestly didn't recall much bullying in my childhood. (When I asked my sister Kate for suggestions, she said, "I don't know. If it was my job to contact my bully, I would call you.") Anyway, I finally settled on Sister Ginetta.

I didn't exactly tell her what the show was about, though. I think she was a little upset when she discovered that the reason we'd been goofing around with fighting nun puppets was because I'd said she was my childhood bully, and she sent me an angry letter. At least I assume it was angry—what I received was a few scraps in a plastic wrapper, marked something like "DESTROYED IN TRANSIT." Who says there's no such thing as miracles? Thank you, U.S. Postal Service.

A lot of people complain about being brought up Catholic and I understand why, but on balance what I've taken away from it is more about caring for others than being rapped on the knuckles with a ruler. I'm sure that's partly because of the way my parents expressed their faith by helping others.

Every Easter, they'd invite kids from a halfway house for families in crisis over for Easter dinner. The rest of the year, they helped out in other ways. One day my dad noticed one of our neighbors, an old gent named Mr. Hatterman, hesitating as he tried to cross a busy street. My father helped him across, and he learned that Mr. Hatterman lived alone. Dad took to visiting him regularly, and brought him sandwiches every Saturday for lunch. Both my mom and dad were Eucharistic ministers at church, which meant they helped the priest give out the communion wafers at Mass, and afterwards they would go to a nursing home to give communion to the people who couldn't make it to church.

Although they never insisted that we volunteer for anything, I'm sure my parents were trying to encourage us by their example. When I was twelve years old, I began doing community service as well. My seventh grade class at Our Lady of Mercy visited the Ridge Manor nursing home. We played the Maple Leaf Rag and brought gifts to the residents, and we all did our best to cheer up the old folks. I started visiting regularly on my own, and I kept it up all the way through high school. I discovered that I loved spending time with old people. I guess the psychiatrist-type explanation would be that I was used to having fun with infirm elderly people from riding around on the back of my grandfather's wheelchair, counting the silver dollars he kept in an egg-shaped tin, and watching *Batman* with him.

My brothers and sisters didn't come to the nursing home; they preferred other forms of service because they were all scared of old people. For a while, Laura raised Seeing Eye dogs, which was great for the blind people but sometimes a disaster for us. She had one puppy, Gibson, who could chew anything apart, and I mean anything, including plastic and fiberglass. He actually destroyed our sailboat and our lawnmower. My dad said, "I hope the blind guy that gets this one doesn't have a wooden leg."

After I graduated from high school, I wound up at the University of Colorado. Now, it's not a bad school, but it ain't the Sorbonne, either. It has a well-deserved reputation as a party school, and I liked to think of it as a retirement home for students.

As far as academics, I took a lot of courses like Introduction to Sports History and Sports Philosophy with the members of football team. I ruined my eyesight, not from fancy book learning, but from cheating off the Chinese kid next to me. In retrospect I wish I had done anything but just shuck and jive, because nowadays, instead of sleeping in on weekends, I have to spend a

lot of time reading books like *To the Lighthouse* and *The Second Sex* to catch up.

Not that U of C was a total waste, though—far from it. One Saturday morning I stumbled across what I still think of as my real career. I had been out late the night before, so I biked through the snow to the Boulder community pool to swim away the hangover. There were some students in the pool already, and they asked me if I was there for the class. I said, "No, what class?" They explained that they were recreational therapy majors, and that they got credit for running a swimming course for paraplegics. I thought, Holy smokes, course credit for helping out disabled people? Who knew? This could be the job for me. Until then, I never had any sense that I could actually make a career of what I'd done voluntarily at the nursing home—spending time with disabled people.

So I became a recreational therapy major, which was a blast. For one course I had to arrange a camping trip for some disabled students who lived on campus. I had a blind guy, a quadriplegic guy, and about four other people in wheelchairs. So we drove out to a state park and, figuring, What the heck, I let the blind guy drive the van. Then I got them all stoned.

Through an organization called Clearinghouse, I got a free season pass to El Dora Mountain, where I spent every weekend as an instructor for the disabled ski program. I'm not a graceful skier or even a good athlete, but some of the skiers were blind, so I could get away with it—they didn't know about my poor form.

In my senior year, I was elected the Colorado executive director of Clearinghouse, which is the largest student-run volunteer organization in the country. I have no idea how this happened— I have no management skills, and I sure didn't ask for the job. I was just happy to have a secretary to type my papers for me. But somehow, I did well enough to win the Golden Rule Award for

Colorado volunteer of the year from Governor Richard Lamm. It seemed I had a talent for helping people despite myself.

After college, I moved to New York and went to work as a recreational therapist at the Village Nursing Home. I was happy living out my post-college wild and carefree years, and thoughts of making the big time never entered my head. Once, when I was shopping in Bloomingdale's with my friend Greg, we were recruited by a woman from Esprit to audition for part of a new campaign they were doing using "regular people." We didn't get into the ad campaign, though I did get a moment in the sun when the tape of the auditions was shown on *Today*. But I never thought about trying to model professionally. Even if I'd been interested, all I had to do was look in a magazine or a mirror to realize I wasn't tall, blond, or willowy.

I used to get my hair cut in a Times Square barber shop by a one-eyed guy named Louie. He'd cut James Dean's hair years ago, which I thought was cool. I liked the way he cut my hair, too. I think that lacking full stereoscopic vision because of having only one eye helped him give me the slightly asymmetrical quality that I've always favored with my hair. One day I sat down in the chair and he asked what I wanted, and I said, "The usual, long in the front, short in the back." Louie looked at me and said, "Kid, let me tell you something. If you got all that hair out of your face, you'd be a good-lookin' fella." "Uh—I'm a girl," I said. "Cut it out," he said. He refused to believe I was a woman. Obviously Louie's one remaining good eye had started to go, too, but I wasn't surprised that he'd mistaken me for a guy—I'd always been the swarthy tomboy type, not a glamour girl.

At the nursing home, I called bingo every Monday afternoon. "B-9! I hope your tumor is be*nign*, Mrs. Zella!" I gave away lipsticks and lottery tickets to the winners, and generally got the old folks all riled up. Afterwards, I'd go to a bar called Tortilla Flats

down the street, where they also had a bingo night, with corn chips to mark the cards and pitchers of margaritas for the winners. One Monday I was downing a few bowls of the old loudmouth soup and enjoying myself with my date when a man and a woman came up to me and asked me to be in an ad campaign for Mexx jeans. (Maybe you still have a pair in your closet, or maybe you gave them to the Salvation Army a long time ago.) My response was, "Can the chin music. I grew up in New Jersey, I didn't just fall off the turnip truck." They gave me their card, and my friends convinced me to go for it. Within a few weeks my ugly kisser was plastered on buses, subways, department stores, and billboards all over the world.

They used my date for the ads, too, but his career took a different path—he's a perfume sniper at Macy's. I saw a picture of him once in a *New York* magazine article called "Guerillas in the Mist," about the people in department stores who try to spray you with the latest scents. That could just as well be me, though. I didn't think I was going to be a big successful model, and I didn't quit my job at the nursing home. I was happy working as a recreational therapist, and, as far as I was concerned, that was my career. I did decide, though, that maybe I'd better get an agent so I wouldn't get taken for a ride if I got any more of these modeling gigs.

All the agencies have open auditions one day a week, so I went to one at Elite. I remember thinking, Wow, I'm kind of old (I was twenty-seven) and I'm only five foot seven. I couldn't do anything about my age except try and look as good as possible, but height was another matter. I took a big pair of cowboy boots and stuffed the bottom with sweat socks to give myself some extra height, and I wore a big cowboy hat. I looked like I was about a foot taller, or so I thought.

I teetered into the waiting room at Elite and sat down.

Eventually a woman called me into her office and said, "Okay, take off your hat." Now I was down to six-one. Then she said, "Take off your boots and get on the scale." I pulled off my boots, and the compressed sweat socks came bursting out like snakes out of a trick peanut brittle can. I started crawling around her office trying to collect the socks and my dignity as this woman laughed her ass off. Finally she said, "You're really not the right material for Elite, but you can try the Elite Petite division." The petite department is for the models who actually *look* like young girls, as opposed to the models who *are* young girls but look like complete sex bombs. I thought, Petite? I've got a caboose and a mustache, I'm not exactly a fragile little flower. So I said "Screw it" and walked out the door.

I hitched up my self-esteem and tried again, this time at Click. They weren't much interested either, but one of the assistants in the commercial department, Peg Donegan, piped up and said, "I'll represent her." Peg said she thought of me as more of a commercial model than a fashion or runway model, but she sent me to talk to the fashion department anyway.

I went downstairs and met with a guy who told me, "You're old, you're tired looking, you have dark circles under your eyes..." I said, "Well, you know, you're nothing to write home about either." I stormed back upstairs and yelled, "What the hell? These are the people you work with?" Peg calmed me down and said, "Don't worry, you'll just work with me."

She sent me out the next day for a big national commercial for Skippy peanut butter, and I got it. The campaign was "Everybody's Skippy-dipping." You know how in the movies people drink champagne with their arms linked? The idea was that the guy model and I would eat peanut butter like that. Silly stuff, but a big ad break for me.

When I arrived at the set on the day of shooting, the first per-

son to speak to me was the lighting woman. "Aren't you Karen Duffy? You graduated from Park Ridge High School in 1979?" she said. I turned around, and it was ToniAnn Disanto, who was the scariest girl in my high school and beat the crap out of everybody. Well, the male model was eighteen. I was ten years older, and I was nervous about being too old. So I said, "No, my sister Laura graduated in seventy-nine. I'm Karen who graduated in 1986."

Shortly after that, I was picked to be in the new print and television campaign for Calvin Klein jeans with Stephen Baldwin. It was the follow-up to the wildly successful "Nothing Comes Between Me and My Calvins" campaign starring Brooke Shields, and the ads were directed by the fashion photographer Richard Avedon. The man is a legend, and this was only my third modeling job—I was a complete nobody. Ever seen the movie *Funny Face*, where Audrey Hepburn gets discovered and turned into a star model by a photographer played by Fred Astaire? Well, the Astaire character is based on Avedon. I had visions of myself as the next Audrey Hepburn, or at least the next "funny face" to hit the big time.

In the interview with Avedon, he had me tell stories about myself, with the idea that they'd turn my anecdotes into the commercials. All I talked about was how I was the greatest flirt in the world and how I could write a book about flirting. So the commercials had me sitting with three male models, one of whom was Stephen Baldwin. Underneath the table you see my jeans-clad legs intertwined with Stephen's, but my arms are around one of the other models.

Usually Calvin Klein is a marketing genius, but I guess everybody fails once in a while, and the campaign was a complete flop. I am a lot of things, but apparently I'm no Brooke Shields. My career was taking off, though, and soon I was doing dozens of ads, even though I kept my job at the nursing home. Modeling

still seemed like a game then, not my real life. I felt like I'd snuck into a party and I might as well hang out and enjoy myself until somebody caught me and I got kicked out. I didn't take any of it seriously.

My portfolio, the book of pictures Peg sent out to get me modeling work, was filled with cut-and-paste jobs. I put my head on other women's bodies, because I didn't have a typical model body. Then I'd glue the result next to pictures of Barry White and John F. Kennedy as if I was modeling with them. For my first head shot, I did a takeoff of the album cover for *Whipped Cream and other Delights*, by Herb Alpert and the Tijuana Brass. The cover photo is a sexy girl covered in whipped cream, so I recreated the picture with shaving cream.

In the world of modeling, some girls are thoroughbreds and some are trotters, and I'm a trotter. Women like Cindy Crawford or Linda Evangelista or Naomi Campbell are absolute freaks of beauty, with everything lined up perfectly in the stars and in their DNA. It's a little weird that there are only maybe ten or fifteen women in the world who look like that, but they're held up as the absolute ideals of beauty and everyone's always trying to measure themselves against, essentially, mutant anomalies. In reality, the average woman is five foot four, a hundred and forty-five pounds and a size twelve. But the standard of beauty as represented in fashion is six feet tall, a hundred and fifteen pounds, and a size two. Designer clothes even come in a size zero now, as I'll bet every woman reading this already knew. As comedian Joy Behar said, "It's like they're trying to make women disappear."

I think I appeal to women because it's much more feasible to look like me (just slop on the makeup!) than it is to look like Nikki Taylor. I'm no slouch, but I've got a keister, I get zits, I'm not seventeen years old, and I don't work out. (Peg calls me up and wails, "Would it kill you to do a sit-up?") I wish I'd been

born in more Rubenesque times—you know, "Hurry up and pass the fudge sauce, I'm posing for Rubens tomorrow and I'm too skinny."

After I became a Revlon model, I had dinner with Ron Perelman, the head of the company, and told him, "You were really smart to hire me, because you're finally using a model who actually needs makeup. Claudia Schiffer just wakes up looking like that, but it takes me hours. At least there's some credibility to using me."

At the end of Revlon shoots, Fran Cooper, one of my favorite makeup artists, would ask, "Do you want me to take your make-up off?" I always said, "God no—are you kidding? How often do I get to look like this? I'm workin' it. I'm gonna wrap my face in toilet paper and wear it for a week." I tried to make sure that I always had a date scheduled for after a shoot, preferably with an old boyfriend. I'd sweep in, all done up, and the message was, "See how fantastic I look? Aren't you sorry we're not together any-more?" Fran and I used to call this the "go to hell face."

One of the first campaigns I worked on was for a new Cover Girl perfume called Navy, and I was so worried about it that I gave myself a huge zit in the middle of my head. I tried putting toothpaste on it, but that just gave me a minty-smelling zit. I wore a hat to the photo shoot, wondering what I was going to do. Luckily the photographer said, "I want you to pose with a kitten." I said, "Give me the kitty, I love cats." (I don't.) I went into my dressing room, popped the zit, and came running out, screaming, "The kitten scratched me on the face!"

But despite acne and other imperfections, I've had a contract with Revlon's Almay line for the past seven years. And I've done something like three hundred commercials—from Always Maxi Pads to Vidal Sassoon to Pizza Hut to Fred the Furrier. (For the Fred the Furrier ad, they'd brought a 1930s Packard convertible

into the studio, and the director said, "I want you to jump into the car." On the first take I ran in and did a perfect handspring into the car. The fur was literally flying.)

I gave my dad some of the pictures that Richard Avedon shot of me for the Calvin Klein campaign, and he was really disappointed because I wasn't smiling—he didn't get the pouty modeling thing. So, unbeknownst to me, he sent a snapshot (in which I was smiling) to Guinness beer for their "Miss Guinness" contest. One Saturday, I was at home and Federal Express came. The letter inside said, "Congratulations, you've been selected as one of the contestants in the Miss Guinness contest. You've won a free trip to the Big Apple, where you'll stay at the fabulous Sheraton!" (Of course, I was already living in New York.)

I showed up at the Sheraton even though I didn't think I had a chance to win. I was almost thirty, and all the other girls were pink-cheeked, turtleneck-clad twenty-two-year-olds from the sticks, but I thought it might be fun to try and write a magazine story about being undercover at a beauty contest. I just ran around taking snapshots and not taking it very seriously, but, lo and behold, I was selected as one of the three finalists. There were posters of me and the other two girls in bars and liquor stores across the country, so drinkers could vote for their favorite. My campaign slogan was, "Vote for Duff, 'cause I'm just like a Guinness. I'm dark and warm, and I have a big creamy head." The winner got to march in the Saint Patrick's Day parade in New York, which appealed to my Irish pride, but also had to commit to two years of appearances in places like Ye Olde Irishe Pubbe in Gloucester, Massachusetts, so Peg had to get me out of it. I think my dad was a little disappointed.

Throughout it all, I held on to my job as a recreational therapist, even though I quickly got to the point where the paycheck from one modeling job was more than my annual salary at the

nursing home. The other staff always knew if I was going out for a job. I'd come in at 8 A.M. as regular scrappy me, with my hair in a ponytail. If Peg called to say I had an audition, I'd run home on my lunch hour and come back as a glamour queen. The people at the Village Nursing Home were wonderful. They understood that a great thing was happening to me, but that I really loved my job as well.

I continued working at the nursing home for two and a half years, although I eventually went part time. And even when I finally quit, I continued to volunteer in my spare time, which I still do.

The residents of the nursing home were all very excited about my career, and they were always on the lookout for me in ads. They'd watch TV with eagle eyes—or maybe mole eyes—all day long, as if spotting me was like hitting a jackpot and money would come shooting out of the TV. In general, though, their eyesight wasn't too good, so I could pretty much convince them that any girl with dark hair was me. "I saw you three times," they'd say proudly, but they probably hadn't. (Although they might have seen someone who looked like me. For a while my look was pretty popular, and I even went on a casting call for a "Karen Duffy type." I didn't get the job. Perhaps I wasn't myself that day.)

After I'd done about a hundred commercials, I thought, Well, I'm here in New York, the capital of everything, what else can I do with my life besides pose and pout? So I started auditioning for movies. My first role was in Woody Allen's *Alice*, though I barely swiped the screen. I was cast as an extra along with a friend of mine, Lisa Marie, who's now Tim Burton's girlfriend and starred in *Ed Wood*. We were supposed to be cheesy secretaries, but we were embarrassed by the uncool *Working Girl* duds, so we went to the bathroom and ripped our stockings and redid our hair. Lisa licked her hand and tried to change my hairdo with a little saliva so I wouldn't look so corny.

When we broke for lunch, Lisa and I went to eat down on Wall Street, and stockbrokers on the make started buying us beers. When we came back to the set, our scene was ready to shoot, but we'd "redone" our hair and makeup and we were tipsy and giggling. The producer was mad at us, but Woody Allen thought we were funny. So instead of being background extras, he gave us each a line. Since then I've had small parts in a lot of Woody Allen movies.

I had a bigger role in my next movie, *29th Street*, big enough that I had to go to Los Angeles to loop (re-record) some dialogue. The movie seemed like it would be good—it had Danny Aiello, who's great, and a lot of excellent character actors, like Tony Sirico, who now plays Paulie Walnuts on *The Sopranos*. (Tony is a real character, the kind of guy who says things like "I'm so mad, I'm seeing red rats." He's also not unfamiliar with the world depicted on the show.)

Looping involves watching the movie and speaking your lines along with the picture. As I watched my scenes, I thought, This is strange, there's something peculiar about this picture, something distinctiveThen it hit me: *29th Street* was one of the worst movies I'd ever seen. My brother said, "Hey, somebody's gotta make the bad ones," but I decided I'd better try a new line of work before I became box office poison. (Not that I was entirely unblameworthy. I come from the acting school of "Bring on the bread and mustard—the ham has arrived!" I wasn't so much acting as behaving, or pointing my wardrobe at the camera.)

My Uncle Jimmy, my dad's brother, is an orchestra conductor in Las Vegas. He tells me the Jimmy Duffy Orchestra is the greatest party band in the world, and I'm sure he wouldn't lie to me. Uncle Jimmy once said, "You know, kid, I didn't get into this show business racket for fame or fortune. And so far, it's worked out." I figured I could do at least as well as Uncle Jimmy, so I

made a cheeseball videotape of me goofing around and sent it to MTV. Out of thousands and thousands of applicants, they chose me. (This was before they started the "Who wants to be a VJ?" contests that inflicted Jesse Camp on an unsuspecting world.)

I loved it, but I think one of the reasons I did so well was that I didn't have cable, so videos were new to me even though they'd been around for ten years. I didn't know what kind of persona to adopt, so I used to go to the Museum of Television and Radio and watch old tapes of Frank Sinatra's show. The premise was that Frank was the host of a swanky cocktail party, and the guests on his show were party guests. I loved his sense of elegance, and I decided I'd try and do it like Sinatra. I always dressed up for MTV, and tried to have a swank Francis Albert attitude on camera.

Then I realized, There are no guests, and the only thing I'm serving up is some eminently forgettable videos, so I swung in the other direction. It turned out that working with Alzheimer's patients in the nursing home was better preparation for MTV than watching Frank Sinatra. I learned to command the attention of people with a two-second attention span, and my elocution had to be crystal clear so the message got across. I used to have a bad nervous stammer, but I overcame that in the nursing home— I had to be completely uninhibited because I had to get a reaction from somebody. And, of course, I learned to work in a business full of excrement.

I'd open up every show with a slam, like "MTV—we play the classics because you fear the unfamiliar." I got in a lot of trouble for saying things like, "Every once in a while a singer comes along with an amazing voice, whose talent has been poured into making an incredible song, and the video which captures that performance approaches the level of art. But until that happens, here's Mariah Carey." Or, "One reason his fellow Canadians love Bryan Adams

so much is that he was an Olympic athlete—he was the goalie for the dart team." I used to get calls from managers all the time, yelling at me for taking the mickey out of their clients. I got in real hot water for joking, one January, "I know that a lot of men beat their wives on Super Bowl Sunday, so Frank Gifford, if you're watching, get a crack in for me." (Actually, it's not really true that Super Bowl Sunday is a bad day for domestic abuse, but I don't think that's why MTV was mad.)

I continued to model after I started working at MTV, and I did a photo shoot for an Italian magazine (of course) where I took it all off. You couldn't see any of the naughty bits, because I was lying on a bed partially wrapped up in a sheet, but I was technically naked. Pictures like this get put into the "book" of my work that goes around to advertising agencies and photographers. Some kid got his greasy meathooks on my book and sent that picture, and another where my shirt is unbuttoned (though also not revealing anything), to a magazine called *Celebrity Sleuth*. (If you don't subscribe or your local newsstand doesn't carry it, *Celebrity Sleuth* specializes in naked pictures of famous people.) One of the writers at Letterman sent a copy to my boss at MTV, and all of a sudden everyone was running down to the newsstand in front of the building to buy it. The newsagent realized he had a hot commodity on his hands and prominently displayed the issue, with me on the back cover, under a headline that read "DUFF IN THE BUFF!" I was mortified, although it was also kind of funny. (I've never done actual nude photos, so don't pay money to download any from the Internet. They're actually of an Asian girl who doesn't look a bit like me.)

Although I'm a saucy spoonful, and I like to flirt and talk a big game, in a lot of ways I'm a prude. It's no mystery why—I was brought up a good Catholic girl. But I did start to cut loose after I began working at MTV. How can you not run wild and kick up

your heels when you're a VJ? You're around rock stars all the time, and it's practically an unwritten rule that you have to date one. Well, I got a first-hand taste of the rock and roll life from my first and only one-night stand. Luckily, it went on to last for over two years.

In 1992, I flew down to Daytona Beach for MTV's Spring Break. The hot band at the time was Ugly Kid Joe, and they had just broken huge with a song called "I Hate Everything About You." They were in Daytona to perform at Spring Break, and everyone was talking about how the night before I arrived, the lead singer, Whit, had gotten really drunk in a hotel bar. He asked the bartender for one more shot of Jaegermeister and a wheelchair. After they arrived, he downed the shot, pissed himself, and plopped down in the wheelchair so he could be rolled back to his room.

I shot some pieces at a club that night, and after I was done, a great-looking guy walked by, pinched my butt, and said, "Will you have a drink with me?" I said, "Sure, what's your name?" "Beer Belly Lewis," he replied. "All right, Beer Belly, we'll have a drink." I figured he was just some drunk redneck, but he seemed wildly amusing. He actually kept me going for a couple of hours before he let on that he was really—you saw it coming—Whit, the lead singer of Ugly Kid Joe. Just another indication of how little I knew about popular music, I guess.

We stayed out partying until nine in the morning. Then we went back to my hotel room and ordered up champagne and tons of pancakes. By the time we'd eaten some breakfast, MTV's Spring Break festivities had started up again. My balcony over-looked the main stage, so we went out and shot corks and Frisbeed pancakes at Cypress Hill, Naughty By Nature, and the Red Hot Chili Peppers.

I'd had a wild time with Whit, but I didn't necessarily think it

would lead to anything more. Then, a few days later, I got a FedEx package stuffed full of pancakes. Oddly, I'd just sent him the same thing. Before long, I was Whit's full-time girlfriend.

The average kid at Spring Break was twenty, and I was ten years older. Even Whit was six years younger than me. I was finally on the cusp of adulthood and responsibility, and I wound up as a heavy metal chick. In some ways, we weren't that compatible. Whit would call me up to ask questions like, "Duff, is Philadelphia a state?" The only books Whit had ever read were a biography of Jimi Hendrix called 'Scuse Me While I Kiss the Sky, and maybe Harold and the Purple Crayon. When I had to work and needed him to leave me alone for a while, I bought him Juggs and Over 40 to keep him amused. He had an attention span shorter than a politician's memory.

Whit's full name was William Whitfield Crane IV, and his family were heirs to Fuller Brush and O'Brien Paints. Blue blood ran in his veins, but he was definitely the black sheep. There's a family portrait in his grandmother's house from when he was seventeen, with all the aunts, uncles, and cousins. Whit is in the center of the picture making the devil-horns heavy metal symbol. He was practically a feral child, only instead of being raised by wolves he'd been raised by Ozzy Osbourne. Not literally, you understand, but he worshipped Ozzy. In hotels where they had signs with white plastic letters (you know, like "Gazzara-Massey Wedding in the Upstairs Lounge"), he'd switch the letters to say "Ozzy rules." He'd fantasize that maybe one day Ozzy would come to him and say, "Whit, take this ring, you will now be my son." Recently, I was changing the batteries in my Walkman and discovered that Whit had somehow written "Ozzy rules" inside the battery compartment.

He wasn't the brightest bulb on the tree, but I really loved him. We were fearless knuckleheads, like a two-headed Helen Keller or

the two Three Stooges, running around paying no heed to where we were going but having fun bowling everyone and everything over. Whit once called me a female Huck Finn, which is still one of the greatest compliments anyone's ever given me. We'd both hit a mini-peak of fame at the same time, me on MTV and Whit with the record, and we could do no wrong.

Whit and I were apart a lot when he was on tour or recording, so we communicated through the TV. At the end of every shift I told the cameraman, "Let's do the Whit shot." He'd get my most flattering angle, and I'd lean into the camera and snap at it and growl like a dog—"rrufff!" Whit knew that wherever he was, he could turn on MTV and catch me during my shift, and at the end I'd do my special Carol Burnett-type greeting. When Whit was being interviewed, he'd do the little growl-snap as well.

For our first vacation together, we had planned to go to Mexico. The day we were supposed to leave, he was passed out in my hotel room. I tried to wake him, but he just mumbled, "Leave me alone." He was being a big baby. I said, "I'm going to Mexico. If you wanna come, get up, but I'm leaving this room right now and I'm getting into a cab, so you better move." Three minutes later, he came marching through the lobby of the Chateau Marmont with one of those twelve-pack suitcases of Bud. "That's all you're taking?" I said. "Look," he said proudly. He'd taken a couple of the beers out and stuffed some underwear and socks in. Whit made the French seem fragrant and well-mannered.

When we arrived in Cabo San Lucas, the first place we went was Cabo Wabo, Van Halen's restaurant. Whit, being a professional disturber of the peace, got really drunk and took a fire extinguisher and sprayed it all over. The club called the police, so we had to run out before we got arrested and spent our vacation in jail. It was four in the morning, and we ended up wandering through the dusty back streets of Cabo. A little dog started fol-

lowing us, and Whit said, "Watch." He stood in the middle of the street, dropped his pants, and started to pee. Then he started spinning in a circle, like a sprinkler. The dog went crazy, barking and running around in a circle, too. When Whit was done, he said, "I don't know why you don't just turn around and start running away from me as fast as you can." I said, "Because you crack me up." He must have cracked up the dog, too, because he followed us around the whole time we were there. We called him "Future Burrito."

Whit had a lot of penis tricks. He had the inverted penis twist, which is hard to describe but looked sort of painful to me, and the Brain, which involved making his scrotum look like, you know, a brain. He also liked to take pictures of his genitals and send them to me. I framed one where he'd made a little face—drawn eyes on his balls, and the penis was the nose. It's nice to have a picture of your boyfriend to remember him by. I hung it up in my apartment, but my dad came over one day, got upset, and took it down.

When Whit was on tour he'd often call me after a night of debauchery. If my phone rang at four in the morning, I'd always pick up because it had to be Whit. "Hey, baby, do you know what my favorite thing in the whole world is?" he slurred during one particularly memorable call. I was thinking, Yeah—me. "No, baby, what is it?" I said coyly. "In the strip clubs in Atlanta, the girls bend over and you can see everything, and it only costs a dollar," he said. I had to laugh. That was the sort of thing that kept the romance going.

I continued modeling and appearing in commercials while I was on MTV, and one year I did the Bud Bowl spots with Ahmad Rashad, Bob Costas, and Joe Namath. In case you were too young to drink then, Budweiser used to run a series of commercials during the Super Bowl in which bottles of regular Bud played a foot-

ball game against Bud Light, and the outcome was top-secret. I had to sign a confidentiality agreement not to reveal the winner, because there was a betting line in Las Vegas, and serious money was being wagered on the outcome. Whit was really on my ass about it, because he thought this was going to be his big score. He actually sent somebody to Vegas to lay the bet for him and then begged me to tell. I had to lie and say, "I can't remember."

Whit was possibly the most physically beautiful man I have ever seen in my life. He's staggeringly gorgeous. One eye is green, and other one looks like someone cracked an egg in it—the iris is orange and kind of splattered instead of round. (He also has a beauty mark in the corner of his eye that looks like an eye booger.) He has classically chiseled features and long blond hair. He'd probably be classified as a pretty boy if he wasn't such a stinky boozer. I knew that with Whit's looks, and the kind of guy he is, and living the rock and roll lifestyle, there was a possibility that he might not be 100% faithful. Early on, I realized I had to decide whether or not I was going to allow jealousy or insecurity to ruin our relationship, and I made a very conscious choice not to worry about it. The sense of unfettered liberty I got from Whit was exhilarating, and I didn't want to jeopardize that by trying to rein him in with questions and suspicions.

In retrospect, Whit probably could have used some reining in. We took a vacation in Tahiti because I'd found a hotel where the rooms were little huts on stilts in the water with a glass porthole in the floor. I told him I'd lay naked on the porthole and he could swim underneath the house and check out my ass, and he was all for it. So we met at 4:30 P.M. on December 17 at the swim-up bar of the Hotel Bora-Bora. We spent a couple of weeks in Tahiti, during which Whit shook off the few remaining vestiges of his sense of propriety. I'd imagined kayaking around beautiful lagoons, and there was some of that, but Whit put his special

stamp on everything we did. We went to a lagoon where you paid some money to feed sharks fish out of a bucket, and maybe they weren't so dangerous, or maybe they were smart enough not to bite the hands that fed them, but I got them to swim up and take the fish right out of my hand. Whit was having no luck, though; the sharks ignored him, and he got annoyed. When I turned to look at him, his swim trunks were at his ankles, and he was bending over with a dead fish clenched in his butt, waving it at the sharks. The next day we took a snorkeling trip, and the guides warned us not to put a hand or finger in any dark holes on the reef—lurking moray eels might chomp our appendages off. No sooner did we get in the water than Whit swam over to the nearest hole, whipped out his unit, and made as if to stick it in. I admired Whit's dedication to make me laugh, even at the risk of severe injury to his soft parts. I'm kind of an easy girlfriend—just make me laugh hard once a month, and I'm sold. Whit made me laugh every day.

By the end of our time in Tahiti, Whit had gotten even more uncivilized than usual—kind of caveman—to the point where instead of putting on clothes to go outside, he'd just cover his member with what he called a "scrotokini." He flew directly to a New Year's Eve gig in Hawaii, and it was a wild show. Perhaps inspired by the shark-feeding adventure, he ran around the stage with the microphone in his butt cheeks and brought the house down.

If I needed a kick in the ass to alert me that this wasn't going to be another Paul Newman–Joanne Woodward relationship, Whit's burgeoning legal problems sure warmed my butt. In early 1993, I took Whit as my date to the MTV Inaugural Ball. But when we arrived, security wouldn't let him in. Whit had failed his Secret Service background check. He eventually snuck in

anyway, wearing a borrowed tuxedo jacket over his T-shirt and shorts.

The final cherry in the cocktail was when Whit was charged with inciting a riot in Columbus, Ohio. He was hauled off to jail in his underwear, spent the weekend behind bars, and was facing seventeen years in the pokey. I told him, "Oh yeah, I'll wait for you, just don't get too attached to your prison wife."

Whit was a booze hound, perhaps not the sharpest knife in the drawer, and being with him was magical. But after a couple of years, at the point when a relationship should start to jell, I realized it wasn't going to work out, not least because he might be in jail for the foreseeable future. I'd noticed that he always told me how much he loved me when he was drunk. One day I said to him, "Baby, why do you always say that you love me when you're drunk and you never say it when you're normal?" And he said, "'Cause normally, you're not that cool." That might seem mean, but it made me laugh. My head nearly flew off my neck. That was what going out with Whit was like—it was a ball, but it could never have developed into a mature relationship.

We had started talking about having a family and getting married. As much as he said he was, it was obvious that he wasn't ready. I told him, "Well, you'd make a good *first* husband." He kept pestering me to have kids, too. We'd joke about how we'd have a good kid and a devil kid. The good kid would have all of our good qualities, like my nose and his eyes. The devil kid would have all of our bad qualities mushed together—short, drunk, and chubby. But when I got serious, I'd say, "Dude, if we had kids I would want you to raise them. I know you won't be around and it's gonna be some other man raising your son."

I mean, Whit was literally homeless. The whole time we were together he never had a home of his own, just a place to crash. He

lived in his leather jacket, like a turtle. I once went to pick him up at the place he was staying while he was recording in LA, one of those horrible anonymous furnished apartments. (He got it cheaply because the previous tenants' snake had escaped from its tank and made its nest in the walls.) The door was open, so I just walked in. The living room, strewn with beer cans and fast food wrappers and girly mags, had attained a level of filth that you don't really encounter very often. The parts of the room not occupied by trash were covered with smelly long-haired blond guys, and I had no idea which one was mine. So I waited, and eventually Whit came to and sat up. "Hey, baby!" he said. Then he pulled his sock off his foot, rubbed the grease off his face, put it back on, and said, "Wanna go look at guitars?" That was his entire morning grooming.

The thing I loved about him most was his sense of liberty and irresponsibility. He was twenty-six and full of piss and vinegar. I didn't want to be his jailer, the one who took away his freedom to be wild. (If only Pamela Anderson had thought about that before she married Tommy Lee.)

I realized the relationship was coming to an end, and I started seeing other people. One morning, when Whit was staying with me in New York, I got out of bed, stuck a few pillows next to Whit in a Karen Duffy kind of shape, and snuck out for a breakfast date with another guy. (Obviously, Whit waking up any time before early evening and noticing I was gone wasn't really a problem.) Afterward, I came back home and got back into bed, and eventually Whit woke up. "Let's go to the Pink Teacup for breakfast," he said. The Pink Teacup is a great restaurant, but I'd already eaten. But I couldn't say no.

There was a fortuneteller's shop in one of the buildings on West 4th Street, on the way to the restaurant. The fortuneteller leaned out the window and called, "Hey, miss, miss, I have some-

thing to tell you." I'm a New Yorker, and I don't believe in that malarkey anyway, so I said, "No thank you," and kept on walking. "No, I got something to tell you, it's really important," she insisted. Whit said, "Tell me." "She don't love you no more! She's got somebody else, and he's right around the corner!" the fortuneteller yelled. I just hurried Whit along to my second breakfast. Maybe she'd seen me earlier with my date, or maybe there's more to the psychic racket than I thought.

My relationship with MTV was deteriorating, too. Ignoring the fact that I'd done hundreds of commercials before I became a VJ, the brass felt I was getting commercial work because I was on MTV, and demanded a chunk of my payday for any ads I did. Obviously, I disagreed, but the suits devised other ways to screw me. I was offered a very large amount to do a one-day shoot for a Burger King commercial, and MTV called up Burger King and said, "You can't use her unless you buy a huge amount of advertising from us." Well, my job description didn't include selling ads for MTV, so I gave my brother Jim my ID card and ordered up $200 worth of Whoppers from the Times Square Burger King. Jim and his friends barged into the VIP reception area to deliver the burgers and sang "Let Duff have it her way" to the bemused staff. MTV still didn't let me do the ad.

That set me on the grease chute to hell at MTV. My time slots got worse, and so did my assignments, so I started quitting regularly. After the Burger King fiasco, I was supposed to do Spring Break, but I wanted to go on vacation, so I flew to Paris instead. I had a code with my producer, Dave Ladik, so I could call him without anyone else in the company knowing. I called MTV and said, "This is Mrs. Kimball from DelMoro Industries for Dave Ladik." Dave picked up the phone and said, "Mrs. Kimball, where are you?" "I'm in Paris. I quit." Then MTV hired me back for more money. This happened a couple of times, actually, but they

still didn't let me do that Burger King commercial. Eventually it went to Dan Cortese.

It was time for me to move on. I was a late bloomer as a model and a VJ, and I was past my peak at MTV. Anything I'd wanted out of the job, and anything I could bring to it, I already had. I was in my thirties and I had no connection to any of the music. MTV had me under contract until I was forty, but I thought, "What would be more pathetic than having an old goat like me announcing the new Britney Spears video?" (Britney wasn't out then, but that's what I'd be doing if I'd stuck around.) I guess I imposed ageism on myself, but you have to be realistic, and the reality was that it was time for something new. I didn't want to be mutton dressed up as a lamb.

Besides, I just couldn't understand the culture at MTV. Everyone suffered from the collective delusion that working at MTV was "cool." The staff were all "nonconformists" in the same machine-stamped conformist way. They cluttered their offices with "hip," "ironic" bric-a-brac. My boss had a surfboard hanging in his office (he didn't surf). One guy had a box of Quisp cereal sitting on his desk for three years—not to eat it, but because he thought the box was "cool." Work is not cool, and working at MTV is really not cool. You're a cog in a monopolistic corporate machine. But these loudmouthed know-it-alls would compete with each other for the most encyclopedic knowledge of the most obscure subsets of music, as if that made a difference to their job. They tried to bully their co-workers with their refined musical tastes in much the same way they were probably bullied in high school. Meanwhile, all the funny office toys in the world and the rarest twelve-inch singles couldn't disguise the fact that MTV is all about the next 'N Sync world premiere video.

Once I had all that in perspective, I turned back to modeling and movies, despite my earlier fears about stinking up the big

screen. In 1994, Whit flew to Austin, Texas, to stay with me on the set of *Blank Check*, a movie I was doing for Disney. He'd just been busted for inciting the riot, and Whit's manager thought maybe being around me would calm him down a little. As if. I loved Whit, but I knew things weren't working out.

I was still doing occasional work for MTV, and one weekend I shot down to Houston to interview Dwight Yoakam. The scene around him was astonishing. I was used to all the attention Whit got, but I wasn't prepared for a country star being so popular. I fought my way through crowds of grown women milling around his tour bus holding head shots of Dwight, dancing around and kissing the pictures, acting like teenagers with Backstreet Boys centerfolds from *Tiger Beat*.

When I made it on board, it was the first tour bus I'd experienced that wasn't a urine-soaked, centerfold-decorated, Porky's-video-blaring cesspit. I was impressed. I hadn't known you could be on tour in a semidecent environment.

Dwight took off his hat as I came in, and if you've ever seen him hatless, like in *Sling Blade*, you know he's got less than a full Elvis pompadour. I thought, What a gentleman to choose taking his hat off for a lady over his own vanity. But I didn't know anything about Dwight or his music, and he didn't seem all that enthused about the interview, so I said, "Listen, I've got my boyfriend waiting back in Austin to take me out on the town, so if you'd rather not do this let's just skip it." He insisted that it was fine, and as we talked I really started to like him.

Back on the set the next day, the entire cast came down sick from the lousy catering, although the performances were so atrocious that maybe we got food poisoning from all the scenery we'd chewed. In the hospital, lying on a gurney, I hallucinated visions of Dwight Yoakam. I realized I'd kind of fallen for him.

We started a telephone relationship, but when *Blank Check*

wrapped I went off to Australia for another wild vacation with Whit. It was more of the same—a lot of drinking, a lot of drunken stunts. The Australian book of etiquette is a very slim one, and Whit fit right in with the locals. But the constant alcohol-fueled insanity was starting to wear thin.

I'd had a lot of fun with Whit, and we remain tight. He's my favorite old boyfriend. But after Australia, I knew I wanted to see less of Whit and more of Dwight.

When our vacation was over, Whit flew off to Bali for more recreation. I went back to L.A., called Dwight, and we went out on our first date. When he walked into my bungalow at the Chateau Marmont, he noticed a bouquet of roses. "Who are they from?" he asked. I said, "I don't know, the card says, 'Love, John,' but I don't know which John."

Dwight dropped the subject and seemed to forget about it. He drove me to dinner in his El Camino and took me to a movie (*Household Saints*, if you're curious—I loved it). Afterward we hung out and talked until six in the morning.

When I got back to my room the next morning, hey presto— another bouquet, of a hundred roses. The card read, "This is so you can have flowers from someone you know. Dwight." That slinky minx had ordered them for me when he excused himself from the table the night before. I said to myself, This Kentucky ham has style.

The next day, my friend Bob Guccione Jr. came to pick me up for drinks, saw all the flowers, and boom—another hundred-rose bouquet. Bob has quite a charming competitive streak.

Then Dwight came over again, saw the new flowers, and bada bing—two hundred roses in the next vast arrangement.

Then some random hotel guest saw all the roses being delivered to my room and decided, What the hell, I'll send her some, too. I had over six hundred roses in my bungalow. The hotel staff

teased me that I broke the record for most flowers delivered.

But I didn't start dating Bob or "John" or the mystery guest. I'd fallen for Dwight in a big way. He was the perfect antidote to my Jaegermeister-swilling boyfriend Whit, like a refreshing sorbet that cleansed my romantic palate. Dwight was very smart and well read and had a great vocabulary. He was something like a genius. After Whit, being with Dwight was compelling intellectually, something I hadn't realized I'd missed. (In fairness to Whit, what he lacked in intelligence he made up in alcoholic stupidity.)

And Dwight was exotic. I'd never met a genuine hillbilly. You don't generally run into them much in New Jersey. At the time, his house was filled with all kinds of Western-themed stuff, like paintings of Indians and Frederic Remington sculptures glorifying the cowboy lifestyle. Dwight also had traits that were completely incongruous for a bachelor hillbilly. He watched CNN and the History Channel obsessively—I don't think I ever saw him turn on the Nashville Network. He had a silver pattern, and a complete set of fine china. What other unmarried straight man has a silver pattern?

Although he wasn't Catholic, Dwight was very respectful of my religion. He always kept an eye out for gifts he knew I'd like, such as a hand-embroidered silk banner for the Society of Mary from a church in Kansas, a giant carved rosary from Mexico, and a crucifix and candlesticks from a church altar (I'm sure he acquired them legitimately). That was his way—thoughtful and sensitive to who I was.

After spending two years in heavy metal purgatory, I was dating a grownup for a change. For our first Christmas together, he gave me diamond earrings and a matching set of pearls: necklace, bracelet, earrings. Then he gave me a locket he had designed himself. I opened it up, and inside the locket was a huge, flawless diamond. (Not to take anything away from Dwight, but he'd gone

out with Sharon Stone before me, and I'm sure she taught him a lot about how to treat a lady right. Thank you, Sharon Stone.) Zsa Zsa Gabor once said, "I've never hated a man so much that I gave him back his jewelry." Well, I still love Dwight, so I never had a panic attack over whether to return his largess. (If you're wondering what I gave Dwight, it was a fly swatter. Very practical, and he's never returned that, either.)

I went to Mass later in the day, and if you're not Catholic, there's a part called the Sign of Peace when you turn and shake hands with the people nearest you. I turned to my left, and there was Bruce Springsteen, a hometown hero from my New Jersey childhood. "Merry Christmas, Duff," he said as he shook my hand. I knew then that this was a great Christmas for sure.

I finally busted up with Whit for good ("Welcome to Dumpsville, population: you," I told him) and started dating Dwight. We went out off and on for about two years, or, as I like to say, about sixty carats worth. I was crazy for him because he was so compelling, so smart and talented and enigmatic. He sometimes came off like a backwoods type, but in many ways he was more cultured and refined than anyone I knew.

We both did our own thing and gave each other plenty of space. I would go out to visit him, or see him when I was in town for work, but he almost never came to New York unless he had to play a show. Sometimes we'd break up, only to get back together again because I felt so comfortable in a relationship with Dwight. It helped steer me back on the path to adulthood that I'd wandered ludicrously far from when I was going with Whit.

I was still capable of behaving like a child, though, which I'm sure helped me get a part in *Dumb and Dumber*. It's probably the biggest and best movie I ever did, whatever that says. Jim Carrey was exactly like you probably think he is. He works really hard, and he's always on, cracking jokes with the stage hands and prat-

falling. One day he was complaining that he was in terrible pain, and I figured he was just setting up some elaborate joke. When he collapsed and the producer called an ambulance, I realized he wasn't kidding around. The EMTs said he probably had gall-stones, and as he was being strapped on to the gurney, I said, "Jim, save me your stone."

I went to the hospital that night to visit him. His agent had sent Jim an enormous TV, and he was watching the video of his gall bladder operation. I said, "Dude, where's the gallstone?" He said "I gave it to Lauren" (Lauren Holly, his then-future, now-for-mer wife). I guess I couldn't blame him for giving it to her, but I told him sadly, "I was going to make you a necklace out of it."

I dated other guys in and around going out with Dwight, and continued to step out and have a good time. Ever since Chris Farley started on *Saturday Night Live*, I'd had a huge crush on him. My sister Kate and I had a half-funny, half-serious Chris Farley fan club going. We'd talk about him dreamily, "Oh, he's just so

The Body Parts Museum

I was bitterly disappointed when Jim Carrey didn't give me his gallstone. I told him I was going to make him a necklace from it, but that was just to make him feel guilty. Actually, I've always wanted to start a celebrity body parts museum, and Jim's pebble would have been the first actual exhibit. However, I do have a wish list of items I'd like to acquire for the muse-um, or at least display on permanent loan.

Ronald Reagan's rectal polyps

Betty Ford's breast

Elvis Presley's wart

John Dillinger's penis

Napoleon's penis

Napoleon's heart (replica): I've heard that after the little Emperor's death, his ticker was kept in a glass bottle on the island of Saint Helena. One night the attendant heard a crash, and went running in. The bottle was broken and a rat was disappearing into the wall, dragging the heart.

And for the Dean Martin Hepatology Gallery:

David Crosby's liver

Larry Hagman's liver

Mickey Mantle's liver

funny and cute," she'd sigh. "Yeah," I'd breathe. "What do you think he's doing right now?"

I really did think Chris was cute, though. He was the type of guy just the way I like 'em—fat and funny. I thought he'd make the perfect husband, because if you had a bad day, he'd be guaranteed to open up the closet and have a bowling ball fall on his head, and you'd laugh your ass off. When I was with Whit, we went to a *Saturday Night Live* after-party, and Whit, who was absolutely spectacularly gorgeous, ran over to Chris (you remember what he looked like) and said, "My girlfriend is totally in love with you, you have to come meet her." Chris came over to our table, and he was really hammered and sweaty, slurring his words, and he never even noticed me. I swear he couldn't even see. I was a little crushed.

At another *Saturday Night Live* party a few months later, I was introduced to him again. I said, "Don't you remember? We met before." He said, "I don't remember, I must have been really wasted. But I don't drink any more." Then—Heaven!—he asked me out on a date. (Like Katherine Whitehorn said, "Outside every thin woman there's a fat man trying to get in.")

Chris picked me up at my dressing room at MTV. I was feeling pretty sassy, all dolled up with perfect hair and clothes and makeup, but when he called up from the lobby I got weak in the knees and I actually fell to the floor of my dressing room. All I could think was, Whaaaa, my dream came true.

I suggested we go to the Museum of Natural History to see the Imax shark movie. It was snowing like crazy and we couldn't get a cab, so we walked up through Central Park. Chris kept falling down, and I thought, Well, I'm with a comedian, he's just goofing around. Then I started to realize he was really having trouble. I'd never seen a biped move that way. He had really tiny feet and he was pretty heavy, and he was having such difficulty making progress that it seemed like he had no bones in his body. He would take a few steps in the snow, sweating heavily, then slip and fall down. Once he actually kicked my legs out from underneath me, and we both started laughing and tackling and tripping each other in the snow, making a game out of it.

When we finally made it to the museum, we were waiting on line to get tickets to the movie and I realized that everybody was looking at us. I thought, Of course, he's Chris Farley, and they want to know who his date is. The museum was packed with school kids screaming and staring at us. It was pretty overwhelming.

After we got the tickets, I excused myself for a powder, and when I looked in the mirror I saw that my makeup was smeared across like some kind of bad painting. Horsing around in the snow had ruined all the hard work of the makeup artist. I'd been

walking down the street looking like Alice Cooper, and that was no doubt the reason we'd been the focus of so much attention. After I cleaned myself up, I was furious. "Chris, why didn't you tell me?" I yelled. He said, "I wanted you to look ugly so no other men would look at you." I melted.

I started dating Chris on and off, but much less seriously than with Dwight or Whit. He had other relationships just as I did, but I made a point of going out with Chris because we always had so much fun. I took him to the Ernest Borgnine Look-alike Contest at Tortilla Flats, and he showed up at my apartment looking more like Ernest Borgnine than Ernest Borgnine did. He'd gone to the NBC wardrobe and makeup departments, and he had the gap in the tooth, a perfect wig, and the *McHale's Navy* costume. My friend Lori and I went as the two-headed transsexual Ernest Borgnine. Guess who won and who didn't. I said to Chris, "Oh, you Judas, I brought you to my neighborhood look-alike contest and you stab me in the back." He said, "Don't worry, baby. Maybe there's an Ed Asner look-alike contest you can enter."

After that experience, Chris and I made an abortive attempt to write a play called *The Importance of Being Ernest Borgnine*, about the thirty-eight-day marriage of Ernest and Ethel Merman. The disgruntled wife told the judge that Ernest gave her the Dutch oven—farted in bed and then pulled the sheets over her head. It's all in the court records. I guess farting through silk sheets wasn't good enough for Ethel Merman.

In the fall of 1994, we were both in Toronto working on movies. When he brought his two brothers over to visit me, I had what must have been a thousand pounds of Farley in my hotel room, which gave me an idea. In Toronto they have little bicycle rickshaw taxis pedaled by little sprout-eating, Birkenstock-wearing guys. I took Chris and his brothers downstairs and made them hide, which wasn't easily accomplished. I flagged down a pedicab,

and then Chris and his brothers jumped out of hiding and all squeezed in. Chris said, "Take us to the Barbarian Steak House— it's right up that big hill."

At the same time, I'd been working on my most satisfying TV job ever. In the fall of 1993, I went to a screening of the pilot for Michael Moore's *TV Nation*. I brought my friend Anastasia Pappas, who was my writer at MTV. After the screening, she said, "Duff, you were staring at Michael Moore like he was the last fire-cracker on the fourth of July. Why don't you try for a job on his show?" So I wrote him a letter about how proud he must be of a show as good as *TV Nation*. I also wrote a letter to Warren Littlefield, the head of NBC, and Jon Feltheimer, the head of Columbia TriStar, the studio that was producing the show.

Michael Moore was in a meeting with Littlefield and Feltheimer to discuss possible correspondents, and they all took out my letters. I think they were trying to bust me to see if I'd written three of the exact same letter and just changed a few words, but luckily I hadn't been that lazy. After the meeting, Michael called me and said, "If you like the show so much, why don't you come work on it?" I did, and of all the jobs I've had in TV and film, I'm most proud of working with Michael Moore. *TV Nation* was a sort of wise-ass *60 Minutes*. Our mission was to comfort the afflicted and afflict the comfortable, although some stories just documented the dusty corners of America, like my piece on North Dakota, the least-touristed state in the Union.

I was working for *TV Nation* and MTV at the same time, and both jobs had me traveling to Los Angeles fairly regularly. On one trip, my sister Kate called and asked what I was doing the next day. I said I had a date with Chris for lunch and I was having din-ner with Dwight. Kate started singing a nursery rhyme from our childhood: "Fat and skinny had a race, all around the pillow case. Fat fell down and broke his crown, and skinny won the race."

When I met up with Dwight for dinner, he asked what I'd done that day. I said, "Oh, I had a date with Chris Farley." *"Really,"* he said, displeased. He knew I'd always liked Chris. So I sang him the little rhyme, and said, "Don't worry, skinny, you won the race." (How many times does a nursery rhyme actually come true like that? Not since that Little Bo Peep character actually lost all those sheep, I'll bet.)

On the same trip, I went to the House of Blues with Chris, and Sylvester Stallone and Dan Ackroyd invited us to the VIP room. Stallone's girlfriend, Angie Everhart, kept saying to Chris, "Look, you've got bigger tits than I do." It was really hurting his feelings, and I would have kicked her ass if she hadn't been Sylvester Stallone's girlfriend. Yeah, I would have told *her* to shut her damn pie hole if I wasn't such a coward.

On our way out of the House of Blues, Chris and I ran into George Clooney. George had just broken up with his girlfriend, and a mutual friend had been telling us both that we should get together. So when George spotted me, he literally picked me up and spun me around, and said, "Karen Duffy, I'm George Clooney. I've been looking forward to meeting you. Let's have dinner." I needed another fella like a dog needs fleas, but I started to pal around with George, too.

In case you're feeling bad about the way Chris was treated at the House of Blues, let me assure you he had astonishing success with women, me included. The number of women who threw themselves at Chris, as if I were invisible, was amazing. Once I was out to dinner with Chris, George, and Noah Wyle. I excused myself to go to the bathroom, and when I came back, there was a girl sitting at my place, hanging on to Chris. It was like that all night long; Chris got all the action, and George and Noah got the seconds. I guess the really skinny girls love the really fat guys.

As far as I was concerned, things couldn't have been better. My career was swinging, I was dating guys I really liked, and life seemed like endless fun—until something exploded in my head and I got a headache that wouldn't go away.

———•••———

I didn't think about all of this at the doctor's office, of course, just the broad outlines. But my reverie in the MRI tube began a process of reflecting back on my life. In the days and weeks to come, I'd have ample opportunity to examine each and every moment of my life in exquisite detail.

4

Welcome to My World
of Disease and Decay

The night after my first MRI, only a couple of days removed from making the Emmy scene with George Clooney, I went out to my sister Kate's house to watch the Miss America pageant. My whole family was there. It's kind of a tradition. It was the first year of the "interactive" pageant—you could call and vote on whether or not to keep the swimsuit portion of the contest. Right after I called in, I noticed that my left hand was numb. The last feeling I ever had in my left forefinger was when I pressed "I" to vote for keeping the bathing suits.

The numbness spread fast as the lesion grew and pressed on my

nerves, and soon my entire left side was numb and paralyzed. It felt like when part of your body falls asleep, but this was a large part of my body, and the feeling never went away. To make matters worse, the pain that had started as a bad headache quickly became full-body agony. I couldn't stand the feeling of clothes on my skin, so I'd just lay in bed naked and try not to do anything that might make the pain more intense. Even a breeze on my neck felt like I was being dipped in boiling oil.

The pain was so bad that I couldn't help crying, harder than I'd cried since I watched *Old Yeller* and *Sounder* and the other puppy snuff films aimed at kids. But my skin was so sensitive that the tears felt like sulfuric acid as they rolled down my face. I couldn't wipe them away, because the feeling of a tissue scraping across my cheeks was even worse. I wanted to call Amnesty International and report a torture.

Most people, when they're sick, it hurts to laugh. Me, it hurt to cry. It was like a bad country song: "It hurts just to cry, Take your tongue out of my mouth, I'm kissin' you goodbye, Just remember it hurts when I cry."

The Monday after my MRI, I had my very first spinal tap. This was the beginning of six months of almost daily visits to one hospital or another for an endless series of tests. I was in and out of five hospitals: St. Vincent's, Sloan-Kettering Memorial Institute, Rockefeller University Hospital, New York Hospital, and Mount Sinai.

I had daily blood tests, MRI after MRI, and too many spinal taps to count. Doctors whacked my knee to test my reflexes, then stuck me with needles to test the same thing. The possible diagnoses were multiple sclerosis; non-Hodgkin's lymphoma; AIDS; amyotrophic lateral sclerosis, the disease made famous by Lou Gehrig; and sarcoidosis, a disease I'd never heard of. A very cheerful assortment.

There's no one test for MS or non-Hodgkin's lymphoma, so you go through a battery of procedures that, when taken together, *maybe* give your doctors an idea of what's going on. They try to rule out all the things your disease *isn't*, and then they come up with what's called a "diagnosis of exclusion." I was seeing a lot of doctors, and every doctor wanted a full medical history and a complete work-up, so I had the same tests performed many, many times.

Some of them seemed like they were just made up to impress the patients. For one test, called "evoked image response," you get wires stuck all over your head, and then you look at a series of black-and-white pictures. "Okay, your optic nerve works." I could have told them that without the test.

Other tests seem more like you've just been caught at a DWI checkpoint and are in imminent danger of losing your car. Follow the moving finger with your eyes. Walk a straight line. Hop up and down with your eyes closed. I passed, and I got to keep my car.

And then there are the tests that seem like voodoo. To check the progress of the paralysis, I'd lie down on a gurney and a doctor would poke me with a pin. He'd start poking at the base of my spine and move up. It would go like this: "Ow. Ow. Ow. Ow. Ow. Ow. Okay, you stopped, am I done?" But he hadn't stopped. I just had no feeling where he was sticking me. At least it didn't hurt any more. And I don't *think* I wound up with any sinister curses hanging over me.

For a long time, no one could agree on what the results of the hundreds of tests meant. But the possibilities weren't too encouraging. AIDS, Lou Gehrig's disease, and non-Hodgkin's lymphoma are serious and terrifying diseases. I knew something about all of them from doing a story on viatical insurance for *TV Nation*. (Viatical insurance is when dying people sell their life insurance

policies for money up front. Then the buyer waits for the sick person to die so they can cash in.)

But I had seen MS patients first-hand as a recreational therapist, and multiple sclerosis was the possibility that frightened me the most. I knew that if I had MS, I might live a long and healthy life, but it was also very possible I'd end up in a wheelchair and incontinent before the end. Although MS patients often die young (younger if Dr. Kevorkian gets his mitts on 'em), you can linger for quite a while on the downward slope. With the others, at least you're toast a lot faster.

I don't want to depress or unduly frighten anyone with MS, or who knows someone with MS. I think everyone who has to consult a neurologist fears they've contracted something horrible, and my fear of multiple sclerosis was in inverse proportion to the accuracy of the diagnosis. Since the diagnosis had zero accuracy, the math majors among you know that my fears were infinite. I was afraid of the physical effects, like becoming incontinent and having to wear a colostomy bag and a urine bag. And of course the physical effects might severely limit me, so I was afraid I'd never be able to travel or work again. I was scared of loneliness, of not having someone in my life because who'd want to be with a wretch who couldn't even go to the bathroom normally. I wondered, Holy smoke, am I going to die? Living had gotten to be such a habit that I had difficulty conceiving that it might end.

Even more than the physical effects of MS, or whatever I had, I was most scared of becoming dependent on other people—on my family, on my friends, even on recreational therapists like myself. (I guess you could say my primary fear was dependence, and my secondary fear was dependence on Depends.) That was why I'd sent my parents away when they first showed up at my apartment. They understood my fears, but at the same time, I

wasn't really able to take care of myself. So they would come a couple of times a week, take me to the doctor, and cook for me or bring in food. It was just the three of us, and in a way it was nice to be the center of attention, to be the only child for a little while. But it also reinforced my sense of dependence.

The endless tests and specialist visits consumed my days. I grew weaker and lost pieces of my functional self every day. Emotionally, I took some comfort in the fact that the diagnosis was a mystery. If the professionals didn't know exactly what was wrong, maybe it wasn't so bad after all.

My doctor thought for a while that since there was no other good explanation for my lesion, AIDS was a strong possibility. I felt pretty sure that wasn't it, and besides, my blood tests were coming up negative. Since AIDS was out, he didn't know what to think. Maybe MS had caused the lesion, though my symptoms didn't quite match the profile.

I pushed him: "Isn't there any other disease that fits the bill?" He said there was one, sarcoidosis of the central nervous system, but that type of sarcoidosis occurred so rarely that he didn't feel it was a realistic possibility.

"What if you had to choose one diagnosis, MS or sarcoidosis? Which disease would be better to have?" He said neither was better, they were both potentially very serious, but he'd bet a nickel that I had MS. I figured I might as well stick with the most mysterious diagnosis, which was sarcoidosis.

At the same time I was making the rounds of what seemed like every doctor and hospital in New York, I was also going after a part in *The People vs. Larry Flynt*. The competition was pretty stiff. Courtney Love, Patricia Arquette, and a couple other women (all of whom were undoubtedly better actresses than me) were up for the role of Althea Flynt, Larry's drug-addicted ex-stripper wife. I

wanted to work with Milos Forman, the director, so I called up the Czech Embassy to find out how to say "Mr. Forman, please put me in your film, pretty please" in his native tongue. I knew that with my slender talents there was no chance of my getting the role, but I never let that stop me from trying.

Thinking about it now, I'm not sure I would have been so good at the role, even if the ghost of Lee Strasberg had somehow taken over my body and puppeted me through the movie. At the time, I didn't have nearly the experience I have now with heavy-duty pharmaceutical painkillers.

But as September wore on into October, my motor skills steadily deteriorated. The numbness had spread throughout my left side, and even into my right hand and other parts of my right side. I was half-paralyzed, and even if I could have made it to an audition, I couldn't do my hair because washing it was excruciating. And even if in a world of miracles I'd gotten the part—the ratty hair might have helped, come to think of it—there was no way I could act in *Larry Flynt* or even in one of the cheesy flicks I'd always been happy to parade through.

I didn't think I was perfect for the role, or on the level of the other actresses who were auditioning. I didn't even want to be in the movie with my whole heart and soul. *Larry Flynt* wasn't something that had eluded my grasp because I was sick—my lack of acting ability must have shown through in my meeting with Milos Forman, because I was never asked to do a screen test. But a role in a movie was something I couldn't even reach out for anymore. I felt pummeled. I had been trying hard not to admit that being sick was going to change my life, and part of that was fooling myself into thinking that I was still out there in the world, able to pursue jobs even if they were a real stretch. But I couldn't. I was just too debilitated. Everything I had worked toward and hoped for was starting to slip away.

I'm not the kind of person who's content to just come home and go to bed early. And a lot of my career, particularly on television shows like *TV Nation*, was about going out and exploring something and reporting on what I'd found. What was I going to do for a career if I couldn't live my normal peripatetic lifestyle? If I couldn't even get out of my apartment?

I was literally and figuratively losing pieces of myself. My symptoms progressed so quickly from a severe headache to losing the use of my hands that I had no time to adjust. In the movie *Flowers For Algernon*, Cliff Robertson plays a retarded man who through the miracle of science becomes a supergenius. Unfortunately the treatment doesn't last, and you can tell that he's sliding back into retardation by the way his handwriting becomes progressively worse. When I tried to write something down, a journal entry or a phone number, I could see that my handwriting was becoming more and more illegible. Then I got to the point where I could barely hold a pencil. I had to go to the hospital four or five times a week for tests, and I couldn't zipper my clothes or even fish a key out of my pocket—I had to wear it around my neck on a string like a latchkey kid.

One Sunday that fall there was a big bike rally from Boston to New York to raise money for AIDS research. The route went down the West Side Highway, not far from my Greenwich Village apartment. I had the windows open, and as I lay in bed, every nerve throbbing, I could hear music playing from a sound system that had been set up to serenade the bikers as they went by. The haunting, ethereal music echoed through the canyons of New York and flooded in through my windows. I had an unknown debilitating illness, I couldn't work, I should have been out paddling my kayak in the Hudson River but I couldn't even go out of the house, and on top of all that I had to listen to *Enya?* I knew then that I was truly in hell.

I know that some people get angry or depressed, or mad at God, or spend a lot of time praying for relief when they're suddenly faced with grave illness and the possibility of death. My reaction was more of a deep sinking feeling of despair, like "Oh, no, I'm really in trouble now." I didn't really pray for a cure. I prayed for the strength to deal with what was happening to me.

Sometimes I wasn't strong. One day, after another round of tests, I was struggling to walk through Central Park with my mother, and I broke down and said, "Mom, I'm screwed. I can't even walk through the park. I'm never gonna be able to have a kid. I'm not gonna be able to do anything."

I wondered, Do I deserve this? I've done some bad things in my life—announced Michael Bolton videos on MTV, starred in Disney's *Blank Check*—but hell, I'm too young to be put to bed with a shovel for a dirt nap. Didn't *TV Nation* make up for at least a few of the stinkers I'd done? I'd rewind my life history over and over, looking for early signs of the disease that was eating my spinal cord. How could I have missed it? How could I have been so blind? (I only came up with one answer. Before the headache had started, I'd had a persistent pain behind my right ear. I thought at the time it was just irritation from wearing sunglasses. Maybe I'd been stricken down for pulling the star move of wearing sunglasses indoors.)

Then I'd swing to the other extreme. Instead of blaming myself, I'd turn my sickness into a good thing. I remember thinking, Well, if I'm this sick, maybe none of my sisters will have sick kids, because what are the chances of having so many chronically sick people in the same family? Maybe I'm taking the hit for everybody. Kind of like that fellow Je—never mind. Anyway, it was a way to come to terms with what was going on.

But a lot of the time even these purely mental gymnastics were too exhausting. The only thing I could manage to do at times was

lie awake in bed, listening to Frank Sinatra and trying to remember what normalcy was like. His eighty-second birthday was approaching, and there was a big auction of memorabilia coming up, so I got the catalog and fantasized about buying something. A local radio station was working through every Sinatra song ever recorded, so if I was feeling really good, I would run a bath to soothe myself, being careful not to let my head or neck get wet, because that brought on more blinding pain. Then I'd lie in the bath and listen to "Sinatra in the Afternoon" from three to four on WQEW. My family knows how much I love him, so my mother and sisters would tune in, too, wherever they were. "Even when I'm not there, I know you're listening to the same songs, so I still feel connected to you," my mother said.

I'd always loved Frank Sinatra, and I'd seen him in concert about twenty times. My friends and I had a ritual. We'd gather for dinner first and make pasta with Father Guido Sarducci's Secret Celebrity Sauce: one jar of Paul Newman's sauce, one jar of Frank Sinatra's sauce, and one cup of Jake LaMotta's sauce. At the concert, we'd pass a flask of bourbon around and take a sip every time Frank did. I'd had opportunities to meet him, but I never did— he was just too huge a person. I didn't want to ruin the mystique I'd built up around Francis Albert Sinatra.

When my mystery illness first had me in its iron grip, focusing on myself was too depressing. It was like I'd lost the playbook to my life. I had no idea what to do. So I turned all my attention instead to Frank Sinatra, the man who always seemed so self-assured and knew what to do in every situation. His outsize personality helped me to not dwell on the fact that I felt I was turning into a nonperson.

Then somebody told Frank that I was a huge fan and that I was really sick. I don't know who it was, but I'm eternally grateful to my mystery benefactor. First, I got a signed 8-by-10 in the mail.

Then, a crate arrived. Inside was one of his original watercolor paintings—something I would have given my left arm for, even before it went completely dead. It was incredibly moving to know that this man I'd never met, my idol, had wanted to share something so personal and special.

But that was one of the few bright spots in a very grim time. I figured I'd probably end up like Walter Hudson. He was the guy who weighed like a thousand pounds and couldn't even get out of bed. Every now and then he'd go on a diet, or Dick Gregory would come along and pump him full of vegetable shakes and he'd lose a few hundred pounds, but he would still be grossly overweight and hardly able to move. I feared my life might turn into a roller coaster between being merely gravely ill in my apartment and being at death's door in a hospital. The good days would be when I could at least lie in bed frying up some chicken with my personal fryer. Just like Walter Hudson. (Not that chicken fryers in themselves are bad. I hear that Bo Diddley travels with his own deep fryer, and that sounds pretty good—so if any of my friends are reading this, think deep fryer for Christmas!)

I was reading recently about a man who was killed in Central Park. He'd just come out of a three-week stay in the hospital—he had a lesion in his brain, some kind of serious neurological problem. And then he was murdered in Central Park, with no clue as to who killed him or why. It reminded me that when I was at my low point, soon after the mystery illness struck, I considered hiring a hit man to whack me. I knew a few guys with some shady connections, and I told this one guy, "I don't want to know when, I don't want to know where. Just do it." I was only half-serious, but still, I *was* half serious. As you've probably realized from the fact that you're now reading my story, he was just humoring me. But that was the stage I was at—putting a hit on myself because I didn't want to decay slowly, fully aware of my deteriorating con-

dition. In the Middle Ages, it was customary to tip the executioner to ensure that he would sharpen the blade of his ax before delivering the blow directed at your neck. As far as I could see, having myself whacked was just a way of sharpening the ax. So when I read about this guy who was murdered in the park, I said, "Aha! *He* went through with it."

I felt like Marlon Brando was sitting on my heart, and not the young, svelte Marlon Brando either. I'd been reduced to an inert pile of human rubble, and my self-confidence had been beaten down to an all-time low.

When I was a kid, one of my nicknames was "Cannonball," because I was always shooting around knocking into things. As an adult, I'd always been ready for a night on the town or a crazy adventure. My career in television was about going somewhere and doing something, whether it was bringing toilets to anxious women on bathroom lines for *TV Nation*, or the kayaking documentary I was scheduled to do before I got sick. Suddenly, all of that came to a grinding halt, and I was stuck in bed almost all the time.

I had an office in my apartment filled with books, papers, and notes on all the projects I was involved in or wanted to do. When I first got sick, I just closed the door and didn't go in for months. I didn't want to confront all the things I couldn't do any more. The horizons of my life closed in on me.

I'd always been a voracious reader, so I wouldn't have minded thumbing through poetry, but my hands hurt so much I couldn't support the weight of a book. I'd pile up pillows and put a book on them, but sometimes I couldn't even stand turning the pages. I often had scripts to read for TV or movie projects, but I couldn't be in a movie if I couldn't even read, so I just tossed them into my

office. I felt like the Collyer brothers, these two rich eccentrics who lived in a townhouse in New York and never went out of the house. When they finally died, their house was filled with stacks of ancient newspapers and piles of garbage. I didn't let my whole apartment get that bad, but anything I couldn't deal with I threw into my office and then slammed the door without looking in. All my potential—job offers, scripts to read, flyers for resort vacations—I threw it all in the office and closed the door. I couldn't stand to be reminded of all the things I couldn't do. (When I finally felt well enough to confront the mess in my office, it was like a time capsule that had preserved material about everything that was going on in my life when I got sick.)

Luckily, New York City is probably the best place in the world to be sick. You can have anything delivered or picked up—medicine, food, movies, laundry, whatever you want. I don't know how people in other places manage. Without delivery service, I would have starved to death in filthy clothes.

Studies show that invalids make up a huge percentage of the daytime television audience, and I was part of that demographic. True, there's a lot of rubbish on the tube, but I have to believe it's better to have dozens of channels than the three channels that people in iron lungs had back in the '50s.

Of course, watching television can be sort of depressing. When I was still thinking I might have multiple sclerosis, I couldn't turn on the tube without seeing ads for that TV movie about Annette Funicello, the one where she collapses on her glass coffee table, shattering it, and screams, "There is *no* cure!" I also spent a lot of time glued to VH1's *Behind The Music*. I would root against all the washed-up musicians and marvel when they told the cameras how much happier they are now that they're sign painters or computer programmers or touring in a reconstituted version of the original band. They don't miss the limos, the girls, or the wild parties, and

they don't miss the fans, because now they can eat dinner in a restaurant (probably Arby's) in peace. Whenever I saw one of these guys, I thought, I'd like to strap you to a lie detector, because you are the king of lies. I was once a cheesy MTV VJ with a little bit of fame and fortune, and as I lay in bed watching washed-up rock stars, approaching my middle age as an invalid, I was bitter. I missed it all, and I never even had any talent. I guess maybe Leif Garrett never had any talent either, but you know what I mean.

The Latin root of the word "patient" means "suffering," and that was a lot of what I did in the early days of being a patient—suffer. You learn how to suffer, patiently, as your body is ravaged by disease. You learn to wait quietly for doctors to see you, and for the MRI or chemo nausea to end. You learn how to be a good listener, because when crashing bores start flapping their gums you don't have the ability to roll your eyes or the strength to get up and walk away.

I felt like I was disappearing as a person, and I didn't know what to do about it. What a dreary way to go, I thought, slowly losing pieces of myself with every hospital visit and procedure—deflating slowly, until one day I'd go kaput, not in an explosion but in a sputtering wheeze. Accidents happen quickly. Illness creeps up on you and overpowers you in slow motion, sucking out your optimism as it drains your life away.

But I came across a quote from John Donne that changed my approach to being bedridden. Donne wrote that "A sickbed is a grave," and I realized that I was allowing my bed to turn into a pine box. I was practically fused to the mattress.

My job as a recreational therapist in the nursing home was all about trying to entice the residents into activity. In medicine, there's primary disability and secondary disability. The primary disability is what gets you to be bedridden in the first place—

spinal trauma, degenerative disease, what have you. The secondary disabilities are all the uncomfortable, irritating, debilitating side effects that come from lying in bed all day, like bedsores or depression. So the more you lie in bed, the more possibility you have to decay. The goal of recreational therapy is to prevent secondary physical disability, as well as to put the patient into a more positive mental state to prevent secondary mental disability. I'd been ignoring everything I knew about how to deal with debilitating illness, which irked me, I can tell you.

I've always believed that the Newtonian law of inertia applies as much to our lives as it does to physical objects: Once you get started, it's easier to keep going than it is to stop. A woman once approached me and asked how I got my job on MTV, and I told her how I'd sent in the tape. She immediately said, "Oh, I don't have time to do that." Well, what did she want me to do then? Make the tape for her? You can't expect things to come to you unless you start moving toward them yourself. If anyone, even a stranger, asks me for help with a career in TV or modeling, I'll always try to help, as long as they're making the effort themselves.

Take my job on *TV Nation*. I got the job by writing Michael Moore letter after letter and barraging him with ideas. Eventually he called me in for a meeting, and I began reporting stories. Or look at James Gandolfini, the star of *The Sopranos*. I went to high school with the guy, and he spent the time between age eighteen and the premiere of *The Sopranos* beetling away at his acting career, trying to get a big break—and he never stopped. The most important step to take is that first one, to overcome the inertia in your life. It may be hard to start, but once you do, it's a lot easier to keep going, and when you're moving, you're heading toward your goal.

Even when I was sickest, I'd try to go to the library to get myself out of the house, see other people, and see if I could dis-

cover something new in the stacks. Or I'd go over to the nursing home for a little while to talk to my friend Helen and the other residents. When I had energy, I tried to use it. To get the most out of whatever mobility and ability I had, I learned to practice time management. I'd rest up the day before I planned a trip to the library, and promise myself a day of rest afterward.

I'm stronger now, but I still approach bigger tasks this way, like a print or TV shoot. I was in Chicago not long ago to do press for a woman's health-care initiative. I ran around and did eleven appearances in thirty-six hours. I knew that when I got back I'd need to give myself a day puttering around the house in my knockaround clothes so I could get used to feeling like me again. One of the most important lessons I learned from being largely confined to a sickbed was that time management was the only way to live as fully as possible.

I knew I was missing out on social life, career opportunities, and a lot of other stuff because I was in no shape to leave my bed. But I had to roll with it and try to get something useful out of the stillness that had been forced on me. I stayed active inside my head. A lot of the time I really was alone with my thoughts, for maybe the first time in my life. I made a conscious decision that since I had no choice about being bedridden, I'd just have to like it. I wanted to be at home in my body, at home with my disease. After all, I thought, how many more times in my life will I have the opportunity to be this uncomfortable?

I'd always been independent, but I wasn't used to being alone. I had to learn to enjoy my own company. I plotted revenge, which I found entirely relaxing, comforting, and distracting. I have scores to settle, not with life or fate or circumstances, but with individuals who really deserve it. There's one woman in particular who I envisioned locked up in a women's prison, and I'd volunteer with the correctional department so I could bribe the inmates

with Kool cigarettes to ensure that this woman was sold as a prison bitch to a murderous, alcoholic, child-abusing inmate named Peaches. (I'm told forgiveness is more positive for your physical and mental health than nursing a grudge, but this worked for me. I think it's human to hate. Plus, it's a lot easier to forgive after you've already gotten even.)

To give myself something to look forward to, I pestered my doctors for things to make my time in bed more pleasant. They shot down the medical marijuana pretty quickly, but since I was taking morphine already, I wasn't too disappointed. I still don't know why they wouldn't give me a helping-hands monkey, though, because I actually could have used one. These are little monkeys that are trained to do things for disabled people. They'll brush your teeth, comb your hair, wash your face, get you something to drink, and if you drop anything, they'll pick it up. Plus, it's a monkey, and monkeys are funny. Even now that I can do all of these things for myself, I'd still like a little helping-hands monkey to get me Scotch.

Then there were my get-rich-quick inventions, like the organic breast enlarger—a jar full of hungry mosquitoes. I came up with something I called "The Sodomite Collection"—beautiful, collectible porcelain depictions of homosexuality in all its glory. I'd always been jealous of that Heimlich guy who has his name on posters in every restaurant, so I came up with a medical procedure of my own. When you water-ski and fall over, your eyelids sometimes get flipped inside out, so the Duffy Maneuver is the process of applying thumb and forefinger to the lid and restoring it to its proper orientation.

But the best thing that came from lying in bed all the time was that I started to write. I figured, Hell, John F. Kennedy wrote *Profiles in Courage* when he was laid up. I could at least take a crack at something like *Profiles in Cowardice*, which I did write, but maybe

it's better that it was never published. I began to write magazine articles, and eventually I became a contributing editor at *Cosmopolitan* and *Glamour*.

I hate to sound preachy, but it was good to have this stillness enforced on me. To write, you need to be alone and to focus on what you're doing. When I was flat on my back most of the day, I had no choice about the matter. (Now that I'm more mobile, I have to be a lot stricter with myself to get the writing done.) If you're ever bedridden, you, too, can turn the bitter lemon of being a shut-in into the sweet nectar lemonade of opportunity, even if it turns out you're not much of a writer. Call your senator and representative to let them know what you think. Even better, volunteer to do phone calls for a cause you believe in. But whatever you do, don't answer those ads about making a pile of money stuffing envelopes at home. Sure, they sound great, but they're just a big scam.

I still have to spend a lot of time in bed when I have drug side effects or the pain flares up. But even on my worst days, I can still cheer myself up in little ways, like whipping my panties out from under the blankets when a friend comes to visit and demanding, "Just whose are these?" And as a last resort, I like to remember that there are billions of harmless microscopic mites that live on my skin and hair. I can just lie there and feed the bed mites.

———•◦•———

In late October, I was supposed to go to dinner at my friend Aida Turturro's. She'd cooked for two days straight to make a big Italian feast for all her friends, and I was damned if I was gonna miss it. I hoarded every bit of my energy and will, and on the appointed day I heaved myself out of bed and made my way to her apartment. Aida lived in a tenement-style building, which

meant I had to walk up five flights of stairs to get to her apartment. When I got there and looked at those stairs, I realized I couldn't do it. Some friends arrived and tried to help me up, but I just couldn't make it.

Most of these people hadn't seen me in a few weeks, including Aida and Peg, my manager, who are two of my best friends. They knew I'd been sick, but not how sick. I was gaunt, wild-haired, crazy-looking. I heard a collective gasp as they all took in just how bad off I was. Aida in particular is a great actress but has no poker face. As I looked into their faces, I thought what I was seeing was "She's worse than we thought. She looks hideous." I thought they were afraid of me.

The next day was my sister Laura's wedding, and I couldn't even make it out of the house. I was supposed to be in the bridal party, and I was devastated. My father later told me that he'd thought of having everyone pray for me, but then he got worried that my sisters and my mother might start crying and pass out right there in church, so he scotched the idea.

The day of the wedding, I dragged myself out of bed and tried to get some mango juice. I was so weak that when I tilted my head to drink, I fell over backwards. The bottle smashed. I looked like Linda Blair in *The Exorcist*, only instead of pea soup, I was covered with mango juice and shards of glass. I lay there in my flannel nightgown until my roommate, David Heyman, who'd heard the noise, came and cleaned me up and put me back in bed.

I knew things were getting really bad. But just when my life seemed to be sliding right down the outhouse hole, my friend Harvey Weinstein showed up. I'd told my doormen not to let anybody in, but Harvey is the head of Miramax Films, and you don't get to be the head of Miramax Films by taking no for an answer. He'd been trying to set me up with readings for films he was producing, and he'd gotten worried when I kept blowing them off. As

he said, "Who wouldn't want to be in a Miramax movie?" He swept into my apartment, wanting to know where I'd been for the last six weeks. He took David aside, and David filled him in on what had been going on. I was mortified that Harvey was seeing me in my reduced state—wasting away, unable to even drink mango juice without disaster striking.

But Harvey was having none of it. "I'm taking control of this disease. I'm gonna produce this like it's one of my movies," he announced. Harvey packed me off the very next day to Doctor Frank Petito, who's still my neurologist. Dr. Petito started me on massive doses of oral steroids, and morphine for the pain.

The lesion had grown faster than anyone had realized, and I was very much at death's door. Harvey had probably saved my life. (In case you're wondering—no, my life did not flash before my eyes at any point.)

5

Modern Immaturity

The steroids Dr. Petito prescribed had an immediate effect. Their anti-inflammatory effects slightly diminished the pain and increased my mobility. Within a week I went from hovering on the hairy edge of death to actually being able to move around, albeit slowly. I was grateful, but it finally sunk into my hard skull that maybe whatever I had wasn't going to go away. At first, I thought the lesion was going to be a big headache in every sense of the word, but big deal, the doctors would yank it out or fry it out or whatever they do and everything would be fine. I never expected

in a million years that I would have something that would linger until I croaked.

I hadn't been sitting around wailing and crying, or getting very dramatic with myself and vowing with clenched fists, "As God is my witness, I'll fight this thing and win!" I'd just been trying to adjust as best I could to the limited amount of mobility, energy, and time available to me. As my condition grew graver, I uncharacteristically grew much more quiet.

I was still cracking wise with the doctors and nurses. But I'm a fairly gregarious person, and I'd checked out of my social scene. Normally I'd be on the phone making plans with friends, having lunch or coffee or drinks, or meeting up with them at parties, but I was physically and emotionally incapable of doing any of that most of the time.

Even when I felt able to, I didn't want to go out. I didn't want to face people and be judged, be compared to my old self. I didn't want to have people casually ask me how I was doing. I'd either have to lie or come out and say, "I'm really ill." I didn't want to lie, but I didn't want to tell the truth, either. I didn't want to talk about my illness because I couldn't quite believe it myself. I withdrew from even my closest friends because I was ashamed, and I didn't want to reveal my weakness. I was too independent and too embarrassed to ask for help. I didn't want to burden my friends.

After I started on prednisone, my attitude started to change. I didn't necessarily feel like I'd been healed, or even that I'd turned the corner on the mystery illness. But steroids did relieve some of the most acute pain and paralysis, and they gave me more energy than I'd had. My mental condition changed for the better as my physical condition improved, to the point where I wasn't completely averse to showing my face to other people.

Dr. Petito had referred me to a colleague, Dr. Sarah Auchincloss, who helped change my attitude as well. Dr.

Auchincloss studies the psychology of illness in women. She'd had extensive experience with the physical suffering and mental indignities I was going through. When I talked about not wanting to rely on my friends, not wanting to burden them with my condition, Dr. Auchincloss reminded me that if any one of my friends had become sick, I'd want to be there for them. In fact, she pointed out, being the person I am, I would have insisted on it.

⎯⎯•⋯•⎯⎯

My oldest friend in the world is Lori Campbell. I've known her since before high school, but we really became tight when we were on the track team together. I was really lousy as a hurdler, and so was she, but we always waited for each other so we could cross the finish line together, and never have to be alone in last place. If I could've run faster, I would've. All I wanted to do was beat her, and I never did—but she never let me lose, either.

We have an unspoken agreement to always give each other terrible advice, like "Oh, your boyfriend broke up with you? The best way to deal with it is, let's drink a million margaritas and crank-call him." We egg each other on to break the rules. When Lori started her own advertising agency, she had a client who had something wrong with his testicles. When she went to visit him in the hospital, she put up a poster in the elevator that read "SEE THE MAN WITH THE WORLD'S LARGEST BALLS/$5 to look $10 to poke $20 to squeeze hard. Room 607." When the client found out, he didn't laugh as hard as I had, and her agency lost the account.

Lori and I were roommates at the University of Colorado in Boulder, and after graduation, we rented an apartment in Greenwich Village. The apartment was one of the kind called rail-road flats because to get from one end to the other you have to

pass through all the rooms in between. I got the dining room, and Lori's single bed completely filled the only true bedroom. There was an 8-by-6-foot space in the middle, and we decided we could squeeze one more person in. As compensation for the small living space, any woman lucky enough to live with us would enjoy a colorful social life and have a crack at any of our male friends.

We decided to put some sport into the roommate selection process, so we held a bake-off: anybody who wanted to see the "room" had to bring a baked good. (We were having a birthday party the next day, and this way we wouldn't have to make a cake ourselves.) Then, we invited back the girls we liked for the "Roommate Olympics": they had to put a spoon in their mouth, a raw egg in the spoon, and run around the whole apartment. If they dropped the egg they were out. One girl showed up with her own spoon—a huge ladle. She navigated the course successfully, and we said, "You're in." Tragically, she was run over by a truck, so we needed to find somebody else.

My sister Kate's friend Lynn was about to start at NYU and needed a place to live. I said, "Lynn, you can move in with us. You're gonna learn a lot. You'll have to live in a closet, but you'll have a lively social life from all the spillover from our dance cards, and you'll never have to pay for dinner." Kate and our friend Greg jointly called up Lynn and said, "We feel a moral obligation to warn you—for the love of God, don't go live with those two. It'll be like throwing a Christian to the lions." But Lynn moved in anyway.

We were constantly broke, so we'd cut each other's hair to save money. The problem was, we were all too lazy to clean up. We started carrying a chair out onto the street, and we'd cut each other's hair with kitchen scissors beneath the street light at the corner of West Twelfth and West Fourth Streets. Sometimes I'd convince passing strangers that they needed a haircut, and we'd

charge five bucks a head. I'd start on one side, Lynn would be on the other, and we'd meet in the back. Some nights we made as much as sixty dollars giving haircuts.

One time Lynn found a couch on the street and dragged it home. We were having a party and we didn't have enough furniture for our guests to sit on, but the couch was so musty and soiled, we wouldn't let her bring it in. Eventually, though, so many people came to the party that we carried our lamps and tables down the stairs, set up a living room on the corner around the crummy couch, and had a party on the street. After that we had regular street parties when the weather was warm, which we called the "Café de la Schnockered."

Our guests probably appreciated the street parties for more than the novelty, because our apartment was like Calcutta, and this was well before the Indian esthetic became chic. The previous tenants were a blind couple, and we never troubled ourselves to improve on their casual standard of cleanliness.

I dyed my own shoes and never put down any newspaper, so there were spots all over the carpet. To cover up, I glued a book over the biggest stain on the carpet, so it looked more literary than messy. Another time, I was trying to teach myself how to paint and I spilled black acrylic paint all over the carpet. I decided to just paint the whole carpet gray, the color of the rest of the apartment. Of course, it got incredibly stiff from the paint. When the couch suffered a big rip or a cigarette burn, I glued on an old high-heeled shoe. Our bath mat was a Twister board. I had a surplus of Shetland wool sweaters and kilts from my high-school days so we stuffed the arms of the sweaters with newspaper and pulled them over the backs of cast-off chairs to make "armchairs," and I stapled a kilt around a cruddy table to make a table skirt. We once made an Elvis piñata full of bacon bits and Nembutal for a party. I'm sure the Nembutals are all gone, but the

bacon bits are probably still stuck between the floorboards. And we'd make fried peanut butter and banana sandwiches and roll them through the apartment on a skateboard, which often ended in a sticky disaster. The place was so filthy that instead of bringing our garbage out, my friend John Zaccaro brought bags of garbage in from the street as a goof.

As promised, we taught Lynn how to never pay for her own dinner, or at least how to skip cover charges at clubs. We'd try anything. Once, Lori and I wanted to sneak into Boy George's birthday party at a swanky nightclub. So we found two bus tubs full of bar glasses in the back hallway of the club, put them on our heads, and ran into the V.I.P. room. We got thrown out, but the bouncers did say it was a good idea. More often, we'd try something to make the door people laugh, like making Brooke Shields masks to help us cut the line at Nell's. Another time I sat on my friend Greg's shoulders and put on a long coat, and we walked up to the velvet rope at a hip-hop club called the Hundred Thousand Dollar Bar. Greg is six three, so I was like an eight-foot-tall woman. I politely said, "One, please!" The bouncers laughed and waved us in for nothing. And I wasn't above wearing my little Catholic schoolgirl uniform to charm the guys on the door.

I remember riding Lynn home on the back of my bike at four in the morning and feeling incredibly free and alive. I was constantly broke, but I was young and having fun. We'd lived life as fully as we could with our limited means, not focusing on the future but on how to have fun in the moment.

—•••—

Being bedridden had caused me to develop a kind of reverse Alzheimer's—the ability to recall moments in time very clearly. Lying in bed when there was no alternative gave me the opportu-

nity to think back and cherish all the good moments in my life, like the great times I'd shared with Lori and Lynn.

After talking to Dr. Auchincloss about my friends, I realized that I needed to recapture that biking-home-at-four-in-the-morning spirit if I was going to thrive emotionally. When I was young, I didn't have any money, I didn't have any juice, so I would try whatever means I could to charm or scam my way into squeezing as much fun out of life as I could. I'd always been a person who tried to enjoy life as much as I could despite the obstacles, and I'd left that behind when I got sick.

I decided to fill my here and now with as much fun as possible, just like when I was a kid. And for that, I needed my friends. I didn't want someone to come over and clean my house or hold my hand while I wept helplessly. I just wanted some diversion, and my friends were happy to provide it.

So I started throwing parties every Friday to mark the weekly "anniversaries" of being sick. I thought, I have to eat dinner anyway, I might as well have friends over to keep me company.

I was always in severe pain in the morning, but as the day progressed I was able to deal with it a lot better. (Even now, if I have, say, an 8 A.M. shoot, I get up at 5 A.M. to give my body a chance to get going. It takes me a long time to dress, to take my medicine, and to be able to comb my hair without wincing.) On Friday's, I'd call up Balducci's, a swanky grocery store, and have them send over a cake and some steaks so I could enjoy what energy I had and not be bothered with cooking. Close friends who were aware of my condition would come over bearing champagne. I'd greet them in a ball gown that had been lying fallow in my closet. I recognized there was a possibility that I wouldn't get too many more opportunities to wear one. The good times would roll, even if I could barely roll off the couch.

Every week there was a special new poison. Once I rented a cot-

ton candy machine and used cigarettes instead of the paper cones. Another time my guests and I made Nyquil Sno-cones. And of course there were the Binaca juleps. When you're flat on your back in bed, you've got to do something to spice up your life.

When I was feeling well enough, I would cook for my Friday night parties instead of ordering out. Aida and Lori offered to host dinners at their houses and take the strain off me, but I felt that I wanted to offer something in return for their company. (They might have been politely trying to let me know that my cooking—never an especially strong suit—wasn't improved by partial paralysis. But they never complained. How could they? "Hey, cripple, you burned the steaks!" I don't think so. I would have laughed, though.)

As I became comfortable around other people again, I did start letting my friends pitch in for me in practical ways, like bringing me dinner or running errands. But I'd needed to know that they were doing it because they loved me, not because they pitied me. My parents had been helping out from the beginning, and at first I wasn't comfortable with my mother coming in three times a week, either. It just made me feel more helpless. But my new attitude, developing with gentle prodding from Dr. Auchincloss, helped me appreciate that my parents were helping me out of love, not as a duty.

Dwight and I had been in one of our on-again phases when I got sick. I finally got around to calling him and said, "Look, I've come down with something pretty bad, and I'm not sure what's going to happen to me. I don't want you to think you have to stick by me just because I'm ill, and I know it's hard to dump an invalid, so I think we should end it for good this time." He immediately said, "I'll always be there for you, Duff. I want to set up a trust fund for you. I don't want you to ever have to worry about anything." I refused the offer, but that was typical of him—thought-

ful, considerate, a gentleman without any prompting or calcula-
tion. He was and is incredibly generous. It sucked that I was sick,
but I was so stinking lucky to have somebody in my life who could
be so giving. I was glad that when I spoke to Dwight I was in a
state of mind that let me appreciate his generosity instead of
being defensive about it. When I think about it now, his kindness
touches me so deeply that my eyes swim with tears.

Obviously, not all my friends punched their weight. At one
point, early on, I was lying in a hospital bed visiting with a friend.
A resident intern entered my room to deliver the news that my
recent tests had come back with positive results. I wanted to know
more. What did a positive result indicate? She said, "Well, prob-
ably cancer. Your doctor will come in to talk to you about possi-
bly starting chemotherapy." My friend looked at me, burst into
tears, said goodbye, and ran out. I never saw her again. I call her
occasionally to reassure her and let her know I don't have cancer,
but she must have been really scared. If you have any sick friends,
avoid doing this.

And I hated when someone said, "I don't know what to say." Hey,
I hadn't croaked yet. Couldn't they think of *something?* Preferably
something funny. When multiple sclerosis seemed like a strong pos-
sibility, Lori put together an MS joke book for me, which I thought
was perfect.

Now, I'm not someone who likes to lie around with a hand on
my forehead like some frail Victorian hothouse flower. I can run
my own life fine. But when I really needed help—when I was half-
paralyzed and needed a doctor, or a snack, or just a laugh—it was
great to have my true friends by my side. The book of
Ecclesiasticus in the apocryphal Bible (that's the unofficial chap-
ters) says that "A faithful friend is the medicine of life." I owe a
lot to all of my friends. I couldn't have made it through the worst
without them, and the friends who were most supportive when

things were at the worst tended to be the sickest ones them-selves—mentally, anyway. My friends and their willingness to share my reckless joy helped me to be well in my mind again. I've since thought that friendships are also the wine of life, and how lucky I was to have such a well-stocked vintage cellar.

A magnum of thanks goes to my friend Amy Cohen, who was my connection to all the friends in Los Angeles I couldn't see and didn't feel like speaking to when I was at my sickest. She kept my secrets when I wanted them kept, and when I opened up more she was the L.A. branch of the Duff Information Bureau. When she visited New York, Amy slept on the floor next to my bed so she could keep me company all night.

To David Heyman, a gentleman of uncommon courage and decency, a full jeroboam of my eternal gratitude. David is a pro-ducer, and I'd convinced him to chuck Los Angeles and move to New York and share my rent just six weeks before I got sick. He thought he was getting a roommate who could take care of her-self; instead, he got a basket case. David shopped for me, brought me English muffins and tea in bed, put the flowers I received in water, and helped take care of the many practical impossibilities I had to deal with in the early going. Like Amy, he fielded the phone calls of concerned friends with incredible aplomb. Cheers, David.

And finally, a nebuchadnezzar to Mr. Harvey Weinstein for arriving at the crucial moment and sending me to my lifesaving superstar doctor. I know not everybody has a movie mogul willing to step in when they get sick. But I've known Harvey for a long time, from when he was an independent film producer and I was a recreational therapist. I doubt Harvey knew when we met that I would become a model. I certainly had no clue that he'd turn out to be the terror of the movie industry—and I had no idea he'd one day save my life. I owe Harvey big time. I leaned on him heavily in

my worst moments, and he taught me a lot about generosity and helping others, as well as about being willing to accept help when it's offered and needed. I hope I'll be able to give back some of the care and support he gave me, if anyone I know ever needs it.

Of course, I didn't leave Harvey hanging without any demonstration of gratitude. I commissioned a painting of myself as a weeping martyr holding the shroud of Saint Harvey Weinstein, and I gave it to him for Christmas.

6

My Misery Had a Lot of Company

In February of 1996, I went into Memorial Sloan-Kettering hospital for yet another in an unending series of spinal taps. A big, glittery cancer doctor was supervising as a younger doctor performed the procedure. If you've never had a spinal tap, it's basically a doctor taking a two-foot-long needle and sticking it in between someone's vertebrae. *Your* vertebrae.

In a bullfight, before the matador takes on El Toro, his mounted assistants ride into the ring. These men are called picadors, and it's their job to weaken the bull by stabbing it in the back with oversized cocktail toothpicks made of steel. I felt like the bull

whenever I got a spinal tap, except the bullring is probably a warmer and more welcoming place. The tap room at Memorial Sloan-Kettering was as humanitarian as a Skinner box.

Now, I don't want to unduly frighten anyone about spinal taps. Hey, I'm a chicken sissy about pain and medical procedures and if I can stand a spinal tap, anybody can. They're not pleasant, but they're bearable, especially with the help of intravenous Valium. (If you ever need a spinal tap, insist on IV Valium or ask for something else to calm you. The anxiety about having the procedure might be worse than the pain, but then again maybe not, and it helps to take something. Remember, most doctors haven't had a spinal tap performed on them, and they may not think it's such a big deal. The patient's perspective, needless to say, is often different than the doctor's.)

But this time, the younger doctor kept missing, so he had to pull the needle out and jab it in again and again. Then he hit a nerve, and I was lying on my side, so it caused my knee to drive up into my nose. Over and over. Like a frog leg in biology class when you give it a shock. It was a Three Stooges medical procedure. Finally I said, "Stop it. Get that thing out of my spine."

The glittery doctor, who was standing by with his arms folded, said, "No, no, it's fine."

"Get this fucking thing out of my spine RIGHT NOW!" I screamed.

My mother was in the waiting room and heard me, and I was kind of embarrassed that I'd cursed. The assistant doctor put his foot on my back and pried the needle out, and blood came spurting out of me like Old Faithful. I started running around, topless, yelling "Where's my shirt? Where's my shirt?"

I found my shirt, buttoned it on, and said, "Mom, we're getting out of here." My shirt was all bloody, and I was thinking, I've had it. I've had it with those butchers. So I went across the street

to New York Hospital, where Doctor Petito suggested that I should be admitted as an inpatient.

He'd been pushing for me to spend some time in the hospital since I'd begun seeing him in October. He wanted to start me on really high doses of IV steroids—1,000 milligrams a day, as opposed to the 160 milligrams I'd been taking orally.

I'd always refused. I guess I didn't want to believe my condition could be so serious that I'd have to leave my own home. After all, I was in pretty bad shape already, going to the doctor four or five times a week, but I was still living in my pad on my terms. To voluntarily submit to a stay in the hospital was like admitting that there was something serious going on. I knew I was gravely ill, but going into the hospital would be like acknowledging that I really might have something like non-Hodgkin's lymphoma, a disease that might put me down for the count.

But this time I had been weakened by the picador at Sloan-Kettering. And I was so angry about the way I'd been treated that I would have turned my teeth backward and eaten my brain rather than repeat the botched spinal tap. I guess New York Hospital seemed almost like a sanctuary.

Customer of the Month at the Emergency Room

In the year prior to discovering the lump in my head, I'd had more than usual cause to go to the hospital—so much so that one doctor said he was going to nominate me for customer of the month. I responded by giving him a signed 8-by-10 of me. I figured, every Italian restaurant in New York has a signed photo of Frank Sinatra; I'd make St. Vincent's the first emergency room in New York or possibly the world with a head shot.

Here's what happened to me:

- Broke my kneecap when I crashed my scooter.

- Broke my left elbow when I fell in the street. When the city gets rid of, say, a No Parking sign, they cut off the pole about three inches from the sidewalk, and I tripped over the deadly little stump. I had to appear on the *Late Show with David Letterman*, so I had my friend Cynthia Rowley make me a designer sling. It looked so good, Letterman just thought it was part of my outfit.

- While my left elbow was in a cast, I had to do everything with my right hand. My hand got so tender and swollen from carrying all the groceries and dry-cleaning that the rings on my fingers started cutting off the circulation. I called my friend Jim Czarnecki for help, since he's a TV producer and I figured he'd be able to help me out. (I had to dial the phone with my tongue too because neither one of my hands was working.) Jim called the fire department, and they told him not to worry, they deal with this all the time. It's called a "ring job," which sounded vaguely dirty to me. When I found out the fire department was coming, I called my neighbor (with my tongue again) and had her put makeup on me in case one of the firemen was really hunky.

- Broke my other elbow when I slipped on a slice of pizza while walking down Lexington Avenue.

- Stabbed myself in the wrist with an X-acto knife while carving a Halloween pumpkin. I hit the artery, and not only was it a real mess, the doctors thought I'd been trying to kill myself.

So I submitted to my first voluntary incarceration in the hospital. Dr. Petito's office is on the same floor as the neurology ward, so he just put me in a wheelchair and rolled me down the hall to a room. On the way, an orderly spotted me and called, "Hey, you're that girl from MTV!" "Yeah, what's left of her," I muttered.

My first hospital stay was a real shocker. I felt like I didn't belong on the ward, and I tried to explain my way out of the bed. I'd lost my bearings—I was no longer the big shot. I felt oddly removed from the experience.

If you're really rich, like Warren Buffett or the Sultan of Brunei, you can pay to stay in hospital rooms that are like five-star hotels, with marble bathrooms and dinner catered from "21." Unfortunately, I'm not really rich, and New York Hospital didn't have rooms like that for neurology patients.

The ninth floor neurology ward reminded me of the kind of cheap hotel where suicidal people rent rooms to hang themselves from the shower curtain bar. The cracked walls were covered with peeling curls of paint the ugly flesh tone of stockings old ladies buy in the drugstore—sort of an imitation beige. The sinister vapor of disinfectant permeated everything. The TV was suspended in a corner of the ceiling like a wasp's nest, a silent threat. Dust-colored Venetian blinds hung in front of the grimy windows, as if the room was so gorgeous there was no need to look out. For this I paid $2,000 a day. Visitors would ask, "How are you doing?" "How do you think I'm doing? Look around you, I'm in a dump," I said.

There are plenty of reasons to be unhappy about a stay in the hospital, and it's not always easy to be poetic about them. Doctors and nurses can treat you with less than the respect you deserve, hospitals are breeding grounds for dangerous bacteria, and of course it's a bummer not sleeping in your own home. However, I was there, and just as I'd tried to overcome the tedium of being

bedridden, I realized I had to overcome the sterility of my environment as best I could.

Plus, I had to have a positive attitude to survive, because otherwise I think my family would have killed me. Steroids cause wild mood swings and uncontrollable rages, something you're probably familiar with if you've ever watched football or professional wrestling or a German women's swim meet. My sister Kate resurrected my childhood nickname Cannonball to describe me when I was hopped up on megadoses of steroids. I was bouncing off the cruddy lead-painted walls, or as much as it was possible for me to bounce when I was stuck in a hospital bed. When I got really out of hand, Kate would say, "Here, let me fluff your pillow—over your head," and make as if to smother me. Or she'd go over to the socket that powered my IV pump and say, "Oh, is this the TV cord?" and pretend to unplug it.

When I worked at the nursing home, if a resident went to the hospital it was usually because they were about to die. In fact, 80 percent of Americans die in heath care institutions. I had to turn my preconception around and convince myself that the hospital was a place where you get well, a place for life. So—this should come as no surprise at this point—I tried to make my stay in the hospital into one long party. My theory is that it takes a week at home to get over every stinky day you spend in the hospital, and to ease the recovery, I tried to make the hospital as much like home as possible.

First, I brought things that I knew would make me a lot more comfortable: lip moisturizer (hospitals are overheated and dry) and talcum powder (I couldn't shower anyway because of the pain, but I could at least brush some powder through my hair). I never wore the hospital gowns if I could help it. I brought ball gowns and wore my Miss Coney Island Mermaid Queen tiara and cha-cha heels every day. And while there wasn't anything I could do

about the bacteria, I did try to change the attitude of the people who were caring for me.

I hung a picture of Dr. Kevorkian over my bed and informed all the physicians working on my case that I would be consulting with him if things didn't start looking up. Believe me, I wasn't just another patient to my doctors. One doctor just looked at the picture and muttered, "He was a lousy pathologist." Another ripped it off the wall and tore it up, which I found pretty entertaining.

I'd socialize with the nurses and interns on the floor, trying to entertain them, like I was auditioning. I was used to being popular, but I poured on the charm as if I was campaigning for Miss Congeniality. For some stupid reason, I thought I'd increase my chances of survival if the staff liked me.

I was attended by a parade of doctors—residents, pain management fellows, tropical disease specialists, and neurosurgeons—from the Sloan-Kettering Institute, New York Hospital, and Rockefeller University Hospital. To keep myself amused, I liked to flirt with the doctors. I told them all, "The doctor-patient covenant prevents us from dating, but that's out the window if you're not treating me any more. The doctor who saves me gets to go out with me." I figured it was a good idea to encourage my doctors to work toward a cure.

I always had plenty of magazines to read, and when I was done, I gave them to the nurses. In fact, since I saw the nurses most of all, I always treated them nicely—you'd be surprised how the care improved. I would get baskets of fruit and share it with them. I wrote to *E.R.* and got an autographed photo of Noah Wyle for my favorite nurse. (Yes, I happened to know Noah. He is a dreamboat. But anyone can get one—a picture, that is, not Noah—all you have to do is write to the show and ask.) I bought a big box of chocolate for the nurse who gave me an enema, although, thinking about it, maybe she should've given me one.

I should say that although some nurses can be cold and insensitive, for the most part the technical and support staff at New York Hospital were consistently cheery. Caring for sick people hadn't sucked the spirit out of them. If a member of the staff ever treated me, the patient, with impatience, I'd gently point it out to him or her. A simple "Has it been a rough day?" was sometimes all the reminder they needed that they were copping a snippy attitude.

I definitely wasn't at home, but I tried to make it a little like home. Privacy is one of the first things that goes out the window in a hospital. I guess when they're poking around in your body, drawing blood out and pumping chemicals in, invading your space is the last thing on the minds of doctors and nurses. And if your condition is in any way unusual, as mine was, there's a whole host of curious doctors who want to examine you. So I put a "Please Knock" sign on my door. It didn't stop anyone from coming in, but it helped me feel like I had some control over my living quarters.

I even "went out." Hospitals put on lots of lectures and concerts, mainly for the staff, but patients can go, too. All I had to do was ask.

It's tough to exert your independence when you're incarcerated in the hospital under the control of a not-always-benevolent despot, the charge nurse. It's tougher when you're hooked up to IV lines like a living marionette. (I used to call myself the "Intravenous De Milo," after the Spinal Tap album, and the port they put in my arm to make changing the IV easier I called my Port Authority.) Luckily, my misery had some good company—my friend Lori was always there to aid and abet me. I'd sit in a wheelchair and we'd re-enact the scene from VH1's *Behind The Music* where Leif Garrett is reunited with the friend he crippled years before in a car accident. She'd bring me Bud tall boys, or a bottle of expensive Armagnac. Not that I was

getting wasted in the hospital. Okay, I had a sip or two. But the point was that she knew what I wanted wasn't serious looks and hushed voices, but a little fun.

Visiting Etiquette

When a friend or family member is in the hospital, don't feel obligated to bring a gift. The fact that you're there is plenty, and there's not a lot of storage space in hospital rooms. That said, it's always nice to get a gift, so here are some ideas.

- A newspaper or a magazine

- Bottled water

- Lip balm, body lotion, room fragrance

- Flowers are always lovely, but they die quickly in an over-heated hospital room. A small plant or orchids will last.

- A book. Paperbacks are good, because they're smaller and lighter. Always take into consideration the taste of the recipient, but I like short stories and poetry; big thick novels were a little taxing. A dream dictionary helped me pass the time figuring out what all those dreams about the Washington Monument meant, and travel books helped transport me out of the hospital environment. I'd avoid anything overwhelmingly intellectual, like the philosophy of Heidegger. (He was a Nazi, anyway.)

- Writing paper, pens, envelopes, and stamps. Writing letters helps pass the time and keeps the patient in touch.

- A blank book to jot down telephone numbers, thoughts, and messages.

- A box of chocolates or cookies for the patient to share with nursing staff.

- A favorite tea or coffee, filters, and one of those strainers that sits on top of a mug.

- Tweezers. My sister Kate made me promise that if she was ever in an accident and went into a coma, I'd come in and tweeze her eyebrows.

In the hospital, my folks acted as if they were being pulled over by a state trooper. They were very nervous and quiet around the doctors, and they were shocked at some of my behavior. When Lori or Lynn smuggled in liquor, they said, "You can't drink in here!" I said, "Big deal, I'm paying thousands of dollars a day, I can have a distillery in here if I want." They had a little too much reverence for the situation, and that was where we differed. I believed in the medicines, I trusted the doctors, but I had to change the situation if I could into one more conducive to my way of being. Everybody who visited me asked, "Is there anything I can do?" But very few people had the gift of being able to turn love and concern into practicality. Or impracticality, in Lori's case.

Trying to enjoy myself and live life in the hospital on my own terms didn't change the fact that I was there because I was very sick, and I was finally starting to grapple with the idea that I might die. Soon.

A friend had brought my kayak paddle to the hospital as a reminder of something I loved to do and as a hope I'd be able to do it again. My hands were too numb and paralyzed to grip it, so

my old MTV producer Dave Ladik attached Velcro to the handle and made me Velcro gloves so I could hold it. At the time, I was reading *The Happy Isles of Oceania*, by Paul Theroux. On the northern coast of Australia, Theroux bumps into a beachcomber who says, "You can get anywhere in life you want to as long as you give yourself enough time." When I read that passage, I thought, Maybe if I gave myself enough time I could kayak again. I still had faith in my body, that I could get well, that whatever it was that was eating my spine would depart as quickly as it came. But the faith was growing a little weaker. Even if I got better in an instant, I didn't know if I'd ever be able to return to the healthy life I'd left behind.

How to Navigate a Comfortable Hospital Stay

When you've got a serious illness, chances are good that you're going to spend some time in the hospital. Here are twenty-four ideas to make your hospital time more pleasant. Not all of them will be practical for everybody, and some may be outright prohibited, like hot sauce for ulcer patients. But every patient will find something useful.

1. Wash cloths, basin, bubble bath, shower gel: Even if you're well-insured and have the luxury of a private room, it's still a challenge to bathe comfortably in the hospital. Bring your own accessories for sponge bathing to allow yourself a bit more independence.

2. Moisturizer and lip balm: Most hospitals are overheated and dry. If you can, get one of your visitors to massage your

hands with cream or lotion. Bring an attractive basket or bag from home to keep all your beauty products in.

3. Body powder: Washing your hair in the hospital can be a huge pain in the neck, especially if, like me, it hurts to wash your hair to begin with. Avoid sporting a greaseball hospital bed-head by washing the front of your hair. Style with a blow-dryer, and you've faked your way into looking groomed. You'll be lying in bed with your head on a pillow, so who's going to see the back of your head anyway? You can also give yourself a dry shampoo with a teaspoon of talcum powder. Run it through your hair and massage it into your scalp, then brush out the excess. (Many hospital units are talc-free, but cornstarch baby powder works just as well.) If you don't have any powder, ask the hospital kitchen to send up a cup of uncooked oatmeal and use the same technique.

4. A good reading lamp: Tame the pallor of the overhead fluorescent lighting with a light you can control. When you're lying in bed, reading may be your primary diversion, and you deserve a great bedside light source.

5. Cutlery, tablecloth, and cloth napkins: Do you really want to eat three meals a day of hospital-quality food with plastic utensils on an unadorned Formica tray?

6. Hot sauce: To liven up the aforementioned hospital-quality food.

7. Menus: If you're feeling up to it, you can dine with a friend and order in. It gives you something to do, and makes your guest feel useful. Ask your nurse to recommend some good restaurants that deliver.

8. Water pitcher and ice bucket or cooler: Again, hospitals are hot and dry. Rather than waiting for a nurse to quench your thirst, keep your own supply handy.

9. Vase: If you're lucky enough to receive flowers, you may not be as lucky in the vase department. A dozen roses deserves to be displayed in the proper setting. If your room is crowded, a bud vase will hold a flower or two and still do wonders for the ambience.

10. Fruit bowl: Well-wishers often bring fruit. Don't serve it in a bedpan.

11. Scented candles: You most likely will not be permitted to light them, but they'll still help overcome the hospital stench.

12. A sign for the door or curtain: Privacy is the first thing to go right out the window in a hospital. When medical professionals are dispensing medications, drawing blood, and changing IV bags, invading your space is the last thing on their minds. A "please knock" or "privacy please" sign by your bed won't stop anyone, but it will help you feel like you've tried to keep some control over your life.

13. VCR: Most hospitals have TV sets, and many video stores will rent VCR players as well as tapes. This is particularly handy in the daytime if you're not a fan of talk shows or "stories." Depending on where you are, there may be a service like UrbanFetch or Kozmo.com that will deliver and pick up just about anything, including tapes and VCRs, or video games if you're so inclined.

14. A small clock: On the other hand, if you're the kind of person who can't do without your stories, you need to know what time they're on, and you can't wear a watch when you've got IVs in both arms.

15. Walkman: Frank Sinatra always gets me in a good mood, and it drowns out those "Dr. Morton to the OR—stat" announcements.

16. White noise machine: A great nonpharmaceutical way to help you sleep. The machine makes soothing sounds like ocean waves or rain to mask the cacophony of institutional noise. If you're from a big, noisy family and never had your own room, like me, the tomblike silence at four in the morning can be even more nerve-wracking than the noise in the day. The stillness just intensifies the creepiness of the few sounds you do hear, like the metronome tick of the IV pump filling you with powerful chemicals.

17. Scarf: There's a school of thought that says if you look good, you feel better. Try to dress in street clothes or your own pajamas if you can, but at a minimum wear a scarf. You can wrap a scarf around your head, tie it around your neck, use it as a sling, wrap it around your shoulders as a shawl, or use it as a belt to jazz up your backless hospital gown.

18. Costume jewelry: For the same reason as the scarf. My Miss Coney Island tiara brightened up many a day. Don't bring the good stuff, though. You'll have to take it off for may tests and procedures, and there's a chance you might lose it.

19. Linen spray: To freshen up your bed sheets and pillow cases.

20. Instant camera to photograph your guests: My friend Lori kept a camera and a bunch of props in her room when she was in the hospital for her first child. She made visitors wear a balding wig or a black tooth and took photos of us looking ridiculous to make her laugh. Once we put a false beard on her, took a picture, and summoned her doctor. "Doctor, I think the steroids I'm on are having strange side effects," she said. "Look, we took a picture to document it."

21. Guest book: Keep a notebook by your bed for when you're sleeping, or out of the room for tests or treatment. Visitors who've missed you can leave you a note.

22. Your favorite pillowcase from home: Because it doesn't reek of the harsh hospital laundry soap. I had Dwight send me one of his T-shirts, because it smelled like him. For obvious reasons, I couldn't possibly have asked Whit.

23. Laptop computer: If you write, you know it's hard to put aside all the distractions and get yourself started. In the hospital, you have ample time to exhaust the limited entertainment and get down to work. Or you could be like Lori and play computer solitaire for three months.

24. Follow the golden rule: Nurses and doctors have pretty much seen it all. Unfortunately, they can be pretty blasé about your needs and your suffering. Instead of yelling when they seem callous, try treating them as human beings and hopefully they'll start to do the same. Offer them books or magazines you're done with. Share your fruit basket and candy. I'll bet your treatment improves.

Recapturing the Juice

By late November of 1995 the steroids had helped me regain some mobility, and the love of my friends had helped bolster my self-confidence. I decided I was even well enough to start dating again, or rather my friends decided for me. One day, my friend Sharon and her husband Jim announced that they'd fixed me up with their friend "Richard" for Thanksgiving dinner. I was still paralyzed on my left side and embarrassed by it, and I wasn't about to tell "Richard" I was suffering from a mysterious disease. I fixed an Hermès scarf as a sling, and my friend Jody, who's a makeup artist,

did my face. When I arrived for the dinner party, I was seated next to Richard—Richard Gere.

He was wonderful, a complete gentleman, and even cut up my meat for me, since my left side was useless and by now my right hand was numb, too. The problem was, I also had hypersensitive reflexes. At one point he brushed against my knee, and I kicked the table so hard that I knocked over the candles and the center-piece caught fire. This probably wasn't Richard Gere's idea of get-ting a girl hot and bothered, but he leaped to his feet and stamped out the fire like a flamenco dancer.

I was incredibly embarrassed, but Richard's kindly attention made me feel like less of a withering freak. I felt comfortable enough to explain to him and the other guests that I was suffer-ing from a neurological problem, and their response was warm and supportive, just the opposite of what I'd always feared. Then, and I don't know what came over me—I must have been really sick out of my mind at that moment—but I started talking up Carey Lowell to Richard. Carey is so gorgeous that if she went any further on the scale of pulchritude she'd click right around to being ugly. For some reason I started to wax rhapsodic about how smart and talented and beautiful she was and how great she'd be for Richard. I guess what William Thackeray said is true: every woman worth a pin is a matchmaker at heart.

Richard and Carey fell madly in love, and recently added a limb to their family trees with a new baby. I ran into them at a party long after the burning centerpiece incident, and Carey, who was pregnant at the time, rushed over and hugged me. "Duff, thank you for helping us get together. I'm so glad you got sick, because it changed my life," she said. She's such a wise-ass, I love her. And I'm very happy for both of them. (No, that's not the morphine talking.)

After the abortive date with Richard Gere, I began dating in

earnest. I sensed that my condition was grievous, and probably escalating every day. I wanted to get out there on the market before everyone knew that I was sick and my dating stock started to plummet. My attitude before had been, "Hey, a girl's gotta eat." The dates were fun, but they didn't mean anything.

But in my condition, I figured, If I'm gonna croak at thirty-five, I better look for a relationship *now*. I don't want to die alone. I kept having this vision of myself living on Social Security in a wheelchair, not that there's anything inherently wrong with Social Security or wheelchairs, but I really didn't want my life to turn out that way.

I had to be kind of calculating, because I didn't want it known that I was so infirm. I didn't want to look sick or act sick, partly because I didn't want to scare anyone away, and partly because I didn't want anyone to date me out of pity, or some sense of nobility. This was a little easier than it sounds, because I'd just been at the Emmys, so there were a lot of pictures of me in magazines. My Revlon ads were still running on TV and in magazines, too. So while it felt like I'd been bedridden and ill for hundreds of years, there were still a lot of images of the healthy me in circulation.

The actual me was a little less appealing. I suffered occasional seizures triggered by the pressure of the lesion on my brain, which could have had potentially date-ruining results. The worst incident happened with friends at a movie. I'd gotten a cup of tea, and a seizure hit as I sat in the theater. Scalding tea flew everywhere.

The steroids also tended to make me less pleasant to be around. I became incredibly punctual. Smoke would rise from my ears if I had to wait for friends or a date or even on line at the deli. I was making hourly withdrawals from the refrigerator to satisfy my steroid-induced hunger, and I was plumping up. I'm sure that the guys I went out with during this time were amazed to see

a woman actually finish her dinner and order dessert on a first date.

In the early 1700s, Peter the Great, Czar of all the Russias, tried to drag his backward countrymen kicking and screaming into the eighteenth century. Russian men preferred to wear their hair in long beards, but the fashion in the more advanced countries of Western Europe was for men to go clean-shaven. So Peter decreed a tax on beards: pay up or shave off. Most peasants couldn't afford to pay, so they scraped their faces as best they could (this was before the Gillette Mach 3). Noblemen, and anyone else who could afford it, paid the beard tax, and were given tokens to wear around their necks as a receipt. But woe betide anyone caught on the street with a beard and without the tax medallion—the authorities would pluck their facial hair out with tweezers. If my steroid-taking self had been transported back to Russia under Peter the Great, I would have been paying a beard tax based on the whiskers that started to sprout on my face.

If I did manage to swing a date with some poor unsuspecting sap who didn't know he was about to be browbeaten for being five minutes late by a tubby, ravenous bearded lady, I still had to overcome the hurdle of getting dressed. My hands were numb and mostly useless for delicate tasks, so I'd have to go out to the doormen and have them zip up my dresses, and then unzip me when I came home. I still go to visit them sometimes because I loved them all, and they were so good to me when I needed their help. I guess when it comes to gallantly helping a lady zip up a sexy dress, virtue is its own reward.

It wasn't just dating I jumped into headfirst. I'd postponed some work while I was completely bedridden, and in early 1996 I did three pilots, including a disastrous variety show. Though it was somewhat common knowledge that I'd been sick, very few people knew how sick I was or what I had. I was popping

methotrexate in the dressing room, then going out and trying to hold it together as the host of *The Happy Hour* for Disney. The Mouse people had no idea what hit them, though they should have been warned when I insisted that they include a clause in my contract allowing me to drive the Zamboni at Mighty Ducks hockey games.

The Happy Hour was supposed to be a twisted, noncountry version of *Hee Haw*. My old friend from MTV, Dave Ladik, was the producer. He and I came up with a series of sketch ideas, each one sicker than the next. One was a walker for drunk people. We dressed up a production assistant as a Boy Scout, filled him up with Zima, and sent him out with the walker. The Luciano Pavarotti Corn Dog Necklace was a handy snack accessory for people as grossly fat as its namesake. We also devised a lazy boy's dog walker, which consisted of a cat dangling from a long pole strapped to the back of a fifty-five-pound Airedale. At the end of the show, I threatened, "Pick up the show or the cat gets it!"

Well, a certain network was not proud as a peacock about this show. Dave called me on April 1 to say that the network was shocked and appalled and that there was no way in hell they were going to pick up *The Happy Hour*. "Ha ha, April Fool's," I said. Finally he convinced me—they had really hated the pilot. I've still never seen the finished show—Disney wouldn't let anybody have a copy. I was invited to leave the Disney lot, and I accepted before they decided to use force to pry me out.

I also did a sitcom pilot, where I was supposed to be "playing myself"—my character was a sassy model. (I think they were expecting me to play the old Karen Duffy, not the lumpy, bloated Karen Duffy.) I only remember one of my lines. The actor who was trying to charm me said, "I love your hat." "It's not a hat, dude, it's my hair," I shot back. The director started yelling, "Stop! Stop! Stop! 'Dude' wasn't in the script!" Well, I was playing

myself, and "dude" is something I say. I could tell right then that this show wasn't going to be picked up either, and it wasn't. It stunk anyway.

Despite that experience, I continued hustling work. Before I got sick, I'd cry like a blubbering baby wolf to get out of a job. Now that I was sick, all I dreamed about was working. I knew these projects were probably doomed, but I did them anyway because I wanted to sock away as much money as possible. I didn't know how long I'd feel good enough to continue working, bloated and numb as I still was, or how long I'd get work if it came out that I was ill. And I felt, Hey, why not? I'm sick, what does it matter what I do? As long as I could recapture some of the juice, some of the momentum I'd had going before I got sick. I was hoping I could regain the peak I'd previously reached, despite my ongoing medical problems.

In the entertainment business, to some extent it doesn't matter what you're doing, as long as you're doing something. Being in demand helps you stay in demand. It was the same with dating. I wanted to be in demand again, though of course my agenda in dating was more long-term than with the pilots.

During this period, I snagged a job as a correspondent on a show called *American Journal,* which seemed like a good opportunity. It was steady work, I'd be seen on TV regularly, and it seemed like it was right up my reportorial alley.

The job didn't actually start until later in the year. By that time my attitude toward work had changed somewhat, and I only lasted three weeks before I quit. For one of my first assignments, I had to stand on the carpet outside the Emmy Awards and interview the arriving stars. When George Clooney came walking toward me with his date, I realized that I'd made a serious mistake when I'd accepted the job. Instead of going in with him, I was part of the paparazzi. Instead of working for a funny and worthy

show like *TV Nation*, I was scrubbing the toilet of yellow journalism for *American Journal*. By that time I had my head on a little straighter, and I got the hell out.

In early 1996, though, I didn't have that much perspective on what I was doing, and I took a job covering the Grammy Awards for the entertainment tabloid show *Extra*. I knew that the guests at awards shows are always hungry and thirsty because there's never anything to eat or drink, and the shows drag on forever. So I had cookies—"Grammy Crackers"—and bottled water at my little interview area to entice people over.

I was goofing around with Hootie and the Blowfish, and we all licked a cookie. And then I pretended to give it to . . . Stevie Wonder. I'm not proud of it, and maybe it was partly due to steroid-induced mania, but that was my attitude at the time: I'll do anything, I'm sick.

And I was. The steroids and the chemotherapy had gotten me out of bed and begun to shrink my life-threatening lesion, but I was far from well. Whenever I wasn't running myself ragged for some crazy TV job, I was stuck in the hospital.

8

Dr. Sawbones

In mid-May of 1996, I was in Jamaica working on a movie with my friend Aida Turturro. The weather was beautiful, the island was beautiful, and I had a great time, but I found myself staring out at the Caribbean and thinking, This is the last time I'll ever be here.

Paul Bowles wrote in *The Sheltering Sky* that we never stop to think about how death circumscribes us. How many times will we remember a particular afternoon from childhood, one that seems so charged with meaning? Maybe four or five times. How many more times will we watch the full moon rise? Perhaps twenty times

at most, but the number of those moments available to us, Bowles says, seems limitless. Well, I was becoming keenly aware of my limitations.

Before I'd come down with whatever was killing me, I'd become a "big sister" to a little girl named Allison. I sponsored her Catholic school education through the Inner-City Scholarship Fund. (The money comes from a special organization I call the Pimple-Faced Judas Foundation, because even though I hated Catholic school, now I'm paying to send innocent kids there.)

I'd been unable to see Allison at all, what with being sick most of the time and working desperately whenever I was able. So when I came back from Jamaica, I arranged with the principal of her school to visit and spend the day on May 21. I was praying every day that I'd be able to make it, that I wouldn't have to go into the hospital again first. And I did manage to spend the day with Allison, but when I was walking home, the wind on my neck caused so much pain that I knew I'd be back in New York Hospital soon.

That night, I woke up at four in the morning and I really thought I was going to die from the pain. I wasn't hysterical about it, I just thought the end had come. I was with my steady boyfriend at the time, Geoff O'Connor. I woke him up and said, "Geoff, I'm really sick, I have to go to the hospital."

Geoff called Dr. Petito immediately and blurted, "My girl-friend Nancy Duffy is very sick." Nancy Duffy was his old girl-friend's name. "What did you call me?" I screamed. I was at death's door, concentrating on not dying, trying to summon up every last ounce of self-preservation, and he forgot my name. Later on I thought it was priceless, and I tortured him about it endlessly, but it wasn't funny at the time. At least he'd reached the doctor, and in the early morning of May 22 I was rushed to the hospital for what turned out to be my longest single stay.

The neurological ward I returned to was called Starr Six Pavilion. This wing of the hospital was due to close within weeks, and the building was in deep decline. My wardmates and I were the last patients to live on the floor. The next batch of neurological sufferers would move into a brand-new, swanky, high-tech ward, but for me it was the same old peeling paint and crusty Venetian blinds.

Right after I was admitted, I felt a real need to pray, and I asked to see the hospital priest. Well, let's just say there was a reason this guy didn't have a parish anymore. He had a definite whiff of something stronger than sacramental wine about him. The first thing he wanted me to do was put on a scapular, which is two religious images on a silken cord worn around the neck. I tried to explain that my neck was in terrible pain, and couldn't he just lay it on the pillow next to me. "No, it won't work," he said. Finally I managed to convince him to forget about it, and he started administering the last rites. He'd wanted me to wear the scapular because if you have one on when you die, you go straight to Heaven. (I think that's more a superstition than official Catholic belief.) All I wanted to do was talk and pray, and this old whiskey priest was pronouncing a death sentence over me. This was on May 23, my birthday.

But maybe the priest knew more than I did. The lesion was slowly shrinking, but it was still a threat to my life, and the pain it caused during its flare-ups was abominable. One of the doctors from Sloan-Kettering actually began crying and had to leave the room when he saw me wan and writhing on the bed.

While I was incarcerated in the hospital, an old sawbones of a neurosurgeon came to see me and insisted that he should take the back of my skull off and remove the mysterious lesion that was causing all the problems. But the lesion was situated *inside* my brain and spinal cord, where all the wires connect for breathing

and other important activities I wanted to continue participating in. "It's in a really tricky area, and no matter how well it goes you'll be left with a deficit," he said. "Deficit" is a polite term for "severe impairment." I got the sense that he wasn't so much advising me of the possibilities so I could make an informed choice as much as describing the process of rendering to a cow on its way into the abattoir.

I said, "Doctor, I work as an actor and a model, I don't want to do anything that might prohibit that." Sawbones said, "Well, you'll just have to get a different job." "Why don't you get a different job? Go operate on somebody else," I snapped. He was so eager to open me up, I wondered if he thought it was really necessary, or if he just wanted the practice. (Somehow I was reminded of a story about Winston Churchill's son Randolph. He had a tumor in his lung that doctors felt should come out, but after they'd removed his whole lung, they discovered the lump was benign. Evelyn Waugh remarked, "A typical triumph of modern science to find the only part of Randolph that was not malignant and remove it.")

I didn't trust Sawbones one bit. When he spoke, his eye twitched, and it seemed like a physical signal that he was lying. "You'll be fine. Trust me." Twitch, twitch. I don't think so. I pointed this out to Lori, and she started doing it on purpose to tease me: "Duff, you look fabulous!" Twitch, twitch.

I think I'd already decided against the operation when I looked down and noticed the shoes that Sawbones was wearing. How could I trust this brain surgeon with my noggin when, given the choice of all the footwear in the world, he'd chosen orange rubber clogs? He definitely didn't have the right mojo. Sawbones could tell I had no faith in him, so he suggested I visit another woman he'd just operated on, and see how well she was doing.

I rolled down the hall to her room in my wheelchair. The

woman's broken body was sprawled across the bed. Her head was swathed in a nimbus of bloody bandages. "Hello," I said. "I want to die," she moaned. It was a scene right out of *Johnny Got His Gun*, where the grievously wounded soldier begs the doctors to kill him. I spun my chair around and got the hell out of there, and I decided not to have the surgery. I spent the next two weeks praying for that poor woman whenever I recognized her cries of pain.

My friend Jon Sadler called from London while this was going on, and when he found out the doctor wanted to take the back of my head off, he said, "I'll come over for the operation, and when he's got your skull open, I'll eat the bad part of the brain out with a big spoon, like in the Indiana Jones movie where they eat the monkey brains." I'm intensely grateful that neither Jon nor the doctor got his wish.

Jon and I and another friend, Sean Pertwee, have been exchanging newspaper clippings about self-surgery—people who operate on themselves—for years. Most often it's people who want to give themselves a quick, cheap sex change, but there was one story in particular that stuck in my head. This retired British brigadier waited until his wife left the house one day, then amputated his perfectly healthy right leg above the knee with a razor blade just to prove he had a stiff upper lip. If it had come down to a hard choice, I would have cut off my own leg at that point rather than let Dr. Sawbones get inside my skull.

Although my medical crisis was acute, Dr. Petito was still confident that I was getting the appropriate treatment and that I wasn't going to buy the farm. Oddly, he was reassured by the development of another alarming symptom: it had become difficult for me to breathe. Sometimes, when I had to use my voice continuously for a long period, I felt like I was drowning in the air.

Other doctors had suggested different diagnoses, but Dr. Petito had always been fairly sure that I had sarcoidosis of the

central nervous system. Sarcoidosis strikes the soft tissues of the body, causing them to become sort of hard and bumpy. This can cause major problems in the affected area, as I knew from experience. But often people have only mild symptoms that are easily confused with other diseases, like bronchitis (the lungs are usually the first organ to be affected). Pretty frequently, sarcoidosis clears itself up for the same unknown reasons it strikes in the first place.

But sometimes sarcoidosis is serious and life-threatening, as my case was. It's rare to get sarcoidosis in the central nervous system, and it's rarer still for that to be its first manifestation, but I was one of the unlucky few. The sarcoid granules that were now choking my lungs confirmed what Dr. Petito had suspected all along.

Despite my brushes with death, in a way it was fortunate that I hadn't had a firm diagnosis yet. For example, if the medical consensus had been non-Hodgkin's lymphoma, I would have been treated with radiation, which could have killed me and wouldn't have affected the sarcoidosis.

By the middle of June, I was out on the street again. I was bloated, a physical wreck, burned out physically, and feeling very delicate. I had packed on enough weight from the steroids that I finally had to break down and buy bigger clothes. I was glad to be going home. But there was no sense of, Aha! Now the doctors know what I have! Things are looking up! I was just glad to be back in my own bed.

On the day I got out of New York Hospital, I gave a presentation at Sloan-Kettering. (My sister Katie teased me that I was booking gigs even when I was in the hospital.) The subject was "Understanding the Patient in Chronic Pain." I put on a black suit and a beret, and a young, handsome doctor wheeled me to Sloan-Kettering. (I went through the same underground VIP tunnel that

Jackie Onassis had used when she was shuttled between the hospitals for treatment of her lymphoma.)

The format was like *The Tonight Show*. I sat on the stage with a doctor who asked me questions and then invited me to plug my upcoming projects (no, not really). And just like when I'm on talk shows, my father was in the audience waving, while my mother and sisters clutched rosary beads and prayed that I wouldn't say anything stupid. I guess those particular prayers aren't being answered, because I've been saying stupid things on TV for years.

Ill Humor

Although the likelihood of my getting sarcoidosis of the central nervous system was pretty low, I recently realized that there are so many weird diseases that the odds of my getting *something* must surely be pretty high. Here are a few I've come across, some of which I'm glad I didn't get, and some of which seem kind of intriguing.

Asher syndrome After J.K. Asher, who spent nine months in 1908 preparing to cut the Culloden diamond. It was a 3,106-carat rough diamond about the size of an orange, and a mistake could have shattered it into worthless pebbles. After nine months of staring at it, he made up his mind. Whack! And with the first cut he fainted dead away, thus giving the name Asher syndrome to the pattern of extreme concentration followed by unconsciousness.

Blue diaper syndrome An inherited metabolic disorder caused by the incomplete breakdown of tryptophan in the body. The urine of infants with the syndrome is often bluish.

Fox Fordyce syndrome Perspiration becomes trapped in the sweat glands, causing inflammation. The skin becomes dark-

ened and dry and itches intensely, usually in the underarm area, pubic area, and around the nipples. Hair follicles dry out and hair breaks and falls out. This disorder occurs almost solely in women, particularly, I imagine, porn actresses.

Hairy tongue Excessive threadlike growths in front of the taste buds, accompanied by yellowish, brownish, blackish, or bluish discoloration of the tongue. Terrible tastes in the mouth also occur. I call it "bad date syndrome."

Imperforate anus When people are born with no butthole. Easily corrected by surgery, and not to be confused with tightass, stick up the ass, or any other rectal syndrome.

Jumping Frenchmen of Maine A disorder characterized by an unusually extreme startle reaction in response to unexpected noises or sights. First identified in the late nineteenth century among French-Canadian lumberjacks in Maine and Quebec.

Maple syrup urine disease An extremely rare inherited metabolic disorder in which the urine and sweat have a distinctive sweet odor. Although it's dangerous, it seems kind of handy.

Munchausen syndrome Sufferers feign, exaggerate, or self-induce illnesses in order to get the attention they feel unable to obtain in other ways. Basically, it's the liar's disease. Named after an eighteenth-century cavalry officer who made up tales of his military adventures and who inspired the fictional film *The Adventures of Baron Munchausen*.

Munchausen syndrome by proxy When an individual makes another person sick or exaggerates their illness to achieve attention and approval for their caregiving. It's a form of abuse in which children are usually the victims, but if I'm

ever stricken by the syndrome, I'm going to try to make my enemies really sick instead. That way, they'll suffer, and I'll get the credit for being such a generous person that I even look after the people I hate.

Prune belly Congenital absence of abdominal muscles. I may already be suffering from this one.

Stiff person syndrome A progressive neurological disorder characterized by persistent stiffness and spasms of the legs and feet, and sometimes the neck, trunk, and shoulders. I believe that many of the network executives I've encountered suffer from this terrible syndrome.

Wandering spleen An absence or underdevelopment of the ligaments that hold the spleen in place allow it to roam into the abdomen or pelvis. Where, oh where has my little spleen gone?

9

Love and Luther Vandross Burgers

In mid-June of 1996, I drove out to Shelter Island with a friend. I had just gotten out of the hospital, and I was eager to get away and relax at the beach house I'd rented with a group of friends. On our way out, I spotted a black El Camino for sale. It had been the flower car for a funeral home. I've always loved El Caminos, and I liked the slightly macabre association, having recently come close to needing a funeral cortege myself. I figured, Somebody's gotta own it, why not me? So I bought it on the spot and came roaring up to the house in my new wheels.

(Later, at a yard sale, I found a creche and a life-size baby Jesus with a strip of masking tape on his forehead that said "$1." I picked up the habit of collecting old religious items from my mother, who always felt bad that the stuff was for sale, and wanted to give the old rosaries and mass cards a good home. I bought the statue, and in lieu of any better place to put it, I left little baby Jesus in the bed of the El Camino. When I'd come back to the car from a trip into the mini-mart or hardware store, I'd find that people had left money on the statue. I guess they thought the old price tag meant that a one-dollar donation would make Him listen extra-hard to their prayers.)

I'd turned thirty-five in the hospital, and George Clooney sent me a card that said, "Jesus died when he was 33. What have you done?" It was a joke, but it galvanized me. I decided I was going to do things I'd always wanted to do, but had never found the time for. I was feeling saucy, getting back a little of that on-top-of-the-world feeling, ready for adventure and new experiences.

When I got sick, I became obsessed with time, a stickler for punctuality. I was incredibly aware of each passing moment. In May, in Jamaica with Aida, I'd felt like time was slipping away from me. Now, my attitude had changed. It's hard to describe, but instead of being so focused on each moment and experience because there might not be many more of them, I just cherished each moment as it came for what it was. I was looking forward to more, instead of dreading the end. And I started looking for miracles every day, and finding them—like stumbling across a mint-condition 1973 El Camino with only 20,000 original miles on it for sale, cheap.

In the summer of 1995, I'd shared the same Shelter Island house with a group of friends. One of the few people I didn't know well was John Lambros. He and I had some overlapping friends, but we spent very little time together. I was working on a

lot of different projects, and my free time was spent running around with George Clooney and Dwight Yoakam. John was slaving away at an investment bank and had a girlfriend, so I barely saw him that summer, except for one weekend. One Friday, John brought his current girlfriend out for a weekend, and that night, I cooked Luther Vandross burgers for them. Luther's (alleged) method is simple: fry up a pound of meat in a stick of butter. Serve between two jelly donuts.

Bachelor Recipes

Practically anyone can be a decent cook, but it takes real imagination to be a terrible one, which is why I've always admired the culinary skills of bachelors. They cook from necessity rather than an interest in the art of preparing food, so it's astonishing that the results can be so, if not tasty, at least interesting.

- *Exploding Chicken* Mix a handful of unpopped popcorn with store-bought stuffing. Fill chicken with popcorn mixture. Cook in a 350 degree oven until the chicken explodes.

- *Bacon Curls de Sassoon* Wrap bacon strips around a hair curler. Plug in.

- *Piping Hot Peeps Souffle* Place a sugar-coated marshmallow chick in a microwave oven. Run oven at high until the chick expands to nearly fill the oven. Serve immediately.

- *High Noon Hot Dogs* Take the glass cover off a ceiling light and wipe away any dust or dead insects. Place hot dogs inside and reattach to ceiling. Turn on light and nap for an

hour until cooked. Add three tablespoons of cornstarch to the grease to make hot dog gravy.

• *Jaegermeister Jell-O* Mix lime Jell-O with Jaegermeister liqueur. Pour mixture into an ice-cube tray and place in freezer until firm.

John and I stared at each other across the table during dinner, and I stuck to him all night like spinach to teeth. The Luther Vandross burgers led us into a conversation about what it would be like camping with Barry White, in a purple tent with a disco ball. As we laughed, I felt a connection growing between us, but nothing came of it at the time. He was busy, I was busy, and we were both seeing people. We had both planned to go on a dive trip to Honduras in November with some of the people from the house, but I came down with a bad bug called sarcoidosis and couldn't go.

My relationship with John Lambros really began to develop in 1996. Weirdly, at first it was mostly a relationship between John and Geoff, my boyfriend at the time. When the weekly chemo nausea set in on Saturday, I stayed home and they'd go off biking or playing tennis together. When I was feeling well enough, the three of us went kayaking or hiking together.

I never spent time with John alone, because John and Geoff became such pals. They did everything together. They'd talk and crack each other up and follow each other around the house. It was like when you're sitting around laughing with a bunch of your friends on a late-summer night, and it's getting cold but you don't want the good feeling to end, so you huddle together and try and keep the fun going as long as you can.

Meanwhile, I was constantly trying to fix up John. I knew he'd be great for somebody. There's a picture of me on my cell phone at the rehearsal dinner for Lori's wedding. I was calling John to fix him up with Lynn, because she didn't have a date. I recognized all of John's attractive qualities, his sense of humor, his gentility, his beautiful old-school manners, not to mention the fact that he's easy on the eyes, but I didn't consider him as a possibility for me.

Looking back, it's obvious I was slowly falling for John myself, although I wasn't aware of it. He was always kind and attentive, but in a way he knew I'd appreciate. He knew I spent a lot of time curled up on the bathroom floor throwing up from the chemotherapy, and he bought me a dog bed from L. L. Bean so I wouldn't be cold lying on the tiles. John also introduced me to some great literature about illness, like *Time On Fire*. I appreciated the gift, and I admired his self-confidence in acknowledging my illness instead of tiptoeing around it.

Commemorative Plates

I have a friend who used to make commemorative paper plates for friends and acquaintances who threw up in public, similar to the Franklin Mint commemorative dishes you may have seen in advertising supplements in the Sunday paper. I highly recommend one to anyone who's ever thrown up in public, but unfortunately he's moved on to other projects, so I've taken over the business. If you have a vomiting event you'd like memorialized, get out your checkbook and send $10 and a description of your public emesis to Karen Duffy, HarperCollins Publishers, New York, NY 10022.

That summer, John was interested in a girl who also had a house on Shelter Island. She was a stock analyst, and she used to flounce around saying, "I'm either going to be a famous mathematician or a supermodel." She was tall and skinny and pretty, but she didn't have the look. Plus, she was an annoying, self-centered crybaby, and she was insanely jealous that I was a model.

One night she showed up at one of our parties and asked me, "How many months pregnant are you?" She knew I wasn't pregnant—I was bloated on steroids, of course. John just said to her, "Let's go," and he drove her and her friends home. He wouldn't tolerate anyone being rude to me, even if it was a girl he was after. I loved that he was such a gentleman.

As the summer wore on, I grew closer to John. It was hard to get through the week without him, to wait five whole days until I could see him again on Shelter Island. One Sunday evening, as I sat in a splintery Adirondack chair after John had gone, Geoff said, "Duff, you're in love with John Lambros." I couldn't deny it, but I couldn't admit it either. I didn't know what to say. Unbeknownst to me, John was pining after me, too. His mother told me later that he would come home after every weekend and say, "Why can't I meet a girl like Duff?"

At the end of the summer, Geoff and I broke up. He'd stood by me through a lot of awfulness, and I felt a powerful sense of loss after I decided to end our relationship. Lynn had to come and stay at my apartment for a while, because I felt so alone. I knew we were walking away from a man who had loved and accepted me when I was sick. But at the same time, I was afraid that Geoff was staying with me only because I was sick, and he felt he couldn't leave me in the lurch. It's kind of hard to dump a girl who's got a life-threatening illness. I wasn't at all sure I'd done the right thing, but I guess some subconscious part of me

knew I'd found the person I wanted to spend the rest of my life with.

In late September, John had a business affair coming up and needed a date. He called Helen Ward, one of our roommates in the summer house. She was close friends with both of us, and she told him, "John, just take Duff, because you're guaranteed to have a great time. She'll have fun by herself or with your friends. You won't have to worry about her." John called me, and I said, "Of course I'll go." By accepting a date, I was also finally accepting the fact that I was wildly attracted to him.

John's business event turned out to be a dinner party at the home of Shelby Bryan. He's a Texas billionaire, and he was living in Manhattan's largest private residence, the Cartier mansion on Ninety-sixth Street. I was one of the few single women at the party, and Shelby took it upon himself to change the place cards around. I was seated next to him, in the main room, under the Renoir. John was stuck at a table with all the associates from his firm, the corporate version of the cousins' table at family gatherings. So on our first date, we didn't even sit together at dinner.

After dinner, John said, "Do you want to go for a drink?" I said, "Why don't we go down to the feast of San Gennaro?" In September, the streets of Little Italy turn into a big carnival to celebrate the aforementioned saint. There are Italian sausage vendors, games with giant stuffed animal prizes to win for your girlfriend, and about a million people crammed into a few square blocks.

The Coney Island Circus Sideshow had a booth on Mulberry Street, and I was on the board (my title was "big spender"), so I dragged John over to see it first thing. Jennifer Miller, the bearded lady, spotted me in the audience and called out, "Duff, come backstage, we'll smoke a butt." Within an hour we went from din-

ner at a gilded-age mansion on the Upper East Side with a bunch of billionaires to hanging out backstage at the freak show with Screwy Louie the Human Blockhead and Serpentina the Snake Charmer, bumming cigarettes from the bearded lady.

———•··•———

I've always been an incredibly lucky person. It's a standing joke in my family. When I was five, my grandmother would send me across a busy four-lane highway to buy her Salems and lottery tickets at the convenience store. She never hit the lotto, though, because all the luck was used up getting me across and back safely. I'm the kind of person who goes shopping in Bloomingdale's for underdrawers and gets accosted by a stranger who says, "I want you to be the new Esprit clothing model!" I've never entered a contest I haven't won, except for the Second Annual Ernest Borgnine Look-alike Contest, where I lost to Chris Farley. And I'd already won the year before. And Chris bribed the judges.

When I got sick, I thought my luck had run out. But when I met John and we fell in love, I knew the luck hadn't deserted me. It made me realize that whatever freak chance of genetics or fate had saddled me with sarcoidosis, I'd also been incredibly lucky not to die or become a chronic invalid. I was determined not to blow the chance that my luck had dumped in my lap.

In November, John and I went to the wedding of my friend Cha Cha, who's sort of the unofficial mayor of Little Italy. The three ushers were Danny DeVito, Tony Danza, and Danny Aiello—the cream of the Italian-American acting community. At the reception (at Leonard's of Great Neck), each of them gave a floor show. At one point John leaned over to me and said, "Who's that guy over there dressed up like Chuck Mangione?" "That's Chuck Mangione," I hissed.

During the reception, I thought about what John had told me during the wedding ceremony at Saint Patrick's Cathedral: "I come here every morning before work to pray that you'll get better." I knew then that we'd get married. It had taken a long time for me to come together with John, but almost as soon as we started going out I knew that he was the one.

The next week, we went to Paris for a long weekend. John particularly wanted to take me to the church of St. Sulpice, because he'd read that many visitors had been miraculously cured. I was touched, but then again Napoleon had used the church as a hideout, and look what happened to him.

On the plane, I started to develop a big, giant, stinkin' cold sore. But I didn't want to tell John and ruin our vacation before it started, so I said, "I think I bumped my lip on the seat." John asked the stewardess for some ice, which of course did no good, and by the time we landed at DeGaulle airport it was obvious that I hadn't just bumped my lip. I joked that it was a celebrity cold sore I'd gotten from Fisher Stevens, who got it from Michelle Pfeiffer, so if John kissed me he'd get Michelle Pfeiffer's cold sore. "Honey, I'd rather get it from the source," he said, and he refused to kiss me the whole time we were in Paris. The closest we got to a smooch was when John took pictures of me standing in front of the sign for the Brasserie Lipp—"For our future grandchildren," he said. I was happy to discover that John was the kind of person who wouldn't take my illnesses too seriously. And I was thrilled by the implication that he was thinking about marriage, too.

When I was sixteen, a guy I knew gave me a nun's ring, what a nun puts on when she gets "married to God." On the plane to Paris, I'd lost it—just one of the many things that slipped off my finger because I was too numb to tell they were gone. I was really heartbroken because I hadn't taken it off for twenty years. We

looked everywhere for another, and John finally found an even better one at an antique shop on the Rue St.-Germain.

One day we went to the Cathedral of Notre Dame. There's a statue of Saint Therese of Lisieux (my patron saint) in the cathedral that I like to visit, and I lit a candle and offered prayers. As John and I sat there in awe, multicolored sunlight streaming through the stained-glass windows, John said, "I want you to know that I want to be your husband." "Where's the merchandise?" I blurted in the quiet cathedral. "Break out the toolbox and show me the hardware. That nun's ring isn't getting it done. I want a real engagement ring." I did want to marry John, but I wanted to do it properly. For the rest of the trip he kept talking about getting married, and I kept on saying, "Shut your pie hole, you gotta give up the merch first."

I'd been dating Dwight Yoakam on and off for a couple of years now, though it had been mostly off long before I started going out with John. I called Dwight after John and I got back from Paris and said, "Guess what? It looks like you and I are finally over." "Okay, what is it this time?" he sighed. "I'm marrying John Lambros." "Well, good luck," Dwight said. "I wish you and Jonathan (Dwight never calls him by the right name) all the happiness in the world."

The next day I got a FedEx package from Dwight. He'd sent me the book *Born to Rebel* with the inscription, "What the hell happened in Paris?" The thesis of *Born to Rebel* is that the first child is usually an overachiever, because the parents demand success from the firstborn. The youngest kid is the baby, and everyone coddles it. The middle child gets ignored to an extent, but also has a lot of freedom. So middle children are the troublemakers, the

outsiders, the revolutionaries, the actors and artists, because they have to go outside the home for attention. When I read *Born to Rebel*, I felt an intense sense of recognition. I'd always been the crazy one in our family. When I got sick, my dad said, "This is the worst thing that ever happened to a Duffy," and my reaction at the time was, Oh, typical me—getting sick is just an attempt to call attention to myself.

Dwight understood I was someone who always overturned the applecart, and as usual, he acknowledged it with a wonderful gift. Right after I got the book, Dwight flew to New York and asked me to dinner at Café Luxembourg. When we sat down he handed me a little box, and inside was a ring set with a 20-carat blue topaz. Dwight said, "I just want to know, will your husband be able to give you a jewel like this?" Then he slipped the ring on my finger and said, "Hell, honey, if I knew you wanted to get married, I'd have probably married you." The sentiment was incredibly generous, but I knew that it was the gentleman in him talking, not his heart.

Some friends of Dwight's joined us for dinner just after he'd given me the ring, and Dwight said, "Duff, why don't you show Harold and Sandy your present?" Well, I had no feeling in my hands from the sarcoidosis, and the ring had slipped off. It couldn't have been on my finger for more than ten minutes. Dwight dove under the table and searched around for the ring. Café Luxembourg was in an uproar. Luckily, Dwight found it.

A few months later, I got a letter from a Dwight Yoakam fan that said, "Dear Ms. Duff, thank you for breaking Dwight Yoakam's heart, because he just made the most righteous album of his career."

In early January John and I were lying around the house one Sunday morning, reading the *New York Times*. As John rolled me over so I wouldn't get couch sores from lying in one position too long, he suddenly mumbled something that sounded like, "Let's run away." John is usually an immaculate enunciator, but his oratorical skills had deserted him. "Speak up, stinky," I said. "Let's run away," he repeated. "Run away from what?" I said. I knew he was talking about eloping, but I pretended not to understand him. "Run away? I'm thirty-five years old, not fifteen. I'm older than Marilyn Monroe was when she died." I was trying to push John for a proper proposal, but he just couldn't spit it out.

That afternoon, I went to the deli and bought a cantaloupe. I wrote "Can't Elope" on it and left it on the counter. John saw it and ran out and bought a can of El Paso refried beans and wrote on it, "We Can." I went back out again and came back with a honeydew (get it?) and a pint of Chubby Hubby ice cream. On the day we decided to get married, John never actually said, "Will you marry me?" and I never said "Yes." We communicated entirely through food.

Before I met John, the deepest level of commitment I'd ever experienced was being thanked in the liner notes of my boyfriends' albums. I'd always said I wanted to get married in May—may the day never come. I'd changed my mind since falling in love with John.

On Valentine's Day, John gave me a card in which he revealed that he'd been sending me secret Valentines for years. I didn't remember it until he told me the story, but we'd met at a party in the early '90s, and he'd had a little crush on me ever since.

For dinner, John had planned to take me to a Medieval Times restaurant. If you don't have one near you, the idea is to recreate a medieval festival. The patrons sit in a grandstand and eat with their bare hands as men dressed up like knights whack the stuff-

ing out of each other. I'm sure it's all very historically accurate, and I was really looking forward to it. Unfortunately, I had to go to the hospital instead.

This time, the doctors thought I might have pancreatitis. Basically, your pancreas kind of digests itself. There's not much you can do about it, and when the pancreas goes, so do you.

It turned out I didn't have pancreatitis, but the episode concentrated my mind on marriage. I realized we might not be able to plan a wedding to take place six months in the future, because I might be too sick, or not around to enjoy it. Hell, I couldn't even count on keeping a dinner date at Medieval Times.

After I got out of the hospital, we decided not to wait any longer. But to get married in the Catholic Church, you have to go through what's called Pre-Cana counseling, and I didn't want to take the time. I called Harvey Weinstein and told him, "There's a special place in heaven for Jews who help their Catholic friends get married. Could you get me a table at Nobu?" John and I took my childhood friend Peter, who'd become a priest, out for sushi (it was a meatless Friday in Lent). After $500 of raw fish and sake, we convinced him that we had what it takes to get married, and he gave us the certificate we needed.

We bought wedding bands at Tiffany, and I left instructions for John's to be engraved with the words, "Blow Me." I had a hilarious mental picture of John, who's so elegant and aristocratic, as an eighty-year-old grandfather dandling babies on his lap while wearing a wedding ring inscribed with a rude phrase. The day before we ran away to get married, someone called from the store to say there was a problem. "I'm sorry, miss, we can't engrave your husband's ring. Due to the standards of Tiffany elegance, we cannot mar our merchandise." "I paid five hundred dollars for that ring, and it's mine. You can't censor me," I screamed. "You accepted the order to engrave it, and I don't remember any-

one saying you could pick and choose whether you'd do it or not. I'm leaving tomorrow to get married, so you engrave that ring right now." We had two phone lines in the house, and John called in the middle of me pummeling this guy to say, "This is one of the reasons I'm marrying you. You fight to get what you want."

Tiffany gave in and engraved the ring, and the next day we eloped to Jamaica, the place I once thought I'd never return to. (I chose Jamaica because the wedding certificate describes the bride-to-be as a "spinster.") We were married by Reverend Honeychurch, and I carried a pineapple as my bouquet. Jamie, the taxi driver who drove us to the church, gave me away, and doubled as John's best man.

Afterward, we returned to our bungalow in the taxi, which Jamie had decorated with streamers and a "Just Married" sign. We invited Jamie, his wife, and the housekeepers in for champagne and a thin sliver of the world's smallest wedding cake ("compliments" of the management). Stanley, the bellman, took photos.

My wedding dress was a tiny, sleeveless shift, perhaps a little too tiny. When the pictures came back, more of my derriere was exposed than I would have liked my new in-laws to see. I had to have a photo retoucher add four extra inches of computer-generated hem.

We made it up to our families for eloping by throwing a huge party when we returned. My family is pretty colorful, and they all showed up in a big shamrock-covered bus with a keg of Coors Light in the back. John's maternal great-grandfather was pals with J.P. Morgan. It was the first time the families met, but fortunately they all got along together. John's mother gave us an oil painting of her great-grandfather's prize thoroughbred, Chickahominy. Then my father announced that he had an heirloom for us as well—a purse my Uncle Joe made in prison out of Kool cigarette packs. John later hung them side by side in our library.

The party was an unqualified success. I decorated my bicycle with cans, streamers, and a sign that said "Just Eloped" and rode it from our house to the reception and then took a few turns around the floor. Each clamshell place card had not just a table number but a time, and at the appointed hour each guest had to take his or her place in a kissing booth decorated by my artist friend Steve Keane. The booth raked in $900, which we donated to the Village Nursing Home. My brother-in-law kept feeding my four-year-old nephew Jack twenty-dollar bills so he could get smooched. Jack's slightly older cousin demanded hickeys.

I'd invited all the doctors who'd taken care of me for the past eighteen months, when I'd been halfway into the gaping maw of death several times, and I think some of them understood for the first time just what kind of person would put a picture of Dr. Jack Kevorkian over her hospital bed. Everyone did Jell-O shots and lifted skirts with the backscratchers we gave out as wedding favors, and the rest is history.

There were only two disappointments. I wanted to have a cigar-smoking, roller-skating monkey to shake hands in the receiving line. My mother said absolutely not, and my husband teamed up with her against me. The other was that I realized I'd finally have to give up my dream of being shot out of a cannon in Yankee Stadium, ready to become the bride of whichever millionaire bachelor caught me.

There's a joke that when a model turns thirty, her next gig is to marry an investment banker. I guess I'm just another punch line to that joke now. But John isn't defined by his work. What I loved from the first about John was his character. He's a decent, genteel human being. And I know John doesn't love me because I'm a model. He got to know me when I was at my absolute worst, and he loved all of me, *including* the disease.

John and I grew up very differently—me in a middle-class neighborhood in New Jersey, attending a public high school and

the University of Colorado, him on the Upper East Side, going to prep school, and then Harvard. But our spirits are very similar.

When I was a kid, I decided that I would look at everything as a work of art, with a rich history. Take light bulbs. Most people take them for granted, but to me they're beautiful. I love their shape and the light they give. And I like to think about how if Thomas Edison hadn't been born, there might not be light bulbs. If Thomas Edison's grandfathers hadn't met and married his grandmothers, no light bulb, and so on all the way back to the time of the first little organisms swimming around on the earth. When you think of it that way, absolutely everything around us is amazing, the product of millions of years of history. No matter if it's a toothpaste cap or a toilet brush—it's art to me. I have a collection of oddball products I call the Museo de Commercial, which includes cans of Greek corned beef, Welsh tongue, and Scottish haggis. They're not ironic or kitsch for me—they're staples in my larder.

When John was at prep school, he gave a speech about how when you're a kid, flying is a big treat, and you want to sit in the window seat and look out at the world. Then you grow up, maybe become a businessman, and traveling becomes a hassle. All you want is to be comfortable, so you sit on the aisle for easy bathroom access and quicker deplaning. John said that you should never become jaded and always remember what's so great about the window seat. The speech was about keeping your sense of wonder alive, which was exactly what I'd tried to do in looking at everything as art. (I've always chosen the window seat, too. When the plane takes off I pick out a car on the ground and think, AH-HA! You are the chosen one! and I stare at that car until I lose sight of it.)

It's amazing what you find when you lose something. I lost my health, but I found the love of my life. Being with him makes me

intensely happy. I can't get over my good luck. I get to wake up in the morning next to John Fortune Lambros. He's my inspiration.

If I were a man, I'd want to be exactly like John. There are times when I wake up and go into the kitchen and Whit's eating breakfast and John is on the phone with Dwight, and I'm blown away by what a generous and open-hearted person my husband is. He's not in any way jealous of my old boyfriends. He's interested in them because I am, too.

Marrying John was the best thing I've ever done. "Hypergamy" means marrying above one's station, and I definitely feel that I have. Nothing in my past relationships indicated that I would land such a catch.

Of course, it hasn't always been wonderful. We've had our setbacks, just like every couple. I always tell people I'm the best kisser in the world. "Some artists work in marble, some work with paint, I work with lips," I told John when we started dating. "I took the gold medal at the Olympics for tongue wrestling." But when we first kissed I had stitches inside my cheeks from reconstructive surgery, and I guess the kiss was kind of gross. John still likes to say that despite all my boasting, he had to teach me how to kiss properly.

Helen and Potato Joe

The most meaningful thing I've done with my life is the work I've done as a recreational therapist with the residents of the Village Nursing Home. When you're sick, your primary disability, your primary affliction, often isn't what kills you. Say you have chronic rheumatoid arthritis, and you're stuck in bed most of the time. Your health is poor and you have limited mobility, so you get depressed. With depression, you don't feel like socializing, or even getting out of bed. You feel isolated, which deepens your depression. You get decubiti, which are bed sores, from lying in one position for too long. You eat less because of your illness and the

depression, which contributes to decreased immune system function, which makes you more susceptible to a bad infection in the bed sores, and so on and so on. It's easy to spiral downward when you're ill, and it's the job of a recreational therapist to help prevent that.

At the most basic level, I encourage people to take up an outside interest, whatever it is. When new patients come in to the nursing home, I ask them, "What do you like to do? Do you like to read, play or listen to music, cook, paint, anything?" If they have an interest, I encourage them to pursue it. If they don't, I try to draw them into participating in *something*, because if you just lie down and do nothing all the time, your days are numbered.

In a way, being a recreational therapist is like being a professional buddy. It's the sort of thing you probably already do with the old folks in your family—play cards, go for a walk, listen to their boring stories. It might not seem like much, but people in nursing homes often don't have anyone to engage them, no family or friends who visit, so it's up to recreational therapists to motivate the geezers. (Of course, there are special recreational therapist skills and tricks I learned in college and during an internship at U.C. Berkeley, but if you think I'm going to reveal that knowledge for the price of a lousy book you must be kidding. If you really want to know how to be a recreational therapist but don't want to spend four years training, send $10,000 to me care of my publisher, and I'll give you the lowdown.)

Laid out like that, what I do seems both pretty benign and pretty easy. It's neither. The atmosphere in a nursing home is usually filled with death. There's a kind of miasma of germs and urine and disinfectant that hangs in the air, and it's a miracle everybody, the staff and the residents alike, doesn't just keel over.

Trying to engage old people is hard. They know exactly why they're in a nursing home (some residents call it the vestibule of

death, or, more benignly, God's waiting room). Often they don't give a damn about doing something fun or at least diverting. They're a lot older than you, and some feel they've earned the right to not bother being polite about what they think of you and your little music appreciation class. Plus, some of them are so ravaged with dementia it's almost impossible to engage them at all, even in an argument. But my experiences with the residents affirmed my sense of purpose. I continued to work full and then part time at the home even after I started modeling. I finally had to quit, but I've always made it a point to volunteer at least once a week if I can.

When I make a connection with one of the residents—and I know this may sound corny—it's one of the most moving things I've ever experienced. It's immediate gratification. I try to get to know the most unlovable ones, because it's the cute, sweet-smelling, coherent oldsters that usually get all the attention. When the animal-therapy people come in with puppies, they tend to bring the pups to the residents who are smiling and presentable, and the stinky, drooling ones with no teeth and boogers hanging out of their noses get ignored.

There was one guy, Max Herring, who was a real tough nut. With cancerous lesions all over his face, he was hard to look at, let alone approach. I said to myself, I'm going to focus on this guy, make him my personal project. He was resistant, but he also had a really corny sense of humor. I'd go over to see if I could get him involved in some activity, and he'd snap, "Speak up, I'm hard of Herring." He'd mentioned that he liked pigs-in-a-blanket, so one day I brought him some. "What! You peed on my blanket? Get away from me!" But with persistent attention, I managed to persuade him to get out of bed and into a wheelchair to move around. The combined efforts of occupational therapists, physical therapists, and my gentle prodding eventually got Max stimu-

lated enough to start walking a little. (Jim Higgins, the director of the nursing home, called the short skirts I wore "motivational therapy.") I'd take Max to the grocery store to buy corned beef, which he loved, and I took him out for Chinese food every Friday.

In a way the nursing home is a little like high school: the popular people always attract new friends and admirers. When I started to pay attention to Max, other people noticed and began to interact with him, too—both the staff and the other residents. Max had been pretty solitary, but I introduced him to Cornelius Fine, another oldster I was crazy about, and they became fast friends. The two of them sat in the dining room together, smoking cigars and checking out women.

There was one woman I'd always been kind of scared of because she's senile and very hostile. She made the grandmother in *The Sopranos* seem like Katie Couric. Not long ago, when I was paying a visit, she was screaming, "When are we gonna get lunch? When do we eat? When we're dead?" I nerved myself up and walked over and said, "Look at you in your pink cardigan. It looks absolutely great. You should always wear pink, it goes with your complexion." She smiled and said shyly, "Really?" I said, "Absolutely. Oh, look, you don't have any lipstick on. Let me give you one of mine." She took it and said, still very shy, "Is this for me?" I said yes, and she started putting it on. And this woman, who a moment before had been screaming profanities, started singing, "Maybe I'll find a gentleman, a gentleman, a gentle gentle man," and her whole outlook changed. Well, maybe not her whole outlook, but for ten minutes at least this confused old woman with two teeth in her head regained some sense of human dignity. There were some other women sitting nearby who were also scared of her, and I promised to bring them lipsticks, too, so they could all find gentlemen. It opened up some common

ground between them and this woman who a minute ago had been totally agitated and irrational.

The nursing home was such a part of my life that one of the most difficult things about getting sarcoidosis was being away. Before my diagnosis, when the doctors had no idea what was going on, some felt that there was a possibility that I'd picked up whatever I had in the nursing home. Plus, my immune system was compromised from the illness and the medication, and it seemed like a bad idea to put myself around other sick people in my state.

I stayed away for a few months, and I really missed it. I decided, well, I've already got whatever I've got, so I might as well go back to the nursing home. If I'd picked up my mystery disease there, the source was already present, so I wouldn't be a Typhoid Duff. And apart from the medical considerations, I needed to go back—getting out and being with the old folks was recreational therapy for *me*. When I did start volunteering again, all the residents knew I was sick, and they started fawning over me like I was the one who was on the way out.

When I returned to the nursing home, I met two old Sicilian guys, Roberto and Salvatore, who always sat together praying the rosary in Latin. Roberto was 103 and Salvatore was 105. (Actually Roberto lied about his age—he was really 106. I guess he was vain.) The legend was that they were both ex-hit men for the mob, though they hadn't known each other before coming to the home. Salvatore had had six kids, and all of his children had died of old age, so he had no one to visit him. The staff put him together with Roberto because they both spoke Italian, and I guess because they had common interests, like whacking people.

There's twenty-four-hour care at the home from doctors and nurses and physical therapists, but it's good for the residents to have visitors from outside and to make sure nothing falls through

the cracks. Salvatore's big joke was to call me over and say, "Nurse, look at my foot! Something's wrong with it!" "I'm not a nurse," I'd say. "Look at my foot," he'd insist. "I don't want to see your foot, Salvatore, it's going to totally gross me out to see your gnarly hundred-and-five-year-old foot." Every day the same routine. "Nurse, nurse!" "I'm not a nurse. I'm Duff, your friend." "Look at my foot." "No." And then one day he took off his shoe, and he'd cut the top of his sock off so I had to see his foot. So he played a pretty good joke on me, but I also made sure to see the charge nurse and say, "Salvatore has a sore on his foot, let's make sure that gets taken care of."

(My brother once tried to convince me to write a book called *Centenarians I Have Known* because I've met so many ancient people at the nursing home. I really have worked with a number of people in their eleventh decade, and I could write a whole book on working at the nursing home. For a while I was going to, until my book agent explained that my editor was paying for something a little different.)

When I was dating Fisher Stevens, I once asked him out for an evening at the circus. When I arrived to pick him up, I was in a van packed with six geezers in wheelchairs from the nursing home. He didn't say anything. He knew I'd snookered him, but he was game. When we arrived at the circus, he did his manful best, struggling to wheel three crotchety old guys around at once. It was like *Harry and Tonto* meets *I Love Lucy* meets demolition derby. When we finally got settled, I started buying all the guys beer. When their weak old bladders started swelling, Fish had to take all the old men to the bathroom and, you know, assist them. I had a great time, and so did Fisher—or at least he likes to tell the story.

I try not to play favorites, but there was one woman I loved more than any other person I met at the Village Nursing Home.

Helen Peters was an incredibly charming, elegant, and beautiful woman. She'd worked in a law firm, never married, and had lived independently her whole life. Then, in her ninth decade she'd been dispossessed of her health and independence and was forced to give up her apartment and live in an institution. She was completely cogent and still active, but she was stuck in a tiny bed in the corner of a room she shared with three women in the deep despair of senile dementia, with only a curtain between her and their babbling and incontinence.

Despite her circumstances, Helen's attitude was, "Oh my gosh, I'm on the back nine here, I'd better enjoy every minute." One day she said to me, "You know what? I've never played basketball, and I'd like to." So every now and then I'd walk to the playground with her and she'd shoot hoops from her wheelchair. Helen had always admired painting but had never tried it, so she took it up in the nursing home. I loved her fearlessness. Instead of thinking, "How can I do that at my age?" her approach was, "When's the next time I'm ever going to have this opportunity?" We had a little book club, just the two of us. She loved the most gory, hideous, vile, horror stories, like *Silence of the Lambs*. I can't stand them—they scare me—but I read them for her anyway. Because she'd worked in a law office, she also loved John Grisham–type thrillers. I once asked her where she got all her spunk, and she told me, "You know, when you're prepared to die, that's when you really find out how to live." (I later came across a similar line while reading Sartre—"You have to live each moment as if you are prepared to die." I don't know if Helen had read philosophy or if she'd arrived at her insight independently, but, either way, I was impressed.)

Helen was smart and educated, but she always made me laugh because she couldn't get a cliché right for love or money. If I was quiet, she'd say, "What's the matter, have you got a cat's tongue?" She'd describe something that had moved her so much that she'd

"cried like a beaver." And to emphasize her points, she'd say, "I'm not just weaseling Dixie here."

One day she told me, "The window was open and I overheard some Perry Como coming from a radio on the street, and it just gave me such joy." I bought her a CD walkman and a bunch of CDs, which was a risk, because in an institution things tend to go missing, but it was worth it for the pleasure it gave her to hear the music she loved—Perry Como, Frank Sinatra, Dean Martin, Johnny Mathis—all the great crooners.

Helen really inspired me and helped me rededicate myself to my volunteer work at the nursing home. Three days a week she got up, got dressed, put on lipstick, and went to help out at a day treatment center for people with AIDS. Her example brought something that had been flitting around in the back of my mind into the full light of my consciousness: I didn't want to use my own disability as an excuse to stop helping other people. No matter how bad off you are, there's someone who's doing worse, and there's a way to offer your help in however small a way.

Despite Helen's vitality, she was increasingly hobbled by arthritis. She had diabetes, and eventually she had to have a leg amputated. A gangrenous infection quickly attacked the wound on her leg, and her weakened system left her prey to pneumonia. Her condition kept getting more and more grievous, and her devoted nephew and I had to be there with the doctors to explain to her what was happening.

Helen was so sick that she eventually had to be moved to a hospital, and there came a day when I knew that this was the last time I would ever see Helen alive. Instead of flowers, I'd bought her one of those modern planty things. Helen started cracking up. "You probably spent sixty dollars for that, and instead of flowers all I get is a box of grass," she laughed. I laughed too, and I said, "You know, Helen, I really love you. You mean everything to me."

She said, "You and me, we go together like ham and eggs. We met late in my life but you're my best friend. When Frank Sinatra and Sammy Davis used to pal around together, if they went to a hotel and the proprietor wouldn't let Sammy in because he was black, Frank Sinatra would say, 'The heck with it, I'm not staying either.' That's exactly what I would do for you. I love you the way that Frank Sinatra loved Sammy Davis." Even at the end, despite the physical indignities she was suffering, she never lost her spirit and her grace.

When Helen died on May 8, 1999, I was inconsolable. I stayed in bed for two days and didn't stop crying. John didn't know what to do with me. He had a picture of Helen in his dressing room, so in the morning when he got dressed I would see that picture of her and it would set me off weeping. I'm sure John thought I was losing it.

I finally went to see her priest, Father Gerard, for comfort. I couldn't deal with the loss of this woman who'd come to mean so much to me. Father Gerard said, "Just think, instead of having someone to pray for, now you have somebody to pray to." I still miss Helen, but at least I feel like I do have a connection to her. I believe in Heaven, and I know that she can hear me when I speak to her.

I also realized that instead of staying in mourning for Helen, I needed to keep moving ahead and find other people at the Village Nursing Home to take care of. Right now my big project is Potato Joe. He was a vegetable man in Italian East Harlem, hence the nickname, and he loves to gamble. He writes down all the numbers he wants to play in crayon, and it's like a little piece of art. I buy these drawings from him for $5, and then he turns around and asks me to take his fin over to a certain bar and play the numbers in the picture.

Whenever I see him, I ask, "Can I run out and get you something, Joe?" He always wants the same thing: "Coffee and maybe

a buttered roll." Then he'll turn to the nearest person in the room and say, "And one for my friend." He doesn't even know the guy, he's just extending the generosity of his friend to someone else who'd probably like some attention, too, not to mention coffee and a roll. I love the way that character really shows through in a nursing home, that at the extremity of life people become fully who they are. Maybe there's something about coming to the end of the line that lets some people drop all pretenses and defenses and just be themselves, something I suppose I've learned myself from my own comparatively tepid dance with death.

Despite what I've said about service and wanting to give something back, I don't want you to get the idea that I'm a complete do-gooder. It isn't only a sense of altruism that leads me to volunteer at the Village Nursing Home. I'm so engaged and entertained and uplifted just by hanging out and talking about someone's grandchild, or helping them out with their makeup, or whatever little thing I do when I visit that I could never stay away. When my husband and I were looking for a new apartment, I told him, "We can't be more than a five minute walk from the nursing home because Jimmie Lou needs me to get him a Sprite, and Potato Joe needs his coffee and a roll."

John's Side
of the Story

I'm going to clam myself for a chapter and let my husband tell his version of the events, because without him this book would be the sad, pathetic story of a lonely, wizened old spinster.

———◆———

I met Duff at a party just before Christmas of 1993. It's funny, the chronology of it is a little hazy. I feel like time zero was when Duff and I started dating. History started then, and anything before that is difficult to recall. But I do remember that a friend

had invited me to this party, and I went with him and his wife. My friend said, "You've gotta meet Karen Duffy."

I was introduced to Duff, and at the end of the evening I spent some time talking to her. Of course it was me and three other guys hanging around competing for her time. For some reason, we spent the whole time talking about the garbage industry and her family's business. I had done some work at the Port Authority on trash hauling issues, so I knew enough to keep a conversation going.

I don't know if I can say that I fell in love with Duff the first time I met her, but I definitely felt she was an amazing person, somebody that I would really love to get to know. She was so dynamic and so interesting and cool, and her whole personality was funny and engaging and open. I left the party thinking, God, she's great. I'd love to meet her again. But is that really going to happen? This was the first time we'd ever spoken, and I was about to go away to business school. I don't know who she was dating at that point, but it was apparent that she wasn't available. All I had to go on was a twenty-minute conversation at the end of a party. I thought, Well, she's a cool person. Stay in touch with her.

In February, I sent Duff a Valentine's Day card. But I didn't sign my name to it. I was brought up that you never put your name on a Valentine's Day card; it should always be a mystery. I just thought I'd send it out and see what happened. I had never done that before, ever. I don't have a list of people that I send anonymous Valentines to. Clearly I wanted to see her again and was interested in her, but I also thought she was someone I could at least be friends with, so I didn't want to press the subject too hard. I didn't see Duff again for years, but I continued to send anonymous Valentine's cards every year.

In January of 1995, a mutual friend called to say that he was in a shared summer house on Shelter Island, and was I interested. My friend rattled off a list of people in the share, and when I heard Duff's name, I thought, This would be a great way to get to know her. I said, "Sure, I'll do it."

I had just started working at Morgan Stanley, and because of work I probably spent a total of three weekends on Shelter Island that summer. For two of the three Duff was off shooting something for MTV, or was with Dwight Yoakam. I heard a lot about the people Duff was dating and what she was doing, but I only saw her once. In early June, I invited my girlfriend out for the weekend. Duff was already at the house, and she came down and picked us up at the ferry. I was really excited. I thought, She knows who I am! She actually knows I'm her housemate! Duff made us Luther Vandross burgers for dinner, and I think I talked to her the entire evening. Once again I thought, God, this woman is great.

As that summer was wrapping up, the same friends who had the share were organizing a dive trip to Honduras, and Duff was supposed to go, so I signed up. About a month before the trip, which was at Thanksgiving, I got a call from Helen Ward about the trip. I asked very circumspectly who was going, knowing full well who was going. She ran down the names of the usual suspects—John, Carolyn, Michael, Barbara, the whole crew—but she didn't mention Duff's name. I said, "Just out of curiosity, I thought Duff was going to go."

Helen said, "Duff is actually really sick. She's got this really bad disease and nobody knows what's going on." I thought, God, what a terrible thing. I was upset that she wasn't going to be on the trip, but obviously I was more upset that she was sick. I wanted to help in some way, but I didn't even know her well enough to call up and say, "Hey, it's John Lambros." I was worried that there'd be a long

silence and then, "Uhhh . . . who?" I would have loved to have said or done something so that she would know I cared, but with 20/20 hindsight, I'm glad I didn't. Duff probably would have resented my trying to help her just because she was sick.

At the time I was dating a woman who worked in publishing and had edited a book called *Time On Fire*, by Evan Handler, about his struggle with leukemia. Although his book was very angry, parts of it were also hysterically funny, and I thought Duff would appreciate that. I sent her a copy, but I didn't follow up, and I didn't hear back from her. The book just went out into the void. At the time, I had no idea how Duff was doing or how she was dealing with her illness (or if she was even able to read anything). Then I thought, maybe she'd hate the book because it was about somebody who was sick and was now well. I knew she'd find it funny. I only hoped that she would get to the funny parts before wondering, Why did this guy John Lambros send me this?

The next year, I was in the same shared summer house. By some miracle, I got out to Shelter Island much more often, despite the demands of my job.

At that point, I knew Duff was sick, and I knew she was taking a lot of medicine, but I didn't know exactly how sick she was. I knew that sometimes she spent a lot of time in her room, but she didn't talk about her disease. When she wasn't feeling really ill, we started to hang out. We went out kayaking together, or we'd go on walks with her boyfriend, Geoff. And as the summer progressed, we started doing more and more things together. Based on what I saw, I had no idea that Duff was really struggling with a terrible illness. I just knew I liked spending time with her.

One Sunday in July, Duff had to go back to New York a little early, and I made up some excuse to take the bus with her. We had a great time, just the two of us talking and laughing all the way

LEFT: Me at age eight.

LEFT: At age twelve. My father insisted on my being photographed; I insisted on not smiling.

ABOVE: Almay advertisement, 2000.

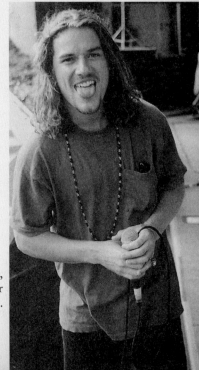

RIGHT: Whitfield Crane, former lead singer of Ugly Kid Joe.

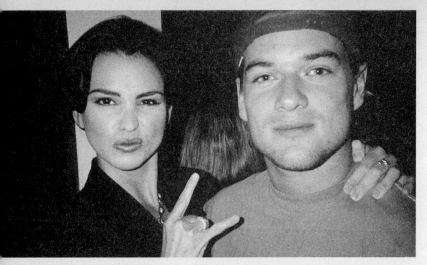

ABOVE: Backstage at "The Tonight Show with Jay Leno,"
January 1993.

LEFT: My first head shot, in homage
to the Herb Alpert and the Tijuana
Brass album *Whipped Cream and
Other Delights*.

ABOVE: 1993. At the airport in Maui,
Whit ingested some unprescribed pills.
He was laughing so hard, his pants fell
down to his ankles and airport person-
nel wouldn't let him on the plane. I told
the steward Whit was my stepson and
that he was mildly incompetent.

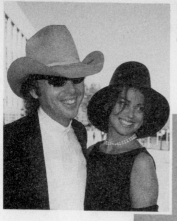

LEFT: Dwight Yoakam, my date for the Emmys. My face is swollen from steroids. (Greg DeGuire/London Features)

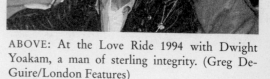

ABOVE: At the Love Ride 1994 with Dwight Yoakam, a man of sterling integrity. (Greg DeGuire/London Features)

LEFT: George Clooney and me at the 1995 Emmy Awards, the last day of my healthy life. The next day I was in the hospital, beginning my odyssey of sarcoidosis of the central nervous system. (Greg DeGuire/London Features)

LEFT: My very first modeling job.

ABOVE: John Fortune Lambros and I eloped to Jamaica in February 1997. The cabdriver, Jaimie, second from left, gave me away and doubled as John's best man. Also attending were Rev. Honeychurch, far left, and the cabdriver's wife, Fay, right.

BELOW: Our wedding night, February 27, 1997.

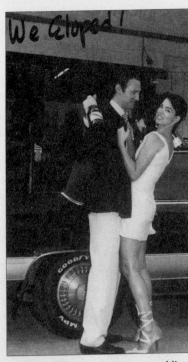

ABOVE: The invitation to our wedding celebration in New York City, May 1997.

ABOVE: My family. From left, Jack Firriollo, Kate Firriollo, Bill DeStephano, Laura DeStephano, Carol Duffy, me, Phil Duffy, and Jim Duffy. In front are Kayla and Jack Firriollo.

BELOW: My parents, who are absolute saints. From left, Red, me, Pops.

ABOVE: My brother Jim had a shiner at our wedding celebration.

LEFT: From left, me, Father Peter Funesti, a childhood friend, John Lambros.

RIGHT: At the kissing booth at our wedding party. From left, Alex Driscoll, Lynn Fisher, Greg Shano, and Jon Sadler.

LEFT: Fran Viola, my boss at the Village Nursing Home, and her husband, Ronnie Viola.

ABOVE: Dr. Frank Petito, my amazing neurologist, surrounded by pulchritude—my hot girlfriends. From left, beautiful Jenny Kustner, me, Helen Ward, Dr. Petito, Barbara Vaughn, and Melinda Farrelly.

LEFT: Kissing booth being stationed by my best friends Lori Campbell, Greg Shano, Aida Turturro, and Michael Gianelli.

RIGHT: John Sadler, Greg Shano, Lori Campbell, Lynn Fisher, and Rob Stone downing tequila-lime Jell-O shots.

LEFT: New Year's Eve 1999, with Cindy Crawford and Rande Gerber.

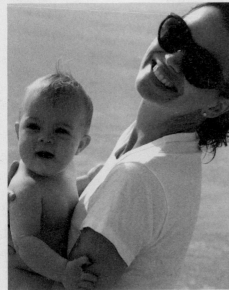

LEFT: With my goddaughter Kayra Ward on Shelter Island.

RIGHT: This shot was taken six days after surgery. The photo editor did some surgery on the photo—retouching my waist and slimming my hips.

to New York. When the bus let us off, it was still early, and I said, "Listen, what are you doing now? Do you want to grab dinner?" I think that dinner finished up at about two in the morning.

That was the start of regular Sunday night dinners with Duff. She was still with Geoff, and I still had a girlfriend, but my attention was definitely very focused on Duff. I stopped inviting my girlfriend out to Shelter Island, and I always kept Sunday nights free for dinner with Duff. We'd make them last as long as we possibly could—and I'd stay out until two or three with Duff, having a tremendous amount of fun. Some Sundays we'd see two movies back to back, and have dinner at midnight. I'd stagger in to work on Monday, realizing that Duff was sleeping through the day while I was crawling my way through a series of Monday morning meetings, and all I could think about was what a great time I'd had.

I didn't know if we were really dating, and she wasn't giving me any indication that it was anything other than just a lot of fun. I was definitely in love with her, but I also felt that it was the wrong time. After all, she had a boyfriend. For the time being, I was willing to let the summer roll along and get to know Duff better and keep my feelings for her a secret.

Our first real date was in the middle of September. I had a business dinner coming up for a client, Shelby Bryan, who was also kind of a friend. He was hosting a big dinner to celebrate the fact that Morgan Stanley had just raised a lot of money for his company. These dinners are usually an extremely awkward mixture of business and pleasure, and they're almost always business people only. But Shelby insisted that we all bring dates. At one point, he turned to me and said, "I expect *you* in particular to bring a date. I do not want you to show up by yourself."

I was terrified. Who could I possibly bring to this thing? I thought. I mean, these types of business dinners can be boring for

the uninitiated. Also, I wasn't dating anybody at that point. Of all the female friends I had, who would want to come to something like this and who would have a good sense of humor about it? I thought, Well, Duff would.

I called our mutual friend Helen and said, "Listen, who should I invite to this dinner?" She paused for a long time, and then said, "Why don't you invite Duff?" That was just the response I was hoping to get. There was a longer pause, and then Helen said: "You didn't hear this from me, but Duff and Geoff just broke up."

I didn't know what to do. I didn't want to seem like I was jumping in as soon as Geoff was out of the way. I asked my mother for advice, and she said, "Absolutely do not ask her. She needs time to get over it."

After careful consideration, I ignored my mother's advice and left a message for Duff asking her to the dinner. She was in Los Angeles for the Emmys, and days passed and I didn't hear from her. As the dinner approached I got really nervous. I'd been ordered to bring a date, but more importantly, I was scared that I had rushed in too soon, or that Duff was blowing me off. Then, a few days before the dinner Duff called me and said, "I'd love to go." I was ecstatic.

My grandfather had a custom called the "psychological," which is the cocktail you have before you go to a cocktail party to get yourself in the right frame of mind. I invited Duff over for a psychological before the dinner, and by the time she rang the buzzer, I'd already had a couple of preliminary psychologicals myself.

Duff and I had a few more drinks together, and we arrived at the party an hour late. Everyone stared at us. They'd all been standing around waiting for us to show up so they could sit down and start eating. Then Shelby switched the place cards around so that Duff was seated next to him. I was at a table in another room

with my back to her, so I couldn't even see her. At the end of the dinner, the junior analysts cracked a few lame jokes at Shelby's expense, and the senior staff all toasted the deal. The next thing I knew, Duff stood up and was toasting Shelby's wife, Katherine, for hosting the party, which never happens at these types of affairs. She even quoted Oscar Wilde, and I'm not sure everyone even knew who Wilde was. I couldn't wipe the smile off my face.

I didn't want the evening to end without actually spending some time with Duff myself, and she suggested that we go down to the festival of San Gennaro in Little Italy. As we walked through these tiny streets filled with people and booths and trash, it seemed like everybody was saying hello to Duff. She introduced me to a bunch of these characters, including Cha Cha, the "mayor" of Little Italy, a dapper guy named Butchie "the Hat," Skinny Vinnie, and others.

Then Duff took me to see the Coney Island freak show, which was performing at the festival, and all the freaks knew her, too. It was just so Duff to go from mixing at a stuffy business dinner to hanging out with Cha Cha and the Bearded Lady.

The next weekend, I asked if Duff wanted to go out to Shelter Island. Duff said, "Great, I was already planning to go with my friend Aida." I was a little disappointed that we wouldn't be alone for a romantic getaway, but in retrospect, it was probably good that we had a chaperone to take the pressure off. After that weekend I think it was clear to both of us that our relationship had gone beyond just being friends.

At the end of October I made plans to go away for a weekend with just Duff. I suggested Miami, but Duff said, "No, it's too crowded and too much of a scene. I'd like to go to Key West, though."

When we got off the plane and walked across the tarmac into the Key West terminal, the first thing we saw was an enormous fat

man wearing diapers. Then we spotted a man dressed in chaps and nothing else. We'd arrived in the middle of the Fantasy Fest, held every Halloween in Key West. Not a great choice of getaway for a guy hoping to have a quiet romantic weekend with his new girlfriend.

When we arrived at our "beachfront hotel," it turned out to be a one-story cinderblock motel. On top of that, they were in the middle of remodeling, and construction supplies and dirt and dust were everywhere. I said to the desk clerk, "Listen, no offense, but is there anywhere more upscale we can move to?" "Oh, this is the nicest hotel in Key West," he assured me.

I was practically tearing my hair out. Everything was going wrong. I suggested we go for a swim, thinking that maybe that, at least, would be fun and relaxing. We immediately bypassed the cloudy pool and walked about fifty yards to the tiniest, filthiest beach I'd ever seen. I gamely ran into the water and splashed around, and when I came out there was a plastic bag wrapped around my ankle.

"I'm sorry," I said to Duff. "Obviously, this is not how I planned for things to go." "That's okay," she said. "I was the one who wanted to come here. We'll still have fun." And we did. That's definitely one of Duff's strong suits, making the best out of whatever's going on, whether it was cruddy vacation circumstances or, as I was learning, her sarcoidosis. And after that weekend I was sure I was in love with her.

It didn't initially occur to me why we always went out on Sunday dates until after Key West, when we started seeing each other on a much more regular basis. We had a little joke together about how we had to do something fun on Sundays, because they're so depressing—it's the end of weekend and on Monday you go back to school. But the real reason was that she couldn't be sure that she'd be up for anything on any other day because of her

chemotherapy schedule. Duff was not physically well enough to do anything most of the time, to get out of bed or go see anybody, and she didn't want to go out on a date with me when she felt sick, or felt less than her fun self.

We didn't really discuss her illness at all. I felt that it was for her to talk about it as much as she wanted to talk about it, and she almost never did. My feeling was that maybe our dates and weekends away were an escape for her from being sick, so why spend time talking about it? I also felt there wasn't really that much I could do. When you're with a person, they sort of let you know in the course of talking about this and that how much they're going to reveal and how much they want you to know. I sensed that for Duff, being sick was really her personal thing, and she didn't want to have anybody else dealing with it. She didn't want to have a boyfriend who was going to come in and "save" her, or take care of her, or go with her to the hospital. And for the better part of that fall, that's how it played out.

After our Thanksgiving trip to Paris, when I told Duff I wanted to marry her, I started looking into what sarcoidosis was on my own. Up until then, my attitude was, We're falling in love and she's sick, but Duff's illness is sort of a sick version of my career. I had a job where I wouldn't leave the office until ten o'clock at night if I was lucky. Duff wasn't able to go out most of the week. Her illness was one of those things that, like my job, we just worked around.

But now, with the idea of marriage in the air, I felt I had to find out more about what was going on with Duff. I got on the Web and looked through all this stuff, and I remember being absolutely horrified and scared. One particular Web site had statistics on how likely people were to survive various types of sarcoidosis, and according to this site, Duff had no chance. I was at work, staring at this information on my computer, and I started crying. I

remember thinking, How could somebody that I love so much and that I care for so much have this thing? How could she be going through this? I was having so much fun with Duff, I loved her, I felt more for her than I'd ever felt for anybody. I thought, God, this isn't fair, how could this happen to the person I'm in love with?

Duff hadn't shared any information about her disease with me, so I felt like I was going through my parents' drawers, seeing stuff that I wasn't allowed to see. I was so scared and shocked that I didn't know how to deal with it. It was like reading somebody's journal, and I felt embarrassed that I had gone on the Web and looked up the information. I had to talk to someone, so I called my mother. "John, remember the important thing is that you've fallen in love with her. Deal with that," she said. "That's what's important, the feeling you have for her, not the feeling that you think she has about what she's going through. You don't necessarily know what she's going through."

I never had even a flicker of a doubt about being with Duff. I never thought, Do you really want to be with somebody who's this sick? I can't even imagine what that would be like. Selfish wouldn't even be the word. It would just be wrong. It would have been so wrong for me to say, Well, you're in love with this person, you've never loved anybody this much, but there's a major drawback. I was having the best times, the best dates, the most fun I've ever had with anyone, and I thought, Who knows what's going to happen, what the future will bring? The chance of Duff surviving may have seemed low on the Web page, but from being with her, I felt that if anybody could get through this it would be her. What I thought more about was, Okay, so this is what it is. This is the landscape, how do you deal with it? When you move into an apartment with somebody and you find out that they have horrible taste in furniture, you don't turn around and walk out the

door. You live with the furniture because you want to live with that person.

I knew enough about Duff's medical condition that if Duff wanted to talk about it, we could, but I focused more on how I could make her more comfortable, how I could make her happier, how I could help her make light of the situation. I tried to make the four or five days a week that Duff was unable to leave the house more enjoyable. Not in a clinical, caregiver kind of way, getting her medicine or taking her to the doctor, but giving her something fun to do.

I thought, She's dealing with it in her own particular way, which is to go out and grab life, and the way for me to deal with it is to go out and grab life, too, to embrace this romance we have and go on with it. I'm having fun, I love this person, I'm not going to change any of that, and I'm also not going to deal with Duff as if she's an incredibly fragile vase.

I also didn't say, "I love you . . . we're in this together." We're not in it together. She's fighting it, and I'm helping her fight it, but I'm not sick. I can't imagine how sick she is. We're in it together in the sense that we're a couple, but my role is to help her live the nonsick part of her life. I planned dinners, or vacations, or an afternoon of kayaking. If I knew that she wasn't feeling well, I'd say, "You know what, let's stay in tonight and watch a movie." Instead of staying in because we had to, because Duff wasn't well enough to go out, all of a sudden we had something to do together inside. I'd come home, and she'd ask, "How was your day?" I'd say, "Well, it was stressful. How was your day?" She'd say, "Oh, I rested." Or, "I spent the day on the couch reading." She read tons of books, and we'd talk about that. I never asked her, "Did you have a fever, did you call the doctor, did you do this or that?" To this day, I've been in the hospital with her maybe

three times. I let her lead on the medical stuff, and let her decide what she wanted to share about her condition.

Over time, Duff started saying things like, "I'd really like you to take my doctor's phone number and have it in your wallet," or "Here's a list of the medicines I take, in case they ever run out and I can't go to the pharmacy." She let me in on these little intimacies about her sickness in the same casual way you might say, "The pipes may freeze, so here's the plumber's number just in case something happens." Duff still didn't want me to be involved in her treatment, but she felt comfortable sharing the information with me.

The first year that we were together, from September 1996 to September 1997, Duff was very sick, much more sick than she is today. At the same time, I had a very demanding job and had to travel a lot. I wondered if I needed to cut back so I could spend more time with her. But I realized that it would have driven Duff crazy if I'd said, "I'm going to leave my job so I can spend more time with you." That would have been me changing my life for her illness—not for her, but for her illness. What she would have wanted me to do would be to change my life for *me*, to get another job or do something different because I really liked it. She wanted me to be happy just as I wanted her to be happy. And that feeling totally excluded the fact that she was sick.

There was a point when Duff was horizontal almost all the time, and the medication was kind of gathering in her stomach and giving her ulcerlike symptoms. Once the situation got really bad and she called me at work and said, "John, I can't get out of bed, and I need eight bottles of Milk of Magnesia." There were a handful of those moments where I would drop everything that I was doing and go to the pharmacy or do whatever she needed. Sometimes she'd say, "Don't even bother to come down, just send a messenger." Or if she wanted me to be there, she'd say so. As

soon as she asked for something, I'd do it in a second. And if she had said, "I want you to leave your job because I need you around," I would have done that, too. But everybody defines their own way of attacking what they do, whether it is work or being sick or having fun. I had to appreciate Duff's approach to being sick, the same way she appreciated the fact that I had a demanding job that had me all over the place and kept me from seeing her every single night.

It wasn't necessarily an easy thing to do. Here's this person that you love who's sick, you don't want to see them sick, you don't want to see them suffering, you don't want to see them in pain. Your instinct is to do *something*, to help in any way you can. Everybody deals with being sick in a different way, and the way Duff deals with it is to take it on by herself. I had to realize that being sick was her job at the time. Taking it on herself gave her the strength she needed. Sometimes, when I remember the time that Duff was much sicker than she is now, I think, Gee, if somebody had asked me who Duff's neurologist was, I wouldn't have been able to answer—I wouldn't have known. I felt kind of stupid for not knowing, but that was how she wanted it.

When she's had a great test result, she tells me all about it, and on the days when her doctors have discovered something that seems like a setback, we talk about that. But I don't have a chart of her condition and her medications so I can say, "Okay, today you take this medication and have that doctor's appointment." I'm a bad nurse, and Duff is a worse nurse. When I come down with a cold or the flu, I sit in bed thinking, Well, *maybe* she'll come and check up on me at *some* point. . . . If she does, she's likely to say something like, "I'm going to make you hot chocolate and put a raw oyster in. That'll get you straightened out."

Sometimes I find myself on a plane thinking, What do I have on my plate here? Will I be married to Duff for another five years? What will my life be like ten years from now? Will she be there? At those times we do talk, and I've told Duff that I'm scared of losing her, scared of her not beating this disease.

At the same time, it would scare me more if I'd decided not to go down this path with her. I'd have missed the best four years of my life. Our relationship has been so much about hope, and doing what you want to do, and believing that this could be overcome, that I can't imagine having done anything differently. There is a risk that maybe Duff won't be there for the rest of my life. But as I've learned, that risk applies to anybody. And it may not be health-related. It could just be a freak accident. I hope that day doesn't come any time soon, because I don't know how I would deal with that.

When Duff had some bad news, I used to think, "How could there be yet another thing that's happening to this great woman? How could this be happening to me?" But after those initial feelings, I stepped back and decided how to approach it. Was I going to walk around morosely, thinking, Boy, we just keep getting dealt worse and worse cards? No, I was going to look at the other side of it, which is, My life with Duff is so great right now, how could it possibly get any better? And if Duff wasn't sick, we'd be worried about something, probably not as potentially dire, but there's always something.

I really admire Duff. It's kind of rare to find yourself in a relationship with somebody who's your hero. I'm married to my hero. What better thing could you possibly imagine? I have so much

respect for how she's dealt with being sick. It puts a lot of things that have come up in my life into perspective.

Duff is utterly contemptuous of people who tell her, "This is going to make you a stronger person," or, "Think of all the good things that come out of being sick," and that attitude is something that I latched onto from the very beginning. There's nothing good that comes out of being sick. It's how you deal with being sick. I don't think I'm a better person because I've helped Duff face her illness, and I have no idea if it's making me stronger. What is making me a stronger, better person is that I'm really happy and in a happy relationship. I would like to think that I've been made to see things differently, and maybe part of that is because Duff is sick, but I think a larger part is because we're so in love with each other. But I don't know. When people ask me if I've changed since I met Duff, I like to say, "There's a lot more taxidermy in my life now." For some reason, Duff likes to buy stuffed dead things, and I can't stand them.

I think one way I've changed a little bit has nothing to do with Duff's being sick. Duff has always done what she wanted to do, even before she got sarcoidosis. But since she's been sick, it's been more apparent to her that she has to do what makes her happy. I think I've always felt somewhat like that, but there's another part of me that feels there are certain things that you have to do because they're steps on the way to where you want to go. It's a more conservative way of looking at life. Duff's attitude is, "I want to do this, and I can do this, so why do I need to have done this resumé list of other stuff first?" I think seeing that, living with that attitude, has changed me. We're here for either a long period of time or a short period of time—who knows which—so when you see something that you want to do, grab it.

I could not have gotten through losing my father without her. My dad was my best friend. I'd always talked to him about all of the things in my life and losing him so suddenly was incredibly tough. Recently, I had the opportunity to change jobs, and it was difficult not to be able to talk to him about it. I did have Duff, though, and I did leave my old job. I'm sure some people might say, "There's so much going on in your life, with your father passing away, and Duff's condition, why make a change now?" I did it because I wanted to do it, and I was able to act on that feeling because I know that's how Duff is. If there were ever moments where I felt like taking a more conservative approach because she's sick, or because my life is kind of crazy in some other areas, I've said, You know what, I'm just going to do it. I learned that attitude from Duff, and it's massively inspiring.

Another way I've changed is that I pray now. Duff is much more religious than I am, and I hadn't spent that much time in churches before I met Duff. But at Thanksgiving of 1996, in Paris, all we did was go to churches. In a funny way, that became something that we did together. And every time we went into a church I'd always pray that Duff would get better, and that I'd be strong enough to deal with her illness. Even now, if I'm around St. Patrick's, I'll stop in and just say a prayer for her, and a prayer for me, too, because it is tough.

Sometimes I hear Duff talking about "When I was bloated and on steroids," and I think, When was that? In my mind, Duff hasn't changed. Maybe it sounds corny, but the attraction goes well beyond the physical. I'm in love with the inner Duff. If her physical beauty was ever off because she was bloated, it was less noticeable to me because that wasn't the basis of my love for her. At the same time, I'm a man. I'm attracted to beautiful women, and I was definitely attracted to the outer Duff.

It's just that she's always looked beautiful to me. She has great style, she carries herself well, she always looks great. I never thought, Duff was a beautiful woman, and she's maybe not that beautiful now, but I know that she was and I know that she will be again.

When I look back at pictures of her from the summer of 1996, I can see that she looks different, puffier maybe, from the steroids, but I never noticed it at the time. Then I look at some photos from when we eloped six months later, and I'd say she looks exactly the way she looks today. Clearly something changed in between the two dates, but I didn't notice it. But you know, I was in love.

There are definitely moments when I'll look at her and say, "You are looking so much better!" Every once in a while I'll notice a change, like she looks more like she looked ten years ago. But it's not a really dramatic change. She's always looked like a babe.

Sometimes Duff's friends call me, and the conversation starts off with, "How is Duff doing?" That's probably the time when dealing with Duff's illness is the most difficult for me. They know Duff, and know how Duff deals with things. I know they know me and how I deal with things. And we both know that that question is awkward for them to ask and for me to answer.

If I say, "Oh, she's doing fine," it's not a sincere answer. Then again, it's hard to give a meaningful update. Duff was on chemo for four years straight, but there was no timetable I could give people, because she didn't know how long the treatments would last. I couldn't step somebody through a process, with an answer like, "She's in this stage and this is what happens." And of course, Duff doesn't keep up on the details of her test results and her illness and neither do I, so I'd feel awkward when I had nothing to say, really.

I think at this point our friends understand that this disease is weird enough that I actually can't have good answers for them. I don't think any of them would think, Gee, I'm really disappointed that John isn't more informed, or Gee, I'm really disappointed that I didn't learn enough from talking to him. But when there *is* news, because our friends are so close, the question "How is Duff doing?" allows me to talk about what's going on with a third person. It's an outlet for me, to be able to share a little of what's going on, even if it's sometimes just, "She's tired and has been resting a lot." It keeps me connected, keeps me from having an isolated life where it's just John, Duff, and the Disease.

Something I find myself saying more and more when I speak with friends is the phrase, "I'm glad you asked." It means a lot to me when friends are genuinely interested. And it's good when I can say, "Duff is feeling better, she's got a lot of energy, things are going great," because it gives me a chance to share the good as well as the bad.

Having so many great friends, and so many friends in common, has been a huge source of strength. They're there when we need them, but they know the way we're dealing with this and they deal with it the same way. And the times when I've had to unload what's happening and share my fears and concerns, they've been there for that, too. It's great that we don't have to deal with the hysterical friend, or the friend who doesn't care. Everybody who knows Duff says, "She's tough, and you guys are so great. I couldn't imagine anybody dealing with this situation in any different way." And that is so reaffirming.

On New Year's Day of 1997, Duff wasn't feeling that well. I was puttering around the apartment, and I found one of Duff's note-

books in the living room. I started to read through it. It was kind of like going to the sarcoidosis Web site. I was going into something I just shouldn't have been looking at. Duff had written in detail how she wanted her funeral to be conducted: She wanted her ashes mixed with gunpowder and scattered across New York in a fireworks display launched from a barge in the Hudson River, as a New Orleans jazz band played on the shore. She'd put a friend in charge of the arrangements because it was just crazy enough that she knew I would probably change something.

I never told Duff that I'd read it, although I guess she knows now. Maybe she even left the notebook out for me to find. When I read through it, I thought, My God, Duff is prepared to die. She's not living in a fantasy world thinking she's not really sick. She was fully aware that she might not make it. I remember thinking that the way she'd dealt with being sick wasn't about putting on a brave face and ignoring the disease. She'd actually dealt with it incredibly realistically, knowing that just because we were in love and happy, she couldn't ignore what was going on. And in that realism she asked herself, "Who am I? I'm somebody who loves to do things a certain way." And I completely fell in love with her again.

Duff is doing better now, but it's not like it's over. We live with the grim reality of the illness. But we live with all the other joyful realities that are the rest of our lives as well. That's what Duff has been so great at. And that's given me a tremendous amount of strength, the strength to say, Okay, it is really bad and I could spend a lot of time thinking that it might be over any time soon now. But it's pointless to live that way. It's pointless to live the other extreme, too, which is to ignore it, pretending it's not there. We've been able to find a balance.

12

Pimple-faced Judas

In March of 1996, in between hospital stays and failed pilots, I was getting ready to go to the Academy Awards. A hairdresser and a makeup artist from Revlon had come to make me up in my hotel room, because I was having my picture taken before the ceremony. Someone from Revlon popped in and said, *"Entertainment Tonight* wants to shoot you getting ready." When she left, I said to the hairdresser, "Listen, don't do anything to my hair. I'm taking some medicine, and my hair's falling out." He said, "Okay, I'll just put a hairpin in." Then the crew came in with cameras rolling, and the hairpin fell out and a big hank of hair came with it. Everybody

screamed. The clump of hair looked like a big tarantula lying on the bed.

Then I had to go downstairs and have my picture taken with the other Revlon models, all these glamazons like Claudia Schiffer and Cindy Crawford and Halle Berry and Daisy Fuentes, and I was missing part of my hair. Drastic measures were called for. I'm the only one of all the models in the picture wearing a hat. I felt like a LeRoy Neiman in a gallery of Van Goghs.

Amazingly, my secret didn't come out. No one who had seen the hair fall out said a word, and the Revlon people assumed the hat was just me being an oddball.

In September, I had a job covering the Emmy Awards for *American Journal*. My hair was still not at its best, and I figured I'd try the hat trick again. As I stood outside the auditorium, waiting for stars to interview, Joan Rivers called me over to talk about my outfit. She was nice to my face, but after I walked away she ripped me up on TV for wearing a hat. Now, she didn't know I was having chemo, but it doesn't take much with Joan Rivers. After I told this story on *Oprah*, Joan's lawyers sent a letter threatening to sue me. She never did, of course. Michael Moore said it was like Don Rickles threatening to sue because you insulted him.

Okay, so I got roughed up by Joan Rivers. Big deal. Every time I see her sniveling face now it just reminds me that I don't get my fashion and beauty advice from Joan Rivers. But the reason she felt free to take a swing at me was because she didn't know why I *had* to wear that hat, and she didn't know because I wasn't telling. I was mad at her, but looking back, I actually credit Joan Rivers for giving me a healthy shove toward telling the truth about my sarcoidosis.

I didn't realize that at the time, though. Breaking the news about illness is never easy, whether it's with friends or your

employers. People can be just as cruel or uncomprehending when they do know as when they don't. And I was very afraid of the reaction if my secret came out.

In October 1996, I went to the *Premiere* magazine awards with Dwight, because he had been named most promising new actor for his work in *Sling Blade*. I wasn't at my best that afternoon. My left arm was numb again, so I was wearing a sling. I put on a scarf and sunglasses to hide my puffy face and screwy hair. The next day, I broke out in the sweats when the *New York Post* ran an item speculating that I was sick or on drugs because I was looking and acting so strange. Again, nothing came of it, but I felt I'd come thisclose to being busted.

Later that month, I had a big photo shoot for Revlon coming up. My cheeks were still swollen with Cushing's syndrome (a side effect of the steroids I was taking). I felt I had an obligation to Revlon to be the person they'd hired, and I was tired of not seeing me in the mirror. I'd spent over thirty years getting used to the way I looked, and in a matter of months I'd become unrecognizable to myself.

So I had reconstructive plastic surgery. It wasn't pure vanity, either. The medication had actually changed the structure of my face. In technical terms, it's called a hyperextended buckle pad. A surgeon removed the buckle pads from my cheeks, and I looked more like my old self again.

Ten days later, I was sitting in the makeup chair for the Revlon shoot, and the makeup guy started rooting around in what remained of my hair. "What are you doing?" I asked. "Looking for scars," he said. It seems he'd met my doctor at a party, and the doctor had told everyone that he'd operated on me. The makeup guy assumed I'd had a facelift and wanted to see the scars for himself.

I was scared. I'd heard horror stories about sick people getting fired from jobs, and not being able to get health insurance. I was afraid I'd lose the insurance I had, and I sure as hell didn't want to stop working. I knew I might need a huge pile of money to fight the disease, and who wants to hire a bald, sick, bloated model? I was terrified of Revlon finding out. They'd hired me to look beautiful; how would they react if they found out I wasn't the healthy, all-American woman they'd hired?

I think the last straw for me came at a party at Giorgio Armani's in Hollywood. I was with my agent, and as we were leaving I noticed he was staring down in horror. I'd closed my pinky finger in my purse, and I hadn't noticed because I didn't have any feeling. He was totally freaked out. I usually wasn't so careless, but I think now that I was dropping clues to my real condition. I guess I was heading toward coming clean.

Besides, I have a degree in recreational therapy, and I've been around disability for a lot of my life. I'd always tried to encourage people not to be embarrassed by incapacity, to be honest about it and work to maximize the abilities they did have. But the first thing I did when I got sick was deny my own illness. It was the height of hypocrisy. I felt like a pimple-faced Judas. And in the end, my manager Peg and I decided it was easier just to be up front about it. Peg said that keeping my sarcoidosis secret was "like trying to keep a beach ball underwater." Sooner or later, that sucker's going to pop out. (I don't *think* she was referring to my puffy, bloated, pre-surgery head, but you never know.)

Ultimately I wrote an article for *Cosmopolitan* magazine announcing to the world that I had sarcoidosis. I didn't know what would happen to my career as a model and actress, but falling in love with John gave me the confidence to be honest about myself. I knew that we'd be together for the rest of my life, and I stopped being so concerned about what the reaction from

the rest of the world might be when everybody learned I had sar-coidosis (which isn't even a popular "celebrity" disease, like anorexia or drug abuse). Sharing my story had become more important to me than whatever effect opening up might have on my ability to work.

Luckily for me, I have still been able to work. Revlon in par-ticular has been very supportive—they told me they'd hired me for my *inner* beauty. Of course, I like to think I'm still not so bad on the outside either.

13

Urine for a Surprise: A Love Letter to Western Medicine

When I first got sick, a neurologist warned me, "You've got to be careful. There are a lot of charlatans who will claim they can cure you." He was right. The perceived hopelessness of many diseases can lead people to unusual and often expensive extremes, and every day I hear from some healer or shaman or medicine woman who wants to cure me. I must have dozens of sets of magnets people have mailed me that I'm supposed to put under my bed to make me better. I could cover a suburban neighborhood's refrigerators with magnets. I could change the axis of the earth if I put all my magnets together. I could pull down the Hubble telescope.

Sometimes the charlatans come wearing pseudoscientific clothes, as with the magnet people or the woman who told me that air de-ionizers would cure me. Sometimes the "alternative" is more on the pure snake-oil end of the scale. One woman called me to say she was spending a year living on a commune in Mexico where they were actually pulling cancerous tumors from her body without knives or anesthesia. This is a procedure sometimes called "psychic surgery," and there's physically no way it can work. It's actually a kind of sleight of hand, and the "tumors" that are "removed" are bits of sponge or raw meat. A few months later the woman called again to say, "My alternative therapy didn't really help." Well, of course not, it's a bunch of hooey. Duh! To deal with the alternative treatment evangelists, I've perfected an imitation of someone who's actually interested in hearing about homeopathy, reflexology, and foil hats. Sometimes I get to use it five times a week or more.

Spot the Quack

Don't be uninformed. Know whether you're dealing with a real doctor or a fraud. These telltale signs are adapted from "Quacks, Crackpots, and Charlatans" by Dr. Stephen Barret, an official at the Food and Drug Administration and an expert on medical quackery.

• *Questionable medical credentials* It's easy to get phony diplomas and certificates. One fraud investigator got his dog certified by the American Association of Nutrition and Dietary Consultants. Look for legitimate degrees from accredited universities.

• *Claims to cure diseases that standard medicine can't* If a treatment is presented as a panacea—something that will cure a whole range of diseases and symptoms—be suspicious. Some drugs are indeed used successfully for many different diseases, including methotrexate, the chemotherapy used on my sarcoidosis. But that's not why Dr. Petito prescribed it. He gave it to me because it's also medically proven to work specifically on sarcoidosis.

• *Lack of evidence* Frauds will cite anecdotal evidence, satisfied customers, and unpublished studies to back up their claims. When pressed, they'll often say that the establishment is threatened by their success. Now think about this for a second. Even if you believe the medical establishment is a vast gray conspiracy against the patient, it doesn't make any sense. Pharmaceutical companies spend a lot of money researching new drugs, because they *make* a lot of money from new drugs. Patients spend $25 billion a year on quack medicines. If any of these "miracle" cures really worked as claimed, legitimate companies would be racing to put it in a pill form to get a cut of that action.

When I go to sarcoidosis meetings, there are some people who think I've got all the answers because I'm the most visible person with the disease. (A woman once stood up at a sarcoid conference and said, "We were praying for somebody famous to come down with this." I said, "Maybe you should have prayed harder and you'd have gotten Julia Roberts instead of me.") Women especially flock around me wanting to know what treatments I've tried. How did I manage to keep my hair? Rogaine. I don't want to take steroids because I'm afraid I'll get fat—how did you do it, Duff? Watch

what you eat and exercise if you're the type who exercises (I'm not, I gained weight). And of course, they want to know if I've tried any alternative therapies. I most certainly have not. Then what's your secret? My secret, if you can call it that now that I'm about to share it with the public at large, can be summed up in one word: compliance. Obedience has never been my strong suit, but since I got sick I've complied with whatever my doctors have said, and I haven't gone chasing the mirage of miracle cures.

I'm not alive and thriving today because of magnets, or aromatherapy, color therapy, or tickle therapy. It's because of chemotherapy, steroids, morphine, and a lot of other pharmaceuticals. I'd rather be the last female on a Greek freighter than take a coffee enema while visualizing a pyramid made of crystals. High colonics have never killed anybody yet, but why take a chance?

At one point I came down with gastritis and got violently ill, which was dangerous because I couldn't keep down the anti-seizure medicine I was taking. At the same time, my husband caught a stomach flu from one of our godchildren. So I called the doctor, who sent over some serious antinausea medication. (John's doctor told him that children are "Petri dishes of disease." We now refer to all of our godchildren as "our little carrier monkeys.")

The only problem was that this particular drug can cause your eyes to roll back into your head like a cartoon character. Not to worry, though, the doctor also sent something to take care of *that*. So after I'd taken the antinausea drug, John came into the bedroom with the anti-eye-rolling medicine and a camera around his neck. He refused to give it to me until he could take a picture of me looking like a still from an *Itchy and Scratchy* cartoon. I liked that. The point is, I took the medicine, despite the weird side effect, because I knew it was the only thing that would help me.

A lot of my current treatment is what's now called "pain management," which is a euphemistic way of saying that without heavy drugs, I'd be in a lot of pain. I take 120 milligrams of morphine to get through an ordinary day. When the pain gets really terrible I can take something called amitriptyline. It helps, but it turns me into a Stepford Wife. (I once saw an episode of Law & Order in which amitriptyline was used as a date-rape drug.) My husband doesn't mind, but usually I'd rather be all there, even if it means a certain level of pain. But if I need it, I've got it, and I take it.

Some people have recommended acupuncture for the pain, but in the area of my spinal cord lesion, the nerves have been completely demyelinated. That means that their protective coating, the myelin, has been scraped away by the inflamed cells of the lesion. They're like turtles without shells. That makes them hypersensitive, which is why I'm in so much pain, and frankly I'm not about to have somebody poking around in there with a needle on the off chance that they might possibly do something positive. Imagine falling off a bike and having the worst road rash of your life. Then someone comes along and says, "I've got an idea. How about we pour lemon juice in your wounds? It'll make you feel better!" I don't think so. The truth is, the only thing that really works is to keep myself busy and distracted so I don't spend time focusing on the pain. (Because pain management is such a part of my life, I have made some exceptions to my overall rule of compliance. I know I'm supposed to get regular dental checkups and cleanings, but the idea of going to the dentist and subjecting myself to any more pain right now is completely abhorrent. I'll be doing denture commercials before I go under the drill again.)

I also get calls and letters from people telling me that Jesus will

heal me, if only I had a personal relationship with the Savior. I've got a great relationship with God already, and I'm pretty sure He's doing all He feels is appropriate. Somebody in a trailer in French Lick, Indiana, isn't going to change that. Neither are the faith healers who want me to come for a visit, or the man who wanted to heal me over the telephone (convenient, anyway), or the guy in Austin, Texas, who said he had the God-given power to actually pull the sarcoidosis lesion out of me (psychic surgery again—how can anyone believe this stuff?).

The latest alternative therapy craze is Chinese traditional medicine. Well, in China, doctors use Western medicine. For most of human history, medical science consisted of chopping off injured limbs, and bleeding you when you were already wounded. That's traditional medicine, too, but I don't hear anyone recommending that, though it would be just as effective as Chinese medicine— that is to say, not at all. For that matter, why is Chinese medicine supposed to be so great? What about the neglected traditional remedies from the Western tradition?

Traditional Western Cures for What Ails Me

According to traditional Western folklore, I'm Satan. A May baby is always sickly, and you should always be suspicious of sick people, because their condition is an insult to the natural order. I'm left-handed, which confirms that I'm evil, as do my dimples—they're the devil's hoof prints. Luckily, traditional medicine also offers some solutions for my many symptoms:

SEIZURES
Drink well water from a dead person's skull (just try finding a living person who'll let you do it!). Or, eat jelly made from any of the following: live earthworms, a raven's brain, a mole's liver, bear bile, or the excrement of a child.

HEADACHE
Tie a corner of a sheet that's been used to wrap a corpse around the head. Or, attach a sardine under each ear. Or, place a plucked magpie cut in two on your face. To prevent the recurrence of a headache, carry an odd number of small potatoes in your pocket.

SKIN ERUPTIONS
Eat a lizard. Or, urinate on a staircase (I recommend you do this at a friend's house, not your own).

GASTRITIS
Quell vomiting by drinking an infusion of St. John's Wort gathered at dawn on St. John's day. Or, swallow a powder made of toenail clippings.

PARTIALLY PARALYZED HANDS
Illness in the hands can be exorcised using the ring finger, which has healing powers.

DIMINISHED LUNG CAPACITY
Lung ailments respond to eating raw cat meat. Or, breathe the air of a stable.

Sometimes old herbal remedies really do work. Native Americans chewed willow bark for pain, and willow bark has a compound that's now used to make modern-day aspirin. In Greece, women still boil poppies to make tea for menstrual cramps, because poppies contain natural opiates (that's where opium, heroin, and my drug, morphine, come from). The use of maggots in the United States has risen 50% in the past year. Maggots eat dead and diseased flesh, but won't touch living, healthy flesh, so they're great at clearing out gangrenous sores and necrotic flesh that are resistant to modern medicine. Spider's silk stuffed into a cut is nature's Band-Aid, and it's sometimes used to make surgical thread, though I wouldn't want something that came out of spider's ass used in any type of dental surgery. And I don't know whether Gandhi was really doing himself any good by drinking his own urine, but pee does have medicinal properties. The urea is good for your skin; in fact it's an ingredient in many moisturizers. And there are at least two medicines made from women's urine. One of them, Pergonal, is made from the tinkle of menopausal nuns in Holland, because the risk of their urine being contaminated with STDs is presumably very small. It's true. Monks make beer, the nuns make water. It's like Perrier—the nuns are "the source."

Maggot Ranching

Chemotherapy makes me weak and nauseous. Steroids make me bloated and hostile. I now have acquired addiction to the morphine I take for pain. But at least I don't have to use maggots for anything.

Actually, I had the idea that if this book is a total flop,

maybe I'll become a maggot rancher, just get me a closet full of rotting meat and raise maggots for the wound-care business. (Isn't "wound" a creepy word, by the way?) "Duff's Organic Maggots," I'd call it. To make it profitable, though, I'd probably have to extend the brand. Maybe the maggots don't just eat the diseased flesh—maybe they also eat away the psychological and spiritual blockages that prevent the body from healing itself. Throw a maggot at a friend to cure the hiccups. Pet dogs and cats are proven to help combat depression—might a pet maggot help, too? Could maggots be used to cure bulimia in some way? Sure, why not?

If this book doesn't make the bestseller list, potential investors can contact me through my publisher.

But all of these traditional cures have been proven to work in the modern world by scientific testing—unlike, say, Chinese medicine. I mean, powdered rhinoceros horn for impotence? Does the rhino go limp after the horn-ectomy? I guarantee I'm twisting the knickers of 50 percent of the people reading this book, but when there's evidence that alternative therapies work better than placebos, I'll look again. Until that day, the only alternative experience I've ever had will remain introducing Pearl Jam videos on MTV.

Of course, placebos sometimes *do* help. The faith that you're going to be cured can help your body heal itself, which is why people who take alternative therapies do sometimes get better. And if you believe you're being helped, that can at least help your state of mind as you deal with profound illness, if not help cure the disease itself. But if you need to have a blind faith in the healing power of a treatment regime, why not place your faith in something that's also proven to work—Western medicine? That's what I do.

The ancients believed in something called *vis medicatrix naturae*—the spontaneous healing power of nature. In the same way gas expands to fill a container, or your clothes expand to fill your closet, or your hind end expands to fill the seat of your relaxed-fit trousers, nature is going to try and take over the void left in you by illness. I do believe your body has the power to heal itself, which is why we don't die of common colds. Whether you call that the immune system or *vis medicatrix naturae* doesn't matter to me. But there are times when your body can't handle the assault it's under. Sarcoidosis was a mutiny in my body—renegade cells attacked my spinal cord, lungs, eyes, and skin. *Vis medicatrix naturae* wasn't going to cut it for me.

Some people get a charge out of the mystical mumbo jumbo associated with many alternative therapies. I get my kick out of all the gleaming futuristic procedures I get to go through. When I get a GAD scan, and the doctors peer into my innermost workings with a nuclear illuminator, I think, Wow, this is truly modern medicine. I feel confident that this futuristic stuff, right out of science fiction as far as I'm concerned, is really going to do the trick.

Even regular doctors have bought into the New Age line about visualizing your illness. Anatole Broyard wrote that in another age, people were advised to go abroad for illness, not visualize good cells and bad cells. Now you're chained to your doctor and your treatment and advised to "Imagine your white blood cells as storm troopers mowing down rows of infected cells!" I'm not a goateed, alpaca-poncho-wearing, hairy-legged pacifist, but the idea of visualizing armies of machete-wielding Tutsis and Hutus chopping each other to bits had no appeal. If I was supposed to visualize the nice cells having a little intervention with the bad cells, taking them out for a pint and saying, Okay, let's knock it off, let's do the Rodney King thing and all get along, maybe I

could get into that. But if I were going to visualize, why waste prime fantasizing time on my boring ordeal with sarcoidosis? Bring on the dancing girls! I'd rather visualize riding on the bitch pad of Al Green's Ducati with a bottle of Jameson's in one hand and the other wrapped around Reverend Al. Or winning the Booker Prize. Either one.

I can't stand the New Age knuckleheads who say piously, "Everything happens for a reason." If I had a dime for every time I've heard "Everything happens for a reason," I'd be on my way to Paris in a private jet for dinner at L'Ami Louis. Right now, there is no known reason for my getting sarcoidosis, no cause to blame or explain. That's the way life goes sometimes. Experiencing severe illness pushes some people to make changes in their lives that turn out to be positive (as I did), but people don't get sick as a warning that they need to make positive changes in their life. When alcoholics get cirrhosis or smokers get lung cancer, the message is "you drank too much" or "you shouldn't have smoked those two packs a day." We know the medical cause for those diseases, so you don't hear anybody mooning about some mystical "reason" for the illness. Nobody knows exactly what causes breast cancer— what's the message there, New Agers, what's the reason? That one in nine women are receiving a message from the Great Spirit to get in touch with their astral soul? Bunkum. I don't think I even need to comment on the saying "Death is nature's way of telling you to slow down."

And I'm aghast over the New Age morality that implies that only the poor bastards that fight the hardest against their sickness will eventually kick it, or that it was something internal that brought on the disease, whether it was stress, or imbalanced chakras, or whatever. It's all just a moderately sophisticated way of blaming the victim, and that's cowardly, the last refuge of the pathetic. When people suggest that overwork brought on my sar-

coidosis, I always say, "I've seen hard work. It's a tiny Dominican woman wrestling a 225-pound invalid into a bathtub. Modeling is not hard work." As for the idea that I brought my illness on myself, why on earth would I do that when I was at the top of my game and loving life?

I understand why these notions are comforting. It's easier to distance yourself from the fear of sickness if you subconsciously believe that I or any sick person somehow brought their illnesses on themselves, and that it's possible to avoid making those same mistakes. Similarly, if you believe that the source of healing is solely internal, then you don't have to worry about the high mortality rates when you get cancer, because, dammit, you're going to be the one who fights harder than everyone else! People want to construct a narrative of their lives that leaves out illness and death. Well, I've got bad news. Illnesses aren't too interested in your little stories.

Guess the Alternative Therapy

Many of the alternative therapies I hear about are too ridiculous to be believed. See if you can guess which one of the following ludicrous-sounding alternative therapies is actually practiced by hucksters and the people they've fooled.

A. Earth Immersion Therapy: Subjects are sealed into a wooden box and placed under large quantities of healing soil. Practitioners claim the emanations from Mother Earth will eventually cure any disease, if the patient remains in the box long enough.

B. Inner Ear Correction: When the sense of balance is out of alignment, we feel physically and emotionally weak. Patients take syrup of ipecac and spin rapidly on "imbalance correctors" until the point of nausea. Afterward, healers massage the temple to realign the sense of balance.

C. Castor Oil Therapy: The patient places an oil pack onto the afflicted area and applies heat. Effective for gastrointestinal and genitourinary disorders, including maladies of the kidneys, stomach, abdomen, and intestines.

D. Animal Transference ("Pet Peeve" therapy): Animals have a special ability to help humans heal physically and psychically. Venting problems on your pet can help restore balanced health. However, "cold" pets—lizards, amphibians, birds—may reflect the negative energy back at you, causing complications such as allergic reactions.

Answer: C is the therapy some people actually practice. But expect the other ones soon from a shaman near you.

14

Un Couple Malade: The Marriage of Patient and Doctor

When Dr. Petito first examined me, he immediately suspected that my lesion might have been caused by sarcoidosis, and he told me, "I have never lost a patient to this." To me, this sounded like a good doctor. He communicated his optimism to me. He had a sense of humor. People choose and recommend doctors based on a good bedside manner over clinical expertise, or vice versa. Dr. Petito has the excellent combination of both.

Your relationship with your doctor is deeply intimate. You're trusting him or her to assist you with monumental decisions about your health. Yet health care is one of our blindest purchases. When

you're rushed to the hospital in a meat wagon, they don't take you to the best one—they take you to the nearest one. A lot of the medical decisions I've made have come when I've been in a state of crisis, in a frame of mind that's not going to last.

There's no way around that in an emergency, unless you have a friend or relative with you who has the fortitude to think clearly, assuming you have the sense to listen to them in that moment. Even if you have the luxury of good health, the time to reflect, or both, we often pick doctors for reasons that have nothing to do with medicine. Often people choose a primary physician by figuring out which doctor who takes their insurance is nearest to their home or office. Most people don't shop around even if there's a choice.

When you're chronically ill, unless you're really at the end of your rope, most of your treatment will come as an outpatient. You will have some choice of facilities and doctors, and choosing them becomes of paramount importance.

My approach to choosing a doctor can be summarized in one word: mojo. I want a doctor who has a certain aura of competence and healing, one who inspires in me the confidence—and even certainty—that I'm being well taken care of. I want a doctor with good medicine, good juju, positive vibrations, whatever you want to call it. And ideally I want a name doctor, one who's known in his field, so I can play the charade of not being so helpless, the comforting fantasy that I'm on top of the situation because I've got the *best*.

Referrals from friends or other doctors are a common way to find a doctor with the right specialty and track record. Just because someone else says a particular doctor is good doesn't mean he or she *is* competent, or right for you, but it's comforting to know that they come with prior approval of some sort instead of being assigned to you by chance or chosen randomly from a

directory of "service providers." When my father-in-law fell off his horse and suffered a grievous injury to the head, the most welcome calls we received were from friends who recommended brain surgeons. Not that there was anything wrong with the doctors who were already treating him, but when somebody gives you the name of a doctor who's somehow already proven himself to be good, that makes you more confident in his healing power.

In *Intoxicated by My Illness*, Anatole Broyard called this feeling about a doctor his "magic." He describes consulting with a doctor his friends had recommended to treat his prostate cancer. His confidence was bolstered when he met with the man and took in the wood-paneled room, the view from the window, the imposing desk, the photos of the man's children in yachting attire. Clearly this was a man who was successful, and how could his success not be a result of high proficiency? It all combined to reinforce Broyard's sense that the doctor had "good magic." (Then he discovered that this wasn't really that doctor's office, and his confidence plummeted.)

Anatole Broyard didn't mean he actually thought the doctor literally had magic powers. He was more cynical about the practice of medicine than I am, and to him feeling a certain ironic faith in his doctor was more important than his treatment. But when I read his book, I realized that I had similar feelings about my doctors. I believe that medical science will cure me, but having the cure dispensed by the right doctors is very important.

I'd started off with a great recommendation from Harvey Weinstein, and of course that made me feel good. If Harvey said Dr. Petito was good, I was sure he must be the best. When I met him, I was immediately impressed by his assurances that I wouldn't die. I'd met with many other doctors, some of them leaders in their fields, but in Frank Petito I felt I'd found a doctor with the "magic" to help me.

In case you're scratching your head because I spent the last chapter ranting against nonmedical cures and now I'm talking about magic, let me be absolutely clear: I don't think Dr. Petito is some kind of wizard. But he's a learned and compassionate doctor. He makes me feel confident that he can take care of me, and I've found that to be an absolute necessity. Call it mojo, juju, a magnetic personality, or just good bedside manner—he gives off an impressive air of competence. Dr. Petito and the other doctors I see have gone to medical school and understand the way the body really works. My need to have a kind of mystical confidence in their abilities is a complement to the fact that they know what they're doing.

I try to look as sharp as I can when I visit Dr. Petito. Usually I wear a short skirt and a pair of come-and-get-me shoes to his office in New York Hospital. ("Why don't you to put on a hospital gown and cover yourself up?" he said once, meaning even a sadistic backward robe was more modest than my street clothes.) If I look good and healthy, and he says so, it must *be* so, because after all, he's the one with knowledge to know the difference. I want him to have confidence that what he's doing is working. I want the entire floor of doctors to see that I'm doing well and add their assessment that I'm improving to Dr. Petito's. I'd love to be mistaken for a visitor, not a patient.

Dr. Petito understands my approach. He included some of my Almay print ads in my medical file, so other attending doctors can refer to a photo of me before I was sick.

As much as I believe in my doctors' competence, there's no such thing as an infallible doctor. It's important to retain control over your treatment and your relationship with your doctor, but it's hard, because there's an intrinsic imbalance. He has more expertise, he can decipher your medical information, and he knows what's wrong before you do. You wait for him, not the other way

around. It's his schedule, not yours. He's dressed, you're often nearly or totally naked. He's allowed to touch you, but you can't touch him (not and get away with it—trust me on this). You reveal the most private bits of your life, and he gives nothing away. You'll probably address him as "Doctor," but he probably won't use a title for you. The whole process gives the doctor all the power. But you can keep or get back some control for yourself, too. It may not be easy—you'll have to work at it. But it's better for you, and might make your doctor better, too. Besides, I believe it helps to remind doctors just who's paying who.

Rules I Wish Doctors Would Follow

1. No waiting. It makes patients hostile, and they start to suffer even before you begin to torture them. If the appointments are backed up, don't use the Pinocchio time clock. There's a big difference between being promised a table at a restaurant "in ten minutes" and getting the same fib from the receptionist at the doctor's office.

2. Be gentle.

3. Express your emotions. Show sympathy.

4. If you have bad news, spit it out.

5. Don't lie. I know it'll hurt worse than a pinch or a sting.

6. Don't tell me when you're about to stick the needle in, or count down to the rectal invasion. You're interfering with the important process of distracting myself from what's going on.

The doctor-patient relationship is a long-term commitment, and it's best to establish some ground rules right off the bat. The first is that you have a right to know as much as you want to know. An examination is nerve-wracking, so prepare a list of questions and concerns so you won't forget anything. Write them down, and bring a note pad so you can jot down the answers and any new questions that occur to you. You can bring a tape recorder if you want, though some doctors will get jumpy because they regard a tape as lawsuit fodder. Ask your doctor if there are any important questions you haven't asked. And if you're too nervous, bring a friend or relative to the exam who can help you get the information you want. A third party may be better able to understand and question the doctor than you'll be if you get bad news.

It can be difficult to encourage some doctors to be forthcoming. Most of them are used to feeling pretty infallible, and for some, any question might seem like you're really questioning their authority and skill. You don't have to stick with a doctor you don't like, but don't change immediately, especially if you think your doctor is good in other ways. Surprisingly few patients take the time to really engage their doctors, and I think many are just rusty on the social niceties. Remember, the last time your doctor had to answer so many detailed questions was probably when he was an intern, and some jerk of an attending physician was trying to expose his ignorance.

If you want your doctor to give your questions and concerns a fair hearing, proceed with the assumption that he knows what he's talking about. Again, I'm not saying you should trust any doctor blindly, but try to give the same respect you expect in return. Don't forget that any information you've discovered may be out of date, or you may have interpreted it incorrectly. If it's off the Internet, your "facts" might be completely false. (There are some good, factual sarcoidosis sites on the Net, as there are for other

diseases, but if you're in any doubt about the information, stick to what the Web does best: pornography.)

I know all this might seem tough, especially when you may have all you can do to deal with the physical and emotional aspects of illness to begin with. Negotiating a relationship with a doctor may not seem high on the list of priorities. But trust me, it'll make a difference to your care if you make the effort.

When I go to my internist, I go to the bakery and get a bunch of pastries. Then I can say to him, "Hey, I got you cannolis at Rocco's!" And he says, "Oh, my favorite!" and the focus isn't on the fact that he's examining me so intimately that he's practically behind me, but on the fact that we both love cannolis. It puts our relationship on a human footing, so if we need to discuss a problem, it'll be on a more empathetic level. I'm not saying you have to bring your doctor Italian pastries—maybe you can't afford to, or maybe he just doesn't like cannolis. But I am saying there's a way to approach your doctor that will encourage him or her to treat you as an equal, not as a guinea pig. I've heard of women who draw a smiley face or write messages for the doctor on their bodies with a marker—the effect is the same. I think my medical team treats me as a patient, not a disease, and I don't think that's an accident.

It's amazing how much control you can have even over medical procedures if you take the trouble to assert yourself. If you need a lot of blood tests, ask to have them combined into one big blood draw, to avoid repeated punctures and to postpone the inevitable flight of your abused veins deep inside your arm. If you need a spinal tap or some other potentially painful procedure like a liver biopsy, ask for IV Valium. Some doctors will say, "Absolutely not, this isn't that painful." Just tell them, "Well, if it's not going to hurt, I'll get it done somewhere else."

When you're faced with chronic illness, your treatment may become a full-time occupation, so try to manage your relationship

with your doctors like a business. The business goal is to provide the best health care possible. If you know anything about current management practices, you'll have realized this means that doctors and patients have to work as a team.

For many people, the most basic way you'll have to form a team is by getting a second opinion, which you should always do when the diagnosis or the proposed treatment is serious. Don't just go to see another doctor; ask both of them to discuss your case. Their shared perspectives will help them diagnose and treat what ails you, and it'll probably make them think more about your individual case and its peculiarities, if any. If you like, get a third or fourth opinion and have all your doctors talk to each other. They should do this on their own, and many will. But in the era of managed care, with its limits on how much time doctors can spend on each patient, it's best to make sure.

Don't worry about hurting your doctor's feelings by getting a second opinion because it seems as if you're doubting his competency. Any doctor worth his country club membership will be open to a second opinion. If he's not, that's a sure sign that you definitely need a second opinion and maybe a new doctor.

If you're pursuing a diagnosis, or need treatment by many different doctors at the same time, you'll need a "team captain," a doctor who coordinates all the information and treatment. For the most part, my "team captain" is my neurologist, Dr. Petito. But at other times, depending on what's going on, it might be my therapist or my gynecologist. It's up to you to put the team together. I need to say to Dr. Petito, "Please call Dr. Auchincloss and explain the medication I'm on." Or to Dr. Auchincloss, "Can you call Dr. Nelson and ask about the side effects of methotrexate?"

I don't try to second guess my doctors at every turn, or even keep track of the details of my disease, but I feel I'm in charge of the process. Sometimes I have to give in and let my doctors take over when there's an emergency. But when I'm able, managing my team of doctors, letting them know how I want to be treated, and getting second opinions if necessary puts me in charge of the medical process, which I think is healthier than feeling helpless in the control of the doctors.

If you feel that your doctor isn't listening to your concerns, doesn't promptly return your phone calls, or keeps you waiting an excessively long time, it might be time to dump him. I could give you advice on how to pull yourself together, screw up your courage, look your doctor in the eye, and tell him that your days as un couple malade are over. Well, this isn't that kind of book. Give yourself a break—you're sick. You don't have to be perfect and face every single challenge. Instead, here's a coupon that will accomplish the same thing with minimal emotional distress.

CUT ALONG DOTTED LINE

Coward's Coupon

Dear Dr. _____ ,

I am changing doctors. Please send my medical records

to _____ .

Thank you,

15

No Finnering in the Waiting Room

Even if you've had the time, ability, and luck to assemble a team of doctors who care for you in the way you want, you'll have no choice about the support personnel you deal with—everyone from receptionists to orderlies to janitors. I've been navigating the medical system for so long that I feel I have a responsibility to help other people do the same, especially when it's impossible to say, "I'd like a different charge nurse, please."

When I'm in the waiting room at a hospital or doctor's office, I try to lead by example. There might be thirty other people waiting anxiously to see a doctor. Many of them are probably sicker

than I am. If I'm dressed up and look healthy, maybe it will inspire confidence in other patients that their doctor, my doctor, is doing a good job.

I dress for my hospital outpatient visits the way travelers used to dress for airplane trips forty years ago. My brother says that these days, Americans in airports look like fat giants clad in pajamalike jogging suits, with athletic shoes the size of Easter hams punctuating their squishy, unathletic bodies, but I don't dress that way to travel and I don't dress that way for the hospital. I slap on makeup, style my hair, and wear a suit or skirt. My goal is to look well enough to be an inspiration to the people in the waiting room.

Some of these people, on top of being wound up about their illness or their grandmother's, have maybe driven in from New Jersey. They've been honked at and cursed at, they've spent sixty bucks to park their car, and since they paid the toll on the George Washington Bridge, no one's been nice to them. I don't want to add to the unpleasantness of going to the doctor in any way, so I practice patience. I don't succumb to "waiting room rage" and blow my top if I have to wait. I bring needlepoint or a book and wait quietly, and I hope that if I'm not helping to lessen the tension, I'm at least not adding to it.

I Was So Mad, I Pulled a Finneran

A few years ago, a businessman named Gerald Finneran was flying home, when he succumbed to "air rage." He'd been drinking more than was necessary, and he went stir-crazy in the first-class cabin. He loudly demanded more alcohol, and when he was refused, he assaulted a flight attendant. Then he climbed on a drinks cart, dropped his pants, and moved his

bowels with malicious intent. After wiping himself with linen napkins, Finneran tracked feces through first class.

Finneran was fined $50,000, but I think he got off too easily. As added punishment, I think that whenever people get irrationally, insanely angry, instead of calling it road rage or air rage or even waiting room rage, we should refer to it as "pulling a Finneran," or "Finnering."

Because of the heightened emotions around going to the doctor, the receptionist in the waiting room is often the target of sick people's bitterness. So I make an effort to treat Sherri, Dr. Petito's receptionist, nicely. She can seem a little intimidating, but I know she loves movies. Every week when I come in, I say, "Sherri, what movie can you recommend for me?" If I have extra tickets to a movie premiere, I give them to her. I hope that talking to Sherri like a human being will help her be a little more easygoing with the next sick, frightened patient who doesn't know they're not supposed to drink coffee in the waiting room. And maybe that dialogue will help the other people in the room to view Sherri as a sympathetic character, not a malevolent agent of the faceless hospital bureaucracy. (Plus, it might be rewarding for the patients to be nice to Sherri. One day when I came in, she said, "Duff, I just went to this spa and I loved it and I thought you would, too. I bought you a day of beauty." I don't know how much she makes, but I'm guessing it's not that much. I was incredibly touched. It's definitely one of the top all-time deeds of generosity ever performed in a hospital.)

Leading by example extends to basic courtesies, too, like holding the door for the more infirm or the elderly. I once saw

an old woman who must have weighed all of a hundred pounds trying to navigate a revolving door. A perfectly healthy sniveling little cad whipped through with no regard for her, and she shot out, hit the floor, and broke her wrist. (I once heard about an electric-powered revolving door in a Spanish department store that seemed to speed up whenever nuns and priests entered the store. After a few people were injured, the Church performed an exorcism on the door, but it didn't work. Eventually the store discovered that a vengeful Muslim security guard turned up the power whenever he saw a man or woman of the cloth approaching.)

I always see fully healthy men pushing to get into the elevator ahead of people whom decency demands should go first. I don't confront these people, but I make a point of holding the elevator door for old people and anyone who seems at all sick. I hope that'll make the jerk who's repeatedly stabbing the "Door Close" button think twice the next time.

The way you deal with being an outpatient is different than the way you deal with being in the hospital. Being an outpatient is more fun—you can walk in and walk out, and return to your sort-of-normal life. But you still have to confront the actual medical procedures. In a way, I think they can be more upsetting as an outpatient, precisely because they come in the middle of an otherwise regular routine. My advice is, do whatever you need to do to make the experience more comfortable for yourself.

I don't like getting MRIs, not because they hurt, but because I'm claustrophobic and for this test I'm encased in a huge machine with the wall only inches from my face. I know that Edna Hung, the MRI technician who slides me into the gleaming white tube, loves country music, so I gave her some of Dwight Yoakam's CDs and a couple T-shirts. From then on we had a leveler, something to talk about besides how I'm doing. Medical per-

sonnel see really sick people all the time, and I think it's easy for
them to turn off to individuals. I always think that if I can some-
how elevate the experience and have some common ground with a
fellow human, it'll make the experience better for me, and maybe
better for the next patient, too.

Unfortunately, getting to know Edna only made the time
before and after the procedure more pleasant. The small enclosure
creeped me out, and I just kept my eyes slammed tight to take
myself away from the reality. Finally, though, I hit on something
that made me feel a little better. I realized that for an hour and
twenty minutes every two months, I have a full understanding of
what a veal crate is like, except without the flies. As soon as I get
released from the big white tube, I go to Chez Brigitte for the
world's best veal ratatouille sandwich. Giving myself something to
look forward to after being penned up in the MRI machine makes
all the difference.

Outpatient Tips

• When you call your doc for a prescription refill, have your
old bottle of pills in front of you. Read the name and
dosage and remind your doctor about any other drugs you
are taking. Don't take it for granted your doctor will
remember every pill you take, or any recent changes in your
condition or medication.

• Always keep a list of your meds in your wallet and another
next to your bed, and give one to all the people in your life.
If I get hit by a car, or anything happens so that I can't com-
municate, someone will be able to pass on the informa-

tion that I have sarcoidosis, what I take for it, that I have acquired morphine addiction, and so on.

• Write things down. Don't expect to remember every random question that pops into your head when you're in the doctor's office. Also, some medications may make you forgetful. I find jotting down notes on just about everything is extremely helpful.

• Half of all doctor's visits last less than eleven minutes. Don't wait until your doctor has his hand on the doorknob to ask him the big questions. And don't ask questions while you're undressed.

• Doctors are trained to deal with delicate situations. You're not the only one with your condition, you're almost certainly not the first case your doctor has seen, and you definitely won't be the last. Don't be embarrassed by your symptoms. Doctors take an oath of confidentiality, and it's against the law for them to blab anything. There's no open mike night in the doctor's lounge where they joke about your problem.

16

I Love My Sarcoidosis!

Grace under pressure has never been my strong suit. My specialties are overreacting and sweaty panic. George Clooney says that it isn't the most talented actor who gets the job, it's the one who exudes the most confidence (easy for him to say, I guess), and I'd always managed to project self-confidence at casting directors and studio executives despite my butterflies. I'd tried to give off the same aura when I re-entered the worlds of work and dating (which, if you think about it, is not unlike auditioning for a role). The results weren't necessarily encouraging. I got jobs, I went on dates, but nothing was as satisfying or exciting as it had been

before I got sick. Despite my attempts to conceal its manifestations and overcome its limitations, somehow the sarcoidosis seemed to color everything I did a dull shade of gray.

I'd thought my dream was in reach at the moment I got sick, but it was already behind me, thrust away by the unnoticed lesion developing in my neck. My life and my career were like this sleek jet that I'd built, and just when I was ready to take off I had to put it back in the hanger and redirect my energies. Like maybe I'd need to build a bicycle instead. And I hate to exercise.

I often wondered, Do I have a future? Sometimes, I was sure the answer was no. So I'd just try to outlive the milk in my refrigerator. I'd hunt in the back of the dairy case for the ones with the longest expiration date, and I discovered that New York grocery stores seem to be the national dumping ground for nearly expired milk. Then I started buying Parmalat, which lasts just about forever. I like to keep raising the bar for myself. I love a challenge.

Something inside me had broken apart. My former self had been irretrievably shattered into thousands of pieces. Try as I might to glue them back together, I knew that whatever reconstituted version of my old self I ended up with could never be better than a cracked, imperfect assemblage, a constant mocking of my former successful individual self.

I had to recover what pieces of my old way of life I could, and invent a lot of new ones, and I didn't know if I'd be able to. My life as a healthy person was preserved in the amber of my memory, something I could look at and ponder but could never touch. What now? I thought. Would I be left an empty husk of a person, shattered and bereft? Or would I be able to make what the poet Reynolds Price called *A Whole New Life*, despite my malady? The answer I always came up with was a resounding "Maybe."

Dr. Elisabeth Kübler-Ross has described the stages of emotion that most people facing death go through: denial, bargaining,

acceptance, and so on. Based on my own experience, I think there are stages of dealing with serious illness just as there are in dealing with death, which isn't so surprising when you think about it—you could croak, after all.

Shock is the first one. I couldn't process the fact that I was sick. Everything was going so well that it simply seemed out of the question that I was ill. I told myself, It's not that big a deal, just another bump in the road. I'll shake it off and move on.

When you run into a friend, and you're asked how you're doing, you always say "fine." When you contract a major illness, this simple exchange takes on a new dimension. I continued to say, "I'm fine," because I still couldn't believe I was sick.

Then, when it dawned on me that yes, I was indeed sick, shame set in. I experienced an illogical embarrassment about being sick, as if I'd brought it on myself, and that people might look down on me if they knew I was ill. I was at the top of my game, in the best shape of my life, I had more job offers than I could possibly take, how could something like this happen? What had I done wrong? I felt weak. I was very apologetic to my parents. I felt I'd failed them as a child. I was ashamed because I didn't know how to be a sick person, and I was afraid I'd do the wrong thing somehow. I couldn't face my friends because I couldn't face myself. I was embarrassed that I'd lost my mobility and my happy-go-lucky attitude. Shame was more crippling at this stage than even the physical effects of being sick, which were considerable.

Michael Nesmith once said to me, "Some people are insecure, some people have a big butt, some people wet the bed until age twenty-five. You have a lump in your head. Big deal." (Actually, this would have been more comforting if I hadn't wet the bed until age twenty-five.) I repeated this to Michael Moore and he commented, "Everybody's got something wrong with them, but at

least you know what yours is. I've got tons of stuff wrong with me, I just don't have a name for any of it." They're right, but in the shame stage I was far from being able to internalize that.

Next came fear. I wasn't so much afraid of death as afraid of what living with disease might do to me. The smelly, sinister vapors of the nursing home lingered in my olfactory memory and prompted fears of incontinence. I loved to travel, and I was afraid I might be homebound forever. I was afraid of loneliness, of never finding an entertaining, cool, loving husband because I was damaged goods, of maybe having to scrape the bottom of the man-barrel just to stave off solitude. Fear of failure also struck me hard—when had I ever failed at anything? Then I remembered most of the movies I'd been in, and realized I'd already successfully dealt with failure. I feared never being able to do everything that I like—kayaking, volunteering at the Village Nursing Home, wearing my red man-trap dress and love-me-do heels.

Finally, I don't think you ever *accept* being sick, but there's a kind of Stockholm Syndrome that sets in. In 1973, a group of people were taken hostage during a bank robbery in Stockholm, Sweden. When they were finally released, police discovered that they'd become sympathetic to their captors. The former hostages raised money for the defense of the bank robbers, and one woman got engaged to one of the crooks. Since then, psychiatrists have realized it's a common reaction in hostage situations.

Something similar happened to me when I got sarcoidosis. My biochemistry had been taken over by terrorists, and since negotiations on releasing me had failed, I had to learn to live with them somehow. Sometimes the terrorists kept me locked up all day, and some days they relaxed their grip enough to let me out for a little fresh air, and I was glad for the opportunity instead of cursing the time I was held captive in my bed. When the little Osama Bin Ladens attacking my nervous system arbitrarily decreed that today

I was too sick to move, I tried to read, or at least lie in bed and think up weird inventions, just as real hostages play mental chess or write long imaginary letters to their families. And I managed to reach a sort of accommodation with my captors.

I'm not the type of person who's angry or bitter. I'm a lover, not a fighter. I can nurse a grudge just fine—I've got Irish Alzheimer's: I forget, but I don't forgive. But I don't have a grudge against my disease. Gradually, I learned to love my sarcoidosis, because an enemy can defeat you, but a loved one can't. I came to feel about sarcoidosis the way I'd feel about a brother-in-law: I know I have him, I love him, but I don't think about him every day. Sometimes he comes to stay on the couch for a while and raid my medicine cabinet, which is annoying, but I can live with it.

Sarcoidosis has become so much a part of my life and identity that it makes me a little nervous to contemplate what I'd do without it, just as hostages suffering from Stockholm syndrome miss their captors when they're set free. When I first got sick, I had to got to a doctor almost every day, and I talked to Dr. Petito every morning. Now that I'm less tied to my treatment, I sometimes get a weird kind of separation anxiety. I want to get better, but I'm so used to being sick, and now that I've finally found a way to deal with it, I might as well *be* sick. Getting better could be as much of a radical adjustment as getting sick in the first place, and there's already been enough turmoil in my life.

Maybe that sounds strange, but I think I had to get comfortable with sarcoidosis before I could really live with it, as opposed to just suffer from it. Once I'd come to terms with my illness, I got past mourning the person I had been and I was able to figure out who I'd become.

Sick Joke

A few years ago I took a road trip to Santa Barbara and Palm Springs with my friend Lynn. I've mentioned how much I adore Frank Sinatra, and I wanted to visit towns where Frank had a home. Frank's fourth wife, Barbara, seemed like the charitable sort, and it was my goal to cruise thrift shops in hopes of finding a golf shirt monogrammed with the initials F.A.S.

On this trip we decided to forgo packing any luggage. Part of the adventure was that I was responsible for dressing Lynn and vice versa, and we could only shop at the Salvation Army or flea

markets. We purchased two outfits per day, and we weren't allowed to spend more than $5 an outfit.

I dressed Lynn as a trampy, heavy-metal vixen in short-short cut-offs, high heels, and a selection of T-shirts, tube tops, and halters. Some of the shirts had welcoming greetings spelled out in glitter across the chest: "Wine 'em. Dine 'em. 69 'em." "Save a tree, eat a beaver." "Eat at the Y."

In retaliation, I was costumed as an insane matron adorned with dashikis, muumuus, pill-box hats, and cat's-eye sunglasses. (I didn't realize they were corrective lenses until I got behind the wheel and almost drove us off the road.)

We had no luck finding any of Frank Sinatra's old shirts, but in Palm Springs I said to Lynn, "I think the Betty Ford clinic is right around here. Let's try to sneak in." I figured that in lieu of Sinatra cast-offs, a few souvenirs from "The Betty" would do nicely.

We drove up to the gate, and I pointed to Lynn, who was dressed in a used Hooters waitress uniform, and told the guard I was checking her in. He waved us through.

I've known Lynn since she was in the fifth grade, and I feel like I raised her from a pup. Still, there are lines that she won't cross even for me. When she wouldn't drag her keister out of the driver's seat, I had to go into the clinic alone.

"Hi, my name is Lynn Fisher and my brother-in-law was here, and he's an inch away from falling off the wagon. He asked me to stop by and pick up a book at the shop," I said. I didn't even know whether they had a gift shop; I figured at best I'd nick an ashtray from the lobby when the guard wasn't looking. But to my surprise, he gave me a guest pass and directions.

The gift shop at the Betty Ford Clinic is amazing. Apparently people love it so much that they really want to remember their stay with a whole array of knickknacks, though I must say, I've

never seen any on display in anyone's home. I grabbed an armful of sweatshirts and T-shirts that said "One stay at a time—the Betty Ford Clinic" as gifts for all my friends, and I was about to pay for my armful of souvenirs when the security guard walked up and busted me. "I thought you were here to buy a book," he growled. I grabbed the first one I saw, a little volume called *Stinkin' Thinkin'*, and beat it on out of there with one book and $700 of assorted shirts. (Incidentally, another great place to buy presents is the Hazelden clinic in Minnesota. If you're not in the upper Midwest area or near one of its other locations, call 1-800-833-4497 and they'll send you a catalog. I bought my manager Peg a graduation ring that says, "One step at a time." She likes to wear it when we drink whiskey together.)

That night, as Lynn and I lounged around the hotel room in our matching Betty Ford sweatshirts, I took a look at the book I'd bought. I came across this little gem: "You become what you think about the most." There I was, being a wise-ass, doing my Christmas shopping at the Betty Ford clinic, and I dredged up an AA book that taught me what I later realized was an invaluable lesson.

Accepting that I had a debilitating illness wasn't the same as realizing I was still a vital person with a lot of life left. (At least I hoped I had a lot of life left.) In the first year of my illness, I'd had to confront and accept the fact that I was grievously ill. Before I got sick, it was essentially my moment, my turn to fly while the window was open. I knew, or I thought, that if I'd been healthy my career would be rocketing. I was evaluating myself by what I had done, and all of a sudden I couldn't do anything. I didn't realize I'd judged my self-worth so much by my achievements rather than my character.

I want to be clear about where I was emotionally. I'd come to terms with being sick, but that was all. I accepted that I was ill

and that I had to deal with it and that it wasn't going to go away like a bad cold. I was living *with* illness, but I wasn't living beyond it. In the terms of that AA book, I'd thought of myself as a model and actress and correspondent, and that's what I'd become. When sarcoidosis knocked those out of my life, I only had my illness to think about, and being sick became my whole identity. And when your horizons are limited by disease, it's a sad and boring world.

Anatole Broyard, who suffered through prostate cancer, urged anyone who becomes sick to develop a style for their illness. In a nutshell, he says that the key to surviving illness with your sanity and self-esteem more or less intact is not to fall out of love with yourself, even though all these creepy things keep happening to you. As the illness attempts to diminish you, destroy you, or distract you, you've got to rely on your style to help you to divert it, defeat it, and transcend it in order to continue loving yourself.

When I read his advice, I realized he'd crystallized some things I'd felt for a long time. I developed a style to make the best of what was happening to me, because I wouldn't have survived without one. I don't take my illness too seriously. I make fun of it. I deflate it by laughing in its face. It's not a style in the sense of how to dress and carry yourself, although those, too, can be part of an "illness style." A good synonym might be "strategy," except that the word is too cold to describe something that's about being as alive and vibrant as possible.

Sir John Wheeler Bennett, a British historian, wrote that "Circumstances determine our lives, but we shape our lives by what we make of our circumstances." When sarcoidosis sticks an obstacle between me and what I want to do, I don't give up, or accept my limitations, or try to bull my way through. I work around the barrier while attempting to maintain my good humor.

This isn't a prescription for every sick person, though. Evan Handler, who wrote *Time On Fire* about his near-fatal bout of leukemia, had a style consisting basically of sustained rage. I loved his book, but I chose not to adopt his way of dealing with illness. I personally wouldn't advise you to develop a style of sullen, laconic resignation, but I'm not your mommy.

Marcus Aurelius, a Roman emperor and philosopher, wrote, "Put from you the belief that 'I have been wronged' and with it will go the feeling. Reject your sense of injury, and the injury itself disappears." I've rejected the sense of myself as an injured person. Even when I'm incapacitated, I don't think of myself as a sick person, but as a complete person who has to deal with the impact of an illness. I'm like a person with a long commute to a great job— I focus on the job, not the commute.

It's not just former rulers of the Roman Empire who've inspired me. Ray Charles helped inform my style, too. When Ray was a kid, one of his friends worked as a delivery boy for a grocery store. When the friend wasn't working, he let Ray use the delivery scooter, and he used to drive all over town. The townspeople of Greensville, South Carolina, were paying to send Ray to St. Augustine's School for the Blind, and some of them got upset, because how could Ray Charles drive if he couldn't see? He was tested, and he was blind all right, but he kept on driving that scooter.

Every New Year's Day in the 1990s, I trundled out to Coney Island on the subway and jumped into the frigid Atlantic Ocean with the Polar Bear Club. (I've got the certificate to prove it.) In the spirit of Ray Charles, I saw no reason to stop just because I was sick. I didn't want to stop enjoying life and taking some risks. It's liberating. If you're skating on thin ice, you might as well dance.

I guess you could say I'm a cheater Polar Bear now, since there are parts of my body that have very little feeling. Then again my

neck is hypersensitive, so I think it all balances out. I'm already battling constant discomfort with heavy-duty drugs, but the nipple-stiffening, ball-shrinking icy-cold water is a discomfort I've chosen, not something that happened to me.

There are some things I won't do anymore, though. I used to keep a motorbike at my summer home on Shelter Island, and I'd tool around at high speeds, frightening the locals. I gave it away, though. My hands and feet are still a little numb from the lesion in my spinal cord, and I didn't feel I had the control or grace that Ray Charles had.

Sometimes having a style isn't so much about bold celebration of the indomitable (or in my case, domitable) human spirit but about fending off despair. When all the medical signs are pointing to incontinence and a wheelchair, you really need a style. It helps you deal with those low points, when the charm of your own company has worn pretty thin, and there's an enema tube sticking out of your butt.

Not long after I got sick, I went to a salon to get my hair washed. I warned the guy, "I've got a lesion in my spinal cord, so you need to be kind of delicate." Of course, he wasn't paying attention and started in manhandling my head. I said, "Please, go easy, it's really hurting." "Listen, honey, how else am I supposed to do it?" he snapped. I wanted to slap the little weasel. I got up and left the barber chair with wet hair.

Even going to the hospital, where they're supposed be healing me, is a cold reminder that no one in this world is making any concession to my illness. There's a hot dog vendor outside the door, and when I walk out after a chemo treatment, the smell of fried onions and boiled mystery meat is like a punch in my already nauseated stomach.

Once, right after I'd had a chemo treatment, when I was feeling really low emotionally and sick physically from the drugs and hot

dog stench, I got robbed just after I walked out of the hospital. I was walking on a narrow sidewalk past a construction site, and this guy suddenly blocked my path and the guy behind bumped into me. I didn't realize anything had happened until a few blocks later, when someone pointed out my backpack was open. It could have been a really terrible moment for me, but instead I thought, You know what? This happens to everybody. Everybody in New York, anyway. You can't spend a lot of time wailing, Why me? I'm sick! The world doesn't change around you because you're sick. You're the one who has to make adjustments, including developing your own style.

The Chilly Girl Style

Whenever you see a skinny woman shivering in a Starbucks, holding her hands dramatically over her paper cup of herbal tea the way a normal person whose weight registers in the triple digits holds their hands out to a roaring bonfire, you're looking at a Chilly Girl. They're always cold, and worse, they're always complaining about it. Chilly Girls are chilly for three main reasons: first, they're too skinny—they've got no body fat to insulate them. I want to shake every Chilly Girl I see and shout, "You wouldn't be so cold if you ate something to sustain yourself besides the ice cubes in a Cosmopolitan!" Second, Chilly Girls are slaves to fashion. There are many distinguishing features of the Chilly Girl, but a real telltale is wearing sandals with no stockings during the months whose names include the letter R. Consequently, they wrap themselves in scarves made from endangered species, which I believe probably makes the source animal pretty damn chilly. Third, Chilly Girls are emotionally chilly as well. They take them-

selves and their clothes very, very seriously, and exhibit a terrifying absence of humor.

I went to a party at the new Hayden Planetarium recently, which would have been cool if it hadn't been so damn chilly. I felt like I was in Communist China, only instead of lumpy olive-green coats and olive-green caps, these lemminglike followers of fashion were all wearing the same slim-cut skirts, ninety-dollar French T-shirts, and stiletto sandals. But if there's one single time when spotting a Chilly Girl can harsh my vibe, it's when I'm walking back from the hospital after chemotherapy. I'm sick, but you don't see me complaining. Meanwhile, there's a Chilly Girl shivering over her green tea at a sidewalk café, despite the fact that it's August.

This is why I'm not a big fan of support groups. You need a lot of fiber to face a life-threatening illness, and I don't believe a room of sympathetic people is the best place to get it. It's like trying to build your biceps by curling a teddy bear. Face it, the world is not a sympathetic place—otherwise, why did you get sick in the first place? I have a lot more going on in my life than sarcoidosis, and I feel that some support groups can reduce your whole life to the one fact of being sick, as if the world will start treating you with kid gloves because of it.

Support groups are great for fundraising, and for gathering information and discovering resources. It's the open-mike night of pain and misery that makes me cringe. I'm not sure that enduring the bloody, uncensored nitty-gritty of other people's diseases helps anyone navigate the world outside that room. Maybe it helps the person who's venting, but I'd rather not know. No one is an expert about your experience except you, and the horrific

personal story of one particular person may have no relevance to your physical and emotional condition. And no matter how bad things are for any one person, I guarantee there's someone out there who's got it worse (except, I guess, for the worst-off person in the whole world, poor bastard).

Perhaps I feel the way I do about support groups because I have a network of informed advisors who help me plan my care, plan for the future, and give me the support I need. After all, not everybody has a movie mogul friend say they're going to take over your disease and produce it like a movie, or a sensitive, caring doctor like Frank Petito. And not everybody has a wonderful husband, as I do now, though everybody who's sick deserves one. (Well, almost everybody. I didn't feel that Mbutu Sese Seko, the former dictator of Zaire, deserved a loving companion when he was ill. And if Hitler was alive, and he got really sick, I'd say good for Eva Braun if she left him on the spot.)

I recently read about a ten-year study that showed that attending a support group increased the lifespan and quality of life for women with metastatic cancer. They felt linked by their common experiences, shared their emotions in a positive way, and encouraged each other to keep up healthful practices. I certainly can't argue with success like that, and I'm not discouraging anyone from at least trying a support group (if you look in the Resources section at the end of the book, you'll find some good ones). There's strength in numbers, and I do believe it's important to stay in touch with the community of people who share your disease. But support groups aren't for me. I felt that the group environment walled me off from the healthy world, in which I try to spend as much time as possible.

I know not every sick person agrees. There's a restaurant I like to go to that has a big bulletin board hanging on the wall behind the bar, with the weather forecast and other information spelled

out in movable plastic letters. At the bottom, there's a set of numbers that change every week. I once asked the owner, "Florent, what are those? Are they new area codes or something?"

He said, "No, those are my T cell counts." He has AIDS, and he posts the results of his tests every week so people can come in and see how he's doing. In a way, I guess he's celebrating his disease and his fight against it—that's his style of dealing with illness.

I admire him, but his style isn't mine. I'm not interested in my daily blood count or the results of the many other tests. To me, those are part of the world of the sick, not the world of the well. I just figure if it's bad, Dr. Petito will tell me. I try to talk to the disease through him, the same way if I have a problem with my brother-in-law, I talk to my sister.

Sometimes I'm asked if I'm frustrated that I don't know the precise cause of my illness, or what the long-term prognosis is, but I'm not the type of person to get troubled by it. I'm sick— that's more than enough information for me at this moment. That and the fact that so far, the treatment I'm getting helps me. No one knows what's going to happen to me, so why assume the worst? Why obsess over numbers, when no one can say for sure what they mean? Getting bogged down in the details would put me too much at the mercy of the disease, and—all together now—that's not my style.

Being sick is a very bloody, visceral experience, and I'm astonishingly squeamish. I can't sit through gore or violence on TV or in the movies because I feel sympathy pains for the victim. Hell, I feel sympathy pains when I see someone wearing black hose and white shoes. The only time I've ever seen a scan of my lesion was on television. *Dateline NBC* did a story on me, so I turned it on, all unsuspecting, and there was my nemesis. "Whoa, that's creepy," I thought. Then one of my doctors came on and started talking about just what a close brush with death I'd had—something he

hadn't yet told me to my face. I didn't like discovering this so long after the fact, especially when millions of strangers were hearing the same thing. I suppose I could have and maybe should have been told how serious the situation was, but on the other hand, knowing how grave my condition was wouldn't have changed the treatment or the outcome—it would have just made me feel a whole lot worse at the time.

If you're sick or close to someone who is, avoiding an intimate knowledge of your disease may not be your style. My sister Laura is the organized and motivated one in the family, and she did a lot of research on sarcoidosis when I first got sick. I ignored most of what she gave me, but I was grateful to have it because I pass the information on to other people who do want to know.

John did some research in the beginning, too, but at this point we both suspend our belief in the disease and try not to focus on the bad stuff. John and I know that when I can't tie my shoes or feel a key in my purse that things are getting bad. At other times, we give ourselves a reprieve from illness by not focusing on it too much.

I've got a lot of other things to do besides be sick, even if it is just reading the paper, or going for a walk, or visiting my friends at the nursing home. I'd rather do that than concentrate the bulk of my existence on my week-to-week blood counts, or worry about what might happen next—because it might not.

I've made the best of my situation in my own way, and in some respects my life is much better than it was before I got sick, but I can't escape a sense of loss. Despite my deepest fears, it's not my independence I've lost—it's my innocence. I never took anything seriously, from my career as a model to my relationships. I still try not to take anything too seriously, but that attitude doesn't come as easily as it did. I'm no longer able to ignore my own mortality hovering in the background.

I have a friend who's been diagnosed with amyotrophic lateral sclerosis (ALS, also known as Lou Gehrig's disease), and for a while now we've been planning to have a *Tuesdays with Morrie* bonfire. We've both received many copies of the book, and frankly, it stinks. We're not noble sufferers slipping into darkness. Nor are we hungry for the chicken-poop-for-the-soul New Age pap found in a lot of books about illness. Jen was advised to max out her credit cards and enjoy life any way she could: travel, junk food, expensive liquor. I was told I wouldn't be able to model or act any more. Well, Jen started Project ALS, which funds research into treatments for this as-yet untreatable condition, and I'm still working.

Jen once told me, "Duff, you've really inspired me. I'm gonna go out and buy a new dress and find a man who loves me as much as your husband loves you. I'm going to have a family and a new life." I said, "You're crazy, you're the one who inspires *me*." I guess what we see in each other is that we're both trying to live honorable and valuable lives. Just because we're dealing with chronic, debilitating illnesses, we're not using our misfortunes to coast through life. We're focusing on living fully and helping others do the same.

I can understand why people grasp onto books like *Tuesdays with Morrie*. They're a kind of script for a way to live with your debilitating illness, and for the people around you who don't know how to respond. Maybe that works for some people, but I don't want that role.

If you think of yourself as a weak, helpless, unattractive invalid, that's what you'll be. Develop a style for your illness, a flair. If you tell yourself you're a generous, honorable, honest person with a lucky streak a mile wide, *that*'s what you'll be. I've tried to be all those things, and I've never lost my sense of humor about the world and my illness.

Support Groups I'd Like to Join

I'm not a regular attendee of support groups, but there are organizations for just about everything that ails mankind, and I'm sure that I could benefit from some of them.

• *Restless Leg Syndrome Foundation* If only I'd known there were other people with this problem when I set the table on fire while dining with Richard Gere, maybe I would have been able to deal with emotional consequences in a more productive way.

• *Simon Foundation for Continence* Works to overcome the social stigma of incontinence—a tall order if you ask me. I don't like hearing graphic stories of pain and suffering, but listening to someone share their experience of public piddling might help my self-esteem.

• *Reynaud's and Cold Sufferers Network* People with Reynaud's experience numbness in their extremities caused by cold, and the Reynaud's and Cold Sufferers Network helps its members deal with activities like holding cold drinks and shopping in the frozen food section. I'd love to go to a meeting and hear tales of woe about Slurpee-related emotional traumas and the shame of not being able to go down to the bar and drink a frosty cold soda without spilling on the other patrons.

• *Selective Mutism Foundation* The poor unfortunates stricken with Selective Mutism can speak, but simply choose not to. For the life of me, I can't imagine what support groups for these people are like.

18

My World May Be Going to Hell, but I Want to Look Good for the Trip

It was difficult enough to come to terms with having a stinking chronic disease and feel agonizing pain for every second of my life. Realizing I was beginning to look the worse for wear was just one more hurdle for me to jump. At first, I didn't spend a lot of time worrying about the outward effects of sarcoidosis and its treatments, because my main concerns were about retaining my mobility and independence. But before long I had to deal with the inescapable fact that I was beginning to change.

When I started taking steroids, I quickly developed Cushing's syndrome, or "moon face." Simply put, I ballooned. My com-

plexion resembled that of an adolescent fry cook, if that fry cook had ash-gray skin and crow's feet into the bargain. The skin of my arm had been pierced so many times for blood withdrawal and drug deposit that I looked like the biggest junkie in Manhattan. (I used to tell inquisitive busybodies that I had a pet wolverine.) I was undergoing a pharmaceutical mutilation.

I never exercised before I got sick—I always chose withering over a workout. But extensive bed rest and a diet of steroids gave me the muscle tone of a raw clam. I'd always weighed somewhere in the healthy three digits, but in just three weeks of steroids I packed on twenty pounds. I was racking up some serious ass time on the sofa, and I started to look like one of the cushions. My body resembled the Venus of Willendorf more than Venus Williams. At first, gaining the weight wasn't such a big deal because I've always had a stocky, barrel-shaped figure, but thanks to the steroids my form was soon uninterrupted by a waistline. I wasn't too happy about it, but I figured a bigger ass was a small price to pay for feeling better.

Then my hair started falling out from the dual action of methotrexate and tegretol, an antiseizure drug. I could suck in my gut, wear a Lycra exoskeleton like some kind of oversized cockroach to control my butt, slather my raddled face with makeup, and wear long sleeves to cover needle marks. But hair loss was more transforming than any of the other physical defects—the final insult after the exhaustion, gray skin, and weight gain. I cursed every follicle that skipped town. I had so little hair I could comb my head with a sponge. At the same time, the hair on my face came out in force, as if to prove it was more loyal than the hair on my dome. I was the only Revlon perfume model who could have also convincingly shilled for aftershave.

I was used to people looking at me on the street, getting catcalls and wolf-whistles, feeling the eyes of the guys at the news-

stand. Now the only attention I got was the time some dope yelled at me, "Take a shower!" I didn't want to go out because I didn't want to experience those reactions. If I had to leave the house, I shlumped around in a jacket with the hood pulled low to hide myself from the unsympathetic world. When it was colder, I wore one of those winter coats that zips all the way up and makes kind of a snorkel in front of your face. One January day a guy called out as I passed, "Anybody in there?"

When you're famous, even moderately well known, you get recognized on the street a lot, and I thought I was used to scrutiny. I didn't pay much attention to the fact that I was sometimes recognized on the street. But as I got sicker and sicker, I couldn't bear to have people looking at me. I knew it wasn't because I was Duff; it was because I looked sick. I felt the gaze of strangers keenly at a time when I most wanted to be an anonymous face in the crowd.

Ever since high school, I'd gotten used to getting a little extra from men. I'd get away with late video returns, or the counter guy at the deli would give me a free coffee. Sometimes men sent drinks to my table or my seat on an airplane. Then I got sick and sicklooking, and I got nothing. I'd gotten used to the perks of being attractive without even knowing it, and it was a rude shock to realize people weren't so nice to me now that I looked like a hag. I'd never thought that I was that hot to begin with, not compared to Claudia Schiffer, anyway. But when sarcoidosis and steroids mucked up my features, and my looks got more in line with my self-image, I realized just how lucky I'd been. I could have been rented out to scare people out of hiccups. (Jack Mytton, a noted eccentric and hellraiser of the early nineteenth century, once set himself on fire to cure a persistent case of the hiccups. Though burned to a crisp, he was pleased with the results: "Well, the hiccup is gone, by God!" he exulted.) My future career appeared before my eyes: Professional Blind Date.

The open, uncensored stares of people who knew me before I got sick were even harder to take. When I'm in L.A., I always stay at the Chateau Marmont, and there's a room service waiter there who knows me well. When he first saw me after I'd started steroids, he couldn't help blurting out, "You look so different!" Once, in New York, I had to go to the pharmacy to pick up some medicine after a spinal tap. I was hobbling through my neighborhood, hunched over like Quasimodo with my knuckles dragging on the ground, wearing an old overcoat Dwight had given me that was several sizes too large. My hair looked like those dolls at the carnival—those sandbags with wispy tufts at the top that you get three chances for a dollar to knock over with a softball. Then I bumped into my old boyfriend Anthony. It was the first time I'd seen him since he jilted me five years before. Anthony said, "Duff, is that you?" I could see the horrified look on his face. I turned around and hobbled away, and I've never seen him again. I couldn't face him like that.

As for Duff the public person, I was hiding from the world and doing a good job. One time in November of 1995, after I started on steroids, I was sitting in a doctor's waiting room and the woman across from me was reading the *National Enquirer*. On the cover was a picture of me with George Clooney at the Emmys and the headline, *ER Hunk Dating MTV Beauty!* The woman never even glanced at me. I didn't look anything like that picture anymore.

From a detached, anthropological perspective, it was kind of interesting to see how people's reactions to me changed. Psychologically, it was reassuring to contemplate that even as my appearance changed radically, I was still the same person inside. But emotionally, it was humbling. For the past ten years, I'd made my living in large part with my face and figure, by embodying an image of youth and health. My youth was already behind me, and

now my health and looks were going, too. It was incredibly diffi-
cult to feel good about myself or my appearance in that state.

I'd never been particularly self-conscious. But chemo was whit-
tling off pieces of my self-confidence, and my mirror became a
torture device. I tried to address the loss of hair by procuring a
long black Cher wig from my local drag queen supply store.
When I tried it on at home, I discovered it was at least three sizes
too big for my melon. To keep it tethered, I secured the wig with
a brightly colored conical party hat with an elastic chin strap. I
carried a bottle of champagne and balloons around the house and
tried to imagine that I was an innocent partygoer instead of a
desperately ill woman.

Sometimes the unlikeliest things can help rebuild your confi-
dence; for me, it was discovering Rogaine. Yes, the very same hair-
growing drug that anxious middle-aged men use. It had never
occurred to me that there might be a drug to help me look better,
but minoxidil did the trick. (I once worked on a TV pilot where
one of the producers took out an atomizer at four o'clock every
afternoon, no matter where he was or who he was with, and misted
himself with Rogaine. All I can say about that is, I'm glad I didn't
encounter that behavior before I started taking the drug myself.) I
may have had a particularly good experience, but Rogaine worked
well enough to restore what at least *looked* like a full head of hair.

The unwelcome physical changes I experienced gave my self-
confidence a hard knock. But one of the liberating things about
life-threatening illness is that if things got much worse you'd be
dead. I was already bumping against the bottom, and I realized
that the opinions and judgments of other people made no differ-
ence to me. Letting go of other people's standards freed me to feel
good about myself and my looks on my terms.

I've read books on illness where the heroine is glad that as she
wastes away she can at least fit into her favorite jeans again, and I

heard that Helen Gurley Brown enjoys diarrhea because the pounds just drain away. Are these people mad? Health is what's important, not looking good as you die. Maybe I feel this way because I gained weight from my treatments instead of losing it, but I was happy just to be alive. So I lost my low-single-digit dress size—big deal. Henriette Mantel, a very funny comic, summed up this attitude perfectly when she said, "If I'm ever stuck on a respirator or a life-support system, I definitely want to be unplugged, but not until I get down to a size eight."

But it's not what you put on—it's what you put out. In the same way that I had to stop thinking of myself as a sick person, I had to stop thinking of myself as an unattractive woman, let go of that arbitrary size six that has such power over women's self-perceptions. In this case, style is what you make of the mug you were born with. Character is what chisels the face into beauty. Don't submit to a standard of beauty—define it, because if you believe you're a hot ticket, other people will, too. It's never too late to get wiser or better looking.

Adjusting to sickness isn't just a matter of making one or two changes, or trying to be more upbeat. It's a constant process of defining yourself against and in spite of the disease. I was always looking for a way to work around the fact that I looked or felt bad, or both. I had my style to rely on, but sometimes cracking jokes at the expense of my steroid-enhanced waistline got a little tired. I wore monochromatic outfits, and sometimes I'd try to stand on my tiptoes under the mistaken impression that it made me look taller and thinner.

You can't fool the camera, though. On one shoot, they had no dresses that were big enough to fit me. The stylist did a little radical surgery on the back, and I had to take all the photos head-on, because profile shots would have revealed the cut-and-stitch job. When I was in the same picture with Claudia Schiffer and Cindy

Crawford, who were not having the same problems I was, thank you very much, I had to reach desperately for my sense of humor to keep from dissolving in a steroid-fueled emotional breakdown.

After I got married, John taught me a valuable lesson about the physical changes brought on by illness and medication. (Of course, happiness is the best cosmetic, and I've got that in spades with John.) When my husband gains weight, he deals with it in a radical manner: No starvation diets. No bulimia. No cheese enema. He just buys bigger pants. Simple as it sounds, that was incredibly illuminating. I stopped wishing I was thinner and started wearing clothes that fit me, instead of trying to squeeze into something too small or wearing baggy khakis.

From the very beginning of my illness I was confronted with the barriers that sarcoidosis placed between me and intimacy. Even when I looked good on the outside, I knew that inside me something was very wrong. Frankly, it's not great date conversation.

Let's say you're seriously ill, but you're still feeling physically okay, so you decide you're gonna test the waters. You have a great couple of dates with this guy, and you want to have him up for, you know, a martini or something. How do you explain the pill bottles scattered around your apartment? Trust me, it's a mood-killer. Well, that was me in the first throes of being ill. Sometimes it was impossible to believe I was still an attractive, desirable woman, despite the evidence to the contrary. (Hey, the guy went out with me, didn't he?)

But holding on to my romantic side, the part of me that wants to love and be loved, to be kissed passionately, was crucial. Part of my style is to work around obstacles whenever possible, and I applied that to my love life as well. I turned the mirror in my bedroom around, so I wouldn't know exactly how I looked. Every

doctor I visited wanted to weigh me, but I refused to get on a scale, so my exact weight would be a mystery. At home, I'd wear my sexiest marabou-trimmed negligees and wait for my fella to return from work. And instead of waiting for him to bump into the wrong place and make me scream for the wrong reason, I'd give him a road map of where it was good to touch me. I didn't want our intimacy to be interrupted, to make our romantic life about my delicacy. It was kind of like bed Twister—"Left leg! Right cheek!" I won't go into any gory details, but I will say that the sense of imminent death can heighten the experience of intimacy.

At one point, after I got married, my skin started to stink from the medications I was on. I bought two pairs of nose clips so John and I could wear them when we made out. We actually wore them once, as a goof, but the point was more to acknowledge my feelings about the potential barrier to intimacy, and to bring our sense of humor into play in what could have been an uncomfortable situation.

But I never forgot about birth control. It's quite common for women who get gravely ill to completely ignore other health concerns, like reproductive health. When you're so focused on the part of you that's diseased, you can forget that the rest of you is still in good working order. Dr. Auchincloss has seen many women with this dilemma. Carrying a baby might be dangerous for your precarious health, and the treatments you're getting may cause complications, and how in the world will you have time and energy for a new baby? Yet, many women, pregnant or not, worry that this might be their last chance to have a baby, ever. This is how humans took over the world—we reproduce at an alarming rate. When you get seriously ill and your guard is down, Mother Nature pounces. "HAH! We'll get one more out of YOU before you go!" Trust me, you don't want to be following nature's lead at this point.

19

Things I Wish Somebody Had Told Me

Although I don't necessarily like to keep up on the details of my illness, there are a lot of things I know now that I was forced to discover whether I wanted to or not. And dammit, couldn't somebody have warned me?

I love medicine—it's made me the happy, cheerful, chronically sick person I am today. But modern medicine is not always benign, and sometimes it's downright unpleasant. Couldn't somebody have let me know that steroids were going to turn my face into a big lumpy bowl of oatmeal with two raisins for eyes? I also developed a turkey neck and a big hump on my back. For a while

I was in too much pain to even brush my hair, so it got all ratty and big, and with the steroid bloat I looked a lot like Linda Tripp, original version.

My face isn't swollen any more, but my eyes used to be round. Now they're more almond-shaped. This isn't so bad, but it isn't the old me. I feel strongly that I ought to have been warned about that. Or at least about the antiseizure medication that made my gums get freakishly large, like Nancy Kerrigan's.

I still can't take a shower. Calm down out there—I can take baths. But if I'd known the water pressure would hurt too much, I sure wouldn't have invested in one of those fancy shower massage heads. (I'm still cleaner than any French person—the average Frenchman uses only two bars of soap a year. Or than the typical German guy, who only changes his underwear once a week. I read it all in the *Harper's Index*—look it up if you don't believe me.)

And maybe this is no news to some people, but who knew opiates like morphine could give you constipation? I felt like Ignatius J. Reilly in *A Confederacy Of Dunces*—my valve slammed shut. Don't talk to me about fiber. I got stomach cramps like you can't believe. Herbal teas were even worse. They almost made enemas seem like an attractive option.

I wish someone had told me right off the bat that I didn't have to stop living just because I had a life-threatening illness. I managed all right on my own, but it would have been good to hear. I hope everyone reading this will hear it now, whether you're sick or not, because at some point in your life you or someone you're close to will be.

Most of all, I wish I'd known that doctors don't always know what they're doing, or what's wrong with you. I spent the first year of my illness thinking I might have non-Hodgkin's lymphoma, or multiple sclerosis, or AIDS, or Lou Gehrig's disease. Not that what I do have is a picnic, but I feel a lot better about sarcoidosis than I did about those Four Horsemen.

The Louis Armstrong Diet

In addition to being possibly the best jazz trumpeter and singer ever, Louis Armstrong was a keen amateur nutritionist. His mother had impressed on him the importance of "physic" (folk medicine), and specifically the immensely healthful power of a purge. Louis followed her advice strictly and became a "disciple of laxatives." In the early days he was unstintingly loyal to a product called Pluto Water, and took to signing his letters with "Am Pluto Wateredly Yours." Later he became particularly fond of an herbal powder called Swiss Kriss, and in a flyer he wrote and distributed himself, he fantasized about the day "When the Swiss Kriss Company give me a radio show, [and] my slogan will be, 'Everybody, this is Satchmo speaking for Swiss Kriss. Are you loosening? Wow.'" Wow indeed. As a promotional stunt, he sent out cards with a photo of him sitting on the toilet, with the words "SATCHMO SAYS, 'LEAVE IT ALL BEHIND YA!'" When confined to the hospital for exhaustion, Armstrong convinced his doctor to allow him to use Swiss Kriss instead of the hospital laxative, and as a result he was *"wailin'* on time, hitting it on the *nose.* " He even persuaded the head nurse to try it, causing her to come into his room "smiling beautifully, looking as pretty and fresh as she could be," and say, *"Satchmo,* you are a *naughty* boy." And in a diet printed in *Harper's Bazaar* entitled "Lose Weight, The Satchmo Way!" he reminds his readers that in addition to jelly omelettes, lamb chops, and stewed tomatoes, "A laxative at least once a week, is very nice." I only wish I could share his enthusiasm.

20

A Big Fat Happy
Stinkin' Life

Sarcoidosis changed my life. I had to leave some things behind, and make a lot of accommodations to my impaired health. You might expect that I'd have a lot of regrets as a result, but I don't. My only regret is that one lifetime couldn't ever be enough to spend with John. I didn't exactly find John because I became ill, but of all the things to come out of the past five years, John is the best. There's a song by Mott the Hoople called "I Wish I Was Your Mother" that my brother's band plays, about wishing you could have known someone you love for their whole life. That's me with John. I wish I'd known him when I was two years old.

When John and I first got married, I told him that if I croaked, he was not to spend the rest of his life in mourning. I wanted him to get back out there and find another woman—who could never possibly be as good as me, of course, but I didn't want him to be lonely. Now, that's changed. I recently told John, "If you go first, I'll be absolutely respectful of your memory. I won't date for at least two days." John said, "If I go first, I'm going to haunt you for the rest of your life. If you ever bring someone home, I'll drag chains and scare the bejesus out of you and your date. You'll have to be a lonely old widow without me." We're comfortable enough now with each other and with the disease to joke about him dying instead of me. Maybe that seems morbid, but it's just something we do to keep ourselves amused during bad rental movies.

I still look at the expiration date on cartons of milk, but mostly to remind myself of how I used to feel like my life was slipping away, and how much better I feel today. I don't let the possibility of imminent death rule my everyday life. I knew a kid in school who went around saying he was going to die soon because he had, of all things, scoliosis. Now he's a bum because he never thought about living his life, just sat around worrying about death.

F. Scott Fitzgerald famously said that "There are no second acts in American lives," but he never took the trouble to get his drunk ass to an AA meeting. There are second chances. I've been given more than one. Every day I wake up in the morning is a second chance for me. You just have to know when that chance comes and grab at it hard as you can.

Despite my fears about my career, I'm still working. I thought that ship had sailed, but you can still see my mug in fashion magazines and in drugstores everywhere as one of the faces of Almay cosmetics. I'm working again as a correspondent for Michael Moore, this time on his new satirical news magazine show, *The Awful Truth*. I'm a contributing editor at *Glamour* mag-

azine. I travel the country speaking to women's groups as a health-care advocate.

When you confront a catastrophic illness, you realize that you have a limited amount of time and a finite amount of energy left to you. Even if you're cured of what ails you, everybody dies of something sooner or later. It's up to you to devote your resources to living an honorable and valuable life. As Marcus Aurelius said, "Make yourself good while life and power are still yours." (I bet nobody who bought this book thought I'd quote a Roman emperor at all, much less twice.)

Life is made of time, and you can look back on each day as being lost or spent. I've lost too much time to illness to give up any more, and now I'm spending my days to the fullest extent. Disease ignited a passion in me. Before I got sick, even early on in my illness, as you've read, I would have done any job, even *Meatballs 8— Ernest Meets Freddy Krueger.* Now, I'm not so eager to squander my time. I can only squeeze out maybe four good work days a week, instead of seven in my prime, so if I can't find something worthwhile in a project, I'd rather stay home and spend time with my old man and his granny. You can thank sarcoidosis for saving the world from a plague of Karen Duffy movies and TV shows, because if I hadn't gotten sick, I would have been all over the place, doing any project that came my way and generally stinkin' up the joint. The interesting thing is that I've started getting better jobs, because instead of dissipating myself on whatever project that comes along, I hold out for something worthwhile.

That doesn't mean that I spend all my time fundraising for Doctors Without Borders, but I don't think I'll be starring in any more unwatchable movies either. That's one reason I'm so glad that I'm able to continue modeling for Revlon. I feel good that Revlon gives back by funding research into women's cancer. I'm a co-chair, with Cindy Crawford, of the Revlon Run/Walk for

Women's Cancer. Revlon has donated nearly $30 million for women's cancer research, and in the seven years that I've been involved, the Run/Walk has raised over $17 million.

Disease reaffirmed my commitment to service, to my work at the nursing home, because there are people who need love and friendship and companionship more than I need to lie in bed and moan about my suffering. John's gotten involved in some of my do-gooder projects, too. Together, we help raise money for the Village Center for Care, which funds the Village Nursing Home as well as a home for people with AIDS who've sold their life insurance early, figuring they'd need the money long before they died. Now, with the new triple therapies, they need a place where they can start learning how to live again instead of waiting for death. Obviously, discovering life when you thought only death awaited is something I know a lot about.

I hate to sound corny, but I'm still finding miracles every day. John and I recently became godparents to the son of a close friend. She'd gone through five years of treatment for ovarian cancer, and was finally able to have the child she'd always wanted. Her experience helped rekindle my maternal instincts, too.

I've always loved kids. I like to flirt with babies on the street, wink at them or stick out my tongue. I was walking down the street the other day and this kid and I were having a staring contest, and then the kid broke and started picking his nose and we both laughed. His father said to me, "If you don't have children, you should, because that smile deserves to be on a kid's face."

Experiences like that used to be bittersweet for me, because when I got sick, I thought for a long time that I might not be able to have children. Getting pregnant while on methotrexate would have been impossible. And I was afraid to leave my husband with the burden of children if, you know, I *do* die. (Plus, there's a

tradition in John's family to name the first boy in every other generation Lambros Lambros, and, needless to say, I felt that was a good enough reason in itself to remain childless.) Now I think having a child would be wonderful because it would have a part of John and a part of me, a legacy we'd create together. And after all, if I didn't have sarcoidosis, I could have a child and then get hit by a bus.

If you're in one of those pools where you lay money on which celebrities die in a given year, I hope you don't have me. The bus-accident option has recently become a lot more probable (compared to death by sarcoidosis, anyway—I'm not purposely running into traffic or anything). The steroids and methotrexate did their job. My spinal cord lesion is gone.

I recently realized I had a little pink zit on my cheek that hadn't gone away for months. "Do I have sarcoidosis on my skin now, too?" I asked Dr. Petito. "Let's just think of it as a little reminder of what happened to you," he said. My central nervous system could develop sarcoid cells again—it's been known to happen. But now I'm under careful medical supervision, and I'll be able to treat it right away, when it's still small. The other day, Dr. Petito hugged me and said, "I think you're going to beat this, I really do. I think you're going to get better."

I'm not *all* better, though, and I never will be. I still have sarcoidosis in my lungs, eyes, and intestine. Sarcoidosis in these organs is typically less malicious than in the spinal cord, but I take nothing for granted. Nothing about my case has been typical so far. And the scar tissue from the mostaccioli in my spinal cord will never go away. I'm in nun-kicking, bunny-stomping pain all the time. Morphine is my friend to the end. If I'm late with a dose, not only am I in pain, but I get Jimmy-legs—nervous bouncing—from my body's craving for more opiate. Living with

sarcoidosis of the central nervous system, even in remission, is living with the threat of death. I won't consider myself cured until I die of something else.

Then again, isn't death waiting for us at every turn? In a tree on the ski slope? In every small plane? On the edge of a sharp knife? Yes, I have a disease that puts my life in danger, but it's an indeterminate danger. Everybody is in danger of death all the time—my danger is just in slightly clearer focus.

But I have a razor-sharp appreciation for life, too. Now that enough time has passed for the methotrexate to clear out of my system, John and I have begun shooting into the open goal, as my gynecologist says.

Dr. Petito wasn't wild about putting my body through the strain of having a child. Besides, he said, "You're a model! Why do that to your figure? Get a surrogate mother!" But I really wanted to carry our child myself, and I'm sure I can get my naked pregnant picture on the cover of some magazine like all the other models.

My gynecologist was more upbeat. When I first talked to him about having and maybe carrying my own baby, he said no problem. "It would be a sin for you not to have a baby," he said.

In early 2000, I went to my gynecologist for a checkup, and he found something not right in those parts down there: a mass on my uterus. I asked if it was possible to have sarcoid cells on my uterus. "It is possible, but this doesn't seem to be sarcoid tissue," he said. "Can you go to the hospital for a sonogram?" I said, "Okay, I'll make an appointment." "I mean right now," he said.

I'd been here before. The last time I was ordered to take a test, pronto, was when my internist had discovered the sarcoid lesion in my spinal cord. I didn't yet know what was going on, but I felt like I'd been kicked in the head.

Even my experience with the sonogram tech was similar—he recognized me and got all excited. He started calling in his buddies to meet me. "Do you know who this is? Recognize her?" he said excitedly. I said, "At least let me put my knickers on before I meet these people."

When my gyno looked at the sonogram, he informed me that I had a uterine tumor "the size of an orange." "Here, let me show you," he said. "Don't even draw me a picture," I said. I was full of despair. A uterine tumor, after all I'd been through? What next, flesh-eating disease?

I went home and called John. I was crying like a baby. "How can this happen to me now?" Talking to John and unloading my fears helped, but he really turned the tide when he made me laugh by calling me his "little fruit cup." When doctors describe masses in my body that aren't supposed to be there, they usually use fruits for comparison, and I'd just added an orange to my disease compote. It didn't make the tumor go away, but it put me back in my preferred frame of mind and reminded me of how I go on—by cultivating a style that lets me sidestep the horror of disease.

I'd been breezing along, thinking, Well, it already got as bad as it could get, and now things are on the rebound. The odds are on

Bite Me

When doctors discover something wrong in your body, it's always described in terms of either food or sports equipment. A cantaloupe-size mass, a golf-ball-size tumor. Maybe it's because I'm a woman, but I usually get the food imagery. I used to feel this was completely inappropriate—"hand-grenade-size death tissue" would be a more accurate way of characterizing

it. But when John started calling me "fruit cup" after my gyne-cologist discovered the orange-size uterine tumor, I realized that you could actually make a pretty good meal out of my body. The sarcoid lumps in my lungs are the size of grapes, and those in my intestine are plum-size. My uterine mass is the size of an orange, and the lesion in my spine (the odd mass out) was the size of a mostaccioli. So I threw a dinner party for my girlfriends and served dishes made from my metaphorical afflictions: mostaccioli with sausage, wine (for the grapes), and orange soufflé with plum sauce.

my side for the first time in years. I'm married to John, I'm alive, maybe getting better. I wasn't worried about having a child because I thought, How can I have a sick kid? How could some-thing go wrong? It just wouldn't be fair. Well, it turns out that life really isn't fair. Getting kicked in the teeth again by disease reminded me not to take anything for granted, to savor what I've been given, and not to focus on being sick but on being as well as I can be.

At a time like this, I try extra hard to laugh at illness, because the humor in these situations is only where you find it. Life won't bring you comfort free of charge. There's no extra credit for being sick, not from fate, the world at large, or your fellow humans.

I have a kind of dual citizenship in the country of the sick and the country of the well. Most days, you wouldn't think I was sick to look at me, yet I have serious medical problems that haven't stopped hurting me. I take my medicine and go to the doctor, but I also go out shopping and model and act. I sometimes feel like I'm an ambassador between the two realms—explaining to healthy people what it's like to be sick, and to sick people how I

try to live my life as "healthy" as I can. Most times I can shift back and forth pretty easily.

But sometimes I go native in the country of the healthy, and that leads to problems. There are days when I get down about being sick, and the spread of life before me narrows down to a dark tunnel with no light at the end. And there are days when I'm so comfortable with the routine of illness, and so at home with my disease, that I forget I'm sick. And when that happens, and I get smacked in the face by a uterine tumor, it's doubly hard to rebound.

I also have moments when I think, Crikey, what if I do get all better? For starters, will I have to return the money for this book? I hope I do get better, but it would probably be a big adjustment. I've worked hard to live through my sarcoidosis, but being sick has affected who I am in ways that I'm probably not even aware of. In my healthy life, I was the person who never remembered to finish her antibiotics, causing resistant strains to develop that inflict the people who are good medical citizens. Now I'm completely compliant with the regimen imposed on me by the despotic Emperor Sarcoidosis.

Diseases like sarcoidosis of the central nervous system aren't something you just shake off, like a cold. Even if every sarcoid cell did turn normal overnight, I wouldn't magically turn back into my presarcoid self. My body's been damaged. My emotional life has been turned upside down and inside out. When I poke my head above the landscape of the past few years, I realize I'm no longer that perky wish-she-was-my-girlfriend type from the MTV days. That's gone.

My husband likes to say, "No squeal, no deal." Unless both sides in a negotiation are unhappy with something, you haven't reached the middle ground of an accommodation. My life with sarcoidosis is like that; I make the disease squeal with chemo and

steroids and morphine, and it makes me squeal by inflicting pain and incapacity. That's the bargain I've had to strike, and I know it's the best one I'm going to get.

My old friend Father Peter Funesti says I'm a testament to answered prayers. I prayed for the strength to face my affliction, but I learned that you have to accept the answer when it comes. Strength only comes through struggle, through testing yourself against something that seems too difficult for you to handle. In my struggle to deal with sarcoidosis, I think I've become a patient, sympathetic, stronger person.

Sometimes people tell me I'm brave. "Bravery" is possibly the most overused word in the language, next to "genius." Bravery is putting your ass on the line, risking your safety for others. Cops are brave. Soldiers are brave. So are Michael Moore's assistants. Baby Jessica wasn't brave just because she'd fallen down a well, and I'm not brave just because I'm sick. Being randomly struck down with a stinking illness, and being forced to deal with it as best I can, isn't brave—it's unlucky. I just paddle as hard as I can with the oars I have.

When I was first trying to get this book published, my agent sent the proposal out to twelve editors. Eleven called back to express interest. The twelfth sent a letter saying, "We like the idea, but we're afraid we won't have an author for a book tour." That attitude toward illness in both sick and healthy people made me more determined than ever to prove them wrong. I sent the rat bastard at Dell Publishing a sympathy card saying, "Sorry, I'm not quite dead yet. By the way, I'm working with HarperCollins, a *real* publisher."

Paul Tsongas, the senator and presidential candidate, said that if he had to choose the life he had, with the non-Hodgkin's lymphoma that eventually killed him, and a totally different life with perfect health, he'd definitely choose the life he had. I feel the

same way about sarcoidosis. I know what Lou Gehrig meant when he hobbled up to that microphone in Yankee Stadium and said, "Today, I consider myself the luckiest man on the face of the Earth. . . . I might've been given a bad break, but I've got an awful lot to live for." If I had to do it all over again, I wouldn't change a thing, with the possible exception of sitting through *Phantom of the Opera*. That's two hours of my life I'll never get back.

Mostly, my life now is better than it's ever been. Confronting sarcoidosis forced me to look inside myself and discover who I really am, what my strengths are, and where I want to be. When you come right down to it, there have been a lot of advantages to having a rare and debilitating disease. Unless and until things change for the worst, I'll keep on spittin' in death's eye.

Duff Thanks

MANY PEOPLE have made important contributions to the creation of this book, some of whom will remain anonymous because their contribution consisted of providing the author with bloodcurdling examples of boorish behavior.

My eternal gratitude to my family, without whose encouragement, guidance, and assistance this book could never have been written: To my adored parents, Phil and Carol Duffy, for their inspiring love for each other and for all of us; to my brother, Jim, who taught me how to read and how to write; and to my sisters, Kate and Laura, who provided encouragement, compassion, prayers, and an endless amount of material to write about. To Jack and Bill, you guys have been like brothers to me. To Kayla, Jack,

Caroline, and Gabriella, for being the best monkeys. To Cynthia Ryan, whose grace and wisdom are limitless, and to Niki Lambros, for her faith. And most of all, to John Fortune Lambros, my husband, whom I love beyond measure.

Thanks to my extraordinary friends Lori Campbell, Lynn Fisher, and Greg Shano, my best friends since childhood. To Peg Donegan, for believing in me, and to Aida Turturro, Amy Cohen, beautiful Jenny Kustner, Joanna Molloy, Helen and Kevin Ward, Whit Crane, and Dwight Yoakam for proving that a friend is someone who knows all about you and still likes you.

To Dr. Frank Petito, for saving my life. To Dr. Sarah Auchincloss, for saving my joie de vivre. To Odette Couritan, for her gentle touch every time she stabbed me with a needle. To Sherri Jones, Tanya Barbee, and Michele Cohen, whose bright lights illuminated Starr Six Pavilion.

To Revlon, especially Ron Perelman, Kathy Dwyer, and Jeff Nugent, for its generosity to women's health-care research.

To Michael Moore and Kathleen Glynn, whose confidence in me is one of life's highest honors.

To our editor, Diane Reverend, and to Matthew Guma, and David Vigliano, who guided us through the many stages of writing this book, and to Dean Williamson, who fought the hardest and will *never* be forgotten. And finally, to Stu Gelwarg, for being a friend I can count on as well as a bean counter.

Francis Thanks



I'D LIKE TO THANK my parents, Frank and Lucille Gasparini, for giving birth to me, and my sister, Nicole, for providing me with a steady supply of bootleg pacifiers after her birth. Christine Fall, Sinéad Kinnane, Deanna Storey, and Gigi Netzband all helped with the preparation of the manuscript and saved me innumerable hours of labor. I'm sure they enjoyed transcribing and research much more than I would have. It goes without saying that it was a privilege and an honor to work with Duff. John Lambros devoted more time than he should reasonably have spared to ensure that his story was gracefully told, and was

unsparingly generous with praise and encouragement. And of course, many thanks to Dina Varano, who encouraged me as I struggled to make my writing worthy of Duff's story, and helped me keep up with the latest TV shows by watching them in the next room as I typed.

Resources

American Leprosy Missions
I ALM Way
Greenville, SC 29601
(800)543-3135
www.leprosy.org
 Seeks to cure leprosy sufferers.

Centerwatch
22 Thompson Place, 36TI
Boston, MA 02210-1212
(800)765-9647
Fax (800)850-1232
www.centerwatch.com
 Provides information about clinical
 trials and clinical research into new
 medications, procedures, and devices.

**Citizens for Corporate
Accountability and Individual Rights**
P.O. Box 3326
Church Street Station
New York, NY 10008
(212)267-2801
E-mail ccair@consumerwatchdog.org
www.ccair.org
 A corporate watchdog organization
 that tries to protect the right of the
 little guy to sue some big bad compa-
 nies, including health-care companies.

CRISP
*http://www.commons.cit.nih.gov/
crisp/CRISP*

Searchable database of federally funded biomedical research projects.

Foundation for Sarcoidosis Research
P.O. Box 577849
Chicago, IL 60657
(773)665-2400
Fax (773)665-0805
E-mail: fsr@fightsarcoidosis.org
www.fightsarcoidosis.org
Raises money to fund innovative and high-quality research into causes and cures for sarcoidosis. One hundred percent of all money raised by FSR goes directly to funding research projects.

Gilda's Club
195 West Houston Street
New York, New York 10014
(212)647-9700
Fax (212)647-1151
www.gildasclub.org
Offers support and networking groups, lectures, workshops, and social events for people with cancer and their families in a nonresidential, homelike setting.

Greater Rheumatoid Arthritis Care and Education Network (GRACE)
(877)812-6872
Fosters rheumatoid arthritis education among patients, physicians, and other health professionals to ensure accurate diagnoses and effective disease management. Member organizations include the American Academy of Nurse Practitioners, the American Autoimmune Related Diseases Association, the American Medical Women's Association, the Arthritis Foundation, the National Coalition on the Aging, and the National Women's Health Resource Center.

Inner City Scholarship Fund
1011 First Avenue
Suite 1400
New York, NY 10022-6461
(212)753-8538
Fax (212)371-6461
www.innercitysf.org
Raises money to help send children to Catholic schools.

Life and Breath Foundation
1734 Riverside Avenue
Baltimore, MD 21230
(410)752-0004
E-mail srhull@aol.com
www.lifeandbreath.org
Works toward finding a cure for sarcoidosis.

Look Good, Feel Better
1101 17th Street, N.W.
Suite 300
Washington, DC 20036-4702
(800)395-5665
Fax (202)331-1969
www.lookgoodfeelbetter.org
Community-based, free national service founded and developed by the Cosmetic, Toiletry and Fragrance Association and Foundation, which teaches female cancer patients beauty techniques to help enhance their appearance and self-image during chemotherapy and radiation treatments.

Monkey Helpers for the Disabled
541 Cambridge
Boston, MA 02134
(617)787-4419
www.helpinghandsmonkeys.org
 Dedicated to improving the quality
 of life for quadriplegic individuals by
 training capuchin monkeys to assist
 them with daily activities.

National Breast Cancer Coalition
1707 L Street N.W.
Suite 1060
Washington, DC 20036
(202)296-7477
Fax (202)265-6654
www.stopbreastcancer.org
 Works for increased funding for
 research and greater access to treat-
 ment and clinical trials, and to
 increase the influence of activists and
 women with breast cancer.

National Heart, Lung, and Blood Institute
P.O. Box 30105
Bethesda, MD 20824–0105
(301)251-1222
www.nhlbi.nhi.gov
 Plans, conducts, and supports
 research, clinical trials, and demon-
 stration and education projects
 related to the causes, prevention,
 diagnosis, and treatment of heart,
 blood, blood vessel, and lung dis-
 eases, including sarcoidosis.
 If you're interested in partici-
 pating in ongoing clinical studies of
 sarcoidosis at the NHLBI, have your
 doctor write to:

NHLBI
Pulmonary Branch
9000 Rockville Pike
Building 10, Room 6D06
Bethesda, MD 20892
www.saga.njc.org
 Information on NHLBI's
 Sarcoidosis Genetic Analysis
 (SAGA).

National Multiple Sclerosis Society
733 Third Avenue
New York, NY 10017
(800)344-4867
www.nmss.org
 Funds research, furthers education,
 and advocates and provides a variety
 of empowering programs for the
 third of a million Americans who
 have MS and their families.

National Organization for Rare Disorders
P.O. Box 8923
New Fairfield, CT 06812-8923
(800)999-6673
www.rarediseases.org
 Provides information on rare dis-
 eases, networking programs, and
 referrals to organizations for specific
 disorders.

National Sarcoidosis Resource Center
P.O. Box 1593
Piscataway, NJ 08855–1593
(732)699-0733
Fax (732)699-0882
E-mail sandra@nsrc-global.net

www.nrsc-global.net
Provides information and support for people with sarcoidosis.

Procrastinators' Club of America
973 Warfield Lane
Huntingdon Valley, PA 19006
(215)947-9020
For those who, like writers, have trouble getting around to it.

Project ALS
511 Avenue of the Americas
Suite 341
New York, NY 10011
(800)603-0270
E-mail projectals@aol.com
www.project-als.org
Raises money to fund research into treatments and cures for amyotrophic lateral sclerosis (Lou Gehrig's disease).

Restless Leg Syndrome Foundation
819 Second Street S.W.
Rochester, MN 55902-2985
(507)287-6465
E-mail RLSFoundation@rls.org
www.rls.org
Provides information, raises money, and organizes support groups.

Sarcoidosis Center
E-mail sarcoid@sarcoidcenter.com
www.sarcoidcenter.com
Source of sarcoidosis information for patients and physicians.

Sarcoidosis Family Aid and Medical Research Foundation
268 Martin Luther King Boulevard
Newark, NJ 07102

(800)223-6429
Fax (201)877-2850
www.healthy.net/pan/cso/cioi/
TNSFSMMC.HTM
Informs the public about sarcoidosis, refers patients to doctors, and provides financial aid for patients and their families.

Sarcoidosis HelpNet
P.O. Box 022642
Brooklyn, NY 11202
(718)982-7118
www.dynateck.com/helpnet/
Volunteer organization founded to further research and public awareness.

Sarcoidosis Networking Association
c/o Dolores O'Leary
13925 80th Street East
Puyallup, WA 98372-3614
(253)845-3108
E-mail Sarcoidosis
Network@Juno.com or
VBKR29A@Prodigy.com.

Sarcoidosis Online Sites
www.blueflamingo.net/sarcoid.
Information and support for sarcoidosis patients.

Sarcoidosis Research Institute
3475 Central Avenue
Memphis, TN 38111
(901)766-6951
Fax (901)774-7294
www.sarcoidcenter.com/sricontents.
htm#SRI Table of Contents
Distributes up-to-date information on sarcoidosis to patients, the public,

and the medical community.

Sarcoidosis Worldwide Support Group
www.geocities.com/HotSprings/Spa/9139/

Information and on-line support for patients and physicians.

Selective Mutism Foundation
Carolyn Miller
The Selective Mutism Foundation, Inc.
P.O. Box 13133
Sissonville, WV 25360-0133
or
Sue Newman
The Selective Mutism Foundation, Inc.
P.O. Box 450632
Sunrise, FL 33345-0632
Personal.bellsouth.net/mia/g/a/garden/garden/

Simon Foundation for Continence
P.O. Box 815
Wilmette, IL 60091
(847)864-3913
Fax (800)237-4666
(847)864-9758
E-mail: simoninfo@simonfoundation.org
www.simonfoundation.org/html/index2.htm

Educates the public about cures and treatment and management techniques for incontinence, and works to sensitize health-care professionals.

Society for Women's Health Research
1828 L. Street, NW
Suite 625
Washington, DC 20036
(202)223-8224
www.womens-health.org

The Society for Women's Health Research is the only nonprofit advocacy organization dedicated to improving the health of women through research. Promotes the inclusion of women in clinical research, and works to increase funding for research on diseases and conditions that affect women.

Well Spouse Foundation
30 East 40th Street, PH
New York, NY 10016
(212)685-8815
(800)838-0879
Fax (212)685-8676
E-mail: wellspouse@aol.com
www.wellspouse.org

Gives support to husbands, wives, and partners of the chronically ill and/or disabled.

World Sarcoidosis Society
www.worldsarcsociety.com
Distributes information and works toward finding the cause and cure of sarcoidosis.

Bibliography

Allen, James. *As a Man Thinketh*. New York: Andrews McMeel, 1999.

Armstrong, Louis. *Satchmo: My Life in New Orleans*. New York: Da Capo Press, 1986.

———. *Louis Armstrong: In His Own Words*. New York: Oxford University Press, 1999.

Bergreen, Laurence, and Jenny Minton. *Louis Armstrong: An Extravagant Life*. New York: Broadway Books, 1998.

Bowles, Paul. *The Sheltering Sky*. New York: Ecco Press, 1998.

Broyard, Anatole. *Intoxicated by My Illness*. New York: Fawcett, 1993.

Conn, Charis, and Ilena Silverman, eds. *What Counts: The Complete Harper's Index*. Out-of-print.

Conroy, Sandra. *Sarcoidosis Resource Guide and Directory.* New York: PC Publications, 1992.

Diamond, John. *Because Cowards Get Cancer Too: A Hypochondriac Confronts His Neuroses.* New York: Times Books, 1999.

Handler, Evan. *Time On Fire: My Comedy of Terrors.* New York: Owl Books, 1996.

Kelly, Sean, and Rosemary Rogers. *Saints Preserve Us!* New York: Random House, 1993.

Lagne, Sophie, and Andre Pascal Gaultier. *A Dictionary of Superstitions.* Translated by Amy Reynolds. Out-of-print.

Leffell, David. *Total Skin.* New York: Hyperion, 2000.

Mandell, Harvey, and Howard Spiro, eds. *When Doctors Get Sick.* New York: Plenum Publishing, 1987.

Marcus Aurelius. *Meditations.* Translated by Maxwell Staniforth. New York: Viking Press, 1987.

Opie, Iona Archibald, and Moira Tatum, eds. *A Dictionary of Superstitions.* Out-of-print.

Price, Reynolds. *A Whole New Life.* New York: Plume/Penguin, 1995.

Root-Bernstein, Robert S., and Michele R. Root-Bernstein. *Honey, Mud, Maggots, and Other Medical Marvels: The Science Behind Folk Remedies and Old Wives' Tales.* New York: Houghton Mifflin, 1997.

Sweeney, Julia. *God Said Ha!* New York: Bantam, 1997.

Tilberis, Liz. *No Time to Die.* New York: Avon, 1998.

Train, John. *Valsalva's Maneuver.* New York: Harper & Row, 1989.

Train, John. *Most Remarkable Occurrences.* New York: Edward Burlingame Books, 1990.

Watt, Ben. *Patient.* New York: Grove Press, 1996.

Weeks, David, and Jamie James. *Eccentrics: A Study of Sanity and Strangeness.* New York: Kodansha International, 1996.

Young, James Harvey, ed. *American Health Quackery: Collected Essays.* New York: Princeton University Press, 1992.

Zuckerman, Eugenia, and Julie R. Ingelfinger. *Coping with Prednisone and Other Cortisone-Related Medicines.* New York: Griffin, 1998.